THE ART INSTITUTE OF CHICAGO

THE ART INSTITUTE OF CHICAGO

JOHN MAXON

298 illustrations, 33 in color

THAMES AND HUDSON

First published 1970 Revised edition 1977

© 1970 THAMES AND HUDSON LTD, LONDON

ALL RIGHTS RESERVED. NO PART OF THIS PUBLICATION MAY BE REPRODUCED OR TRANSMITTED IN ANY FORM OR BY ANY MEANS, ELECTRONIC OR MECHANICAL, INCLUDING PHOTOCOPY, RECORDING, OR ANY INFORMATION STORAGE AND RETRIEVAL SYSTEM, WITHOUT PERMISSION IN WRITING FROM THE PUBLISHER

PICTURE REPRODUCTION RIGHTS RESERVED BY
THE ART INSTITUTE OF CHICAGO

LIBRARY OF CONGRESS CATALOG CARD NUMBER: 72-125779

Printed and bound in Great Britain

Contents

THE ART INSTITUTE OF CHICAGO	7
Painting and Sculpture	20
Prints and Drawings	126
Рнотоgraphy	172
Oriental Art	174
Classical and Decorative Arts	216
Textiles	234
Primitive Art	240
Appendix	249
Index of Illustrations	279

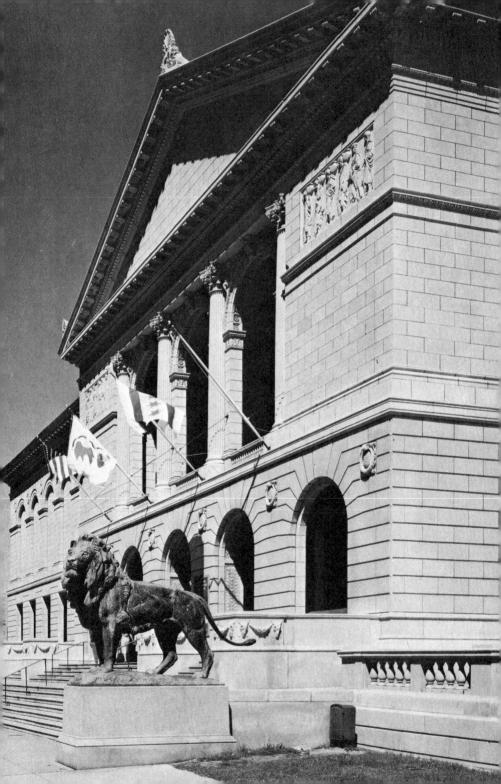

The Art Institute of Chicago

In 1866 there was established in Chicago, Illinois, an institution called the Chicago Academy of Design; this body was formed by a group of artists and managed – more accurately, mismanaged – by them. About 1878 a group of business men was elected to the board of this body in the hope of unsnarling its tangled affairs. After a year's endeavor, the new trustees decided that they could not achieve their goal, and all resigned. They then formed a new organization called the Chicago Academy of Fine Arts, which was incorporated 24 May 1879. (The former institution continued to struggle till 1882 or thereabouts.) In December 1882 the new academy changed its name to the one it still bears, the Art Institute of Chicago. The certificate of incorporation states as its purposes, 'the founding and maintenance of Schools of art and design, the formation and exhibition of collections of objects of art, and the cultivation and extension of the arts of design by any appropriate means.'

The first President of the Institute, George Armour, served one year, and his successor, Levi Z. Leiter, served two years. The man who followed Leiter, Charles L. Hutchinson, was to serve as President of the Art Institute for

forty-three years.

During its first three years of existence the Institute rented rooms at State and Monroe Streets, in which art classes were held from the start, and occasional exhibitions were mounted. In 1882, when the name was changed, the property at the southern corner of Michigan Avenue at Van Buren Street was bought, and a building was put up to front on the latter street. Here there were class-rooms and exhibition galleries. On 19 November 1887, a new building designed by John Wellborn Root was opened. Each year for five years, further changes were made to the fabric, but it was finally decided that the building was hopelessly outgrown, and the property was sold to the Chicago Club for an amount almost ten times what had been paid a decade earlier.

The trustees decided to profit from the World's Columbian Exposition in 1893 by co-operating with the managers of the exposition in the building of a

hall for the World's Congresses, which, at the end of the exposition, would revert to the trustees of the Art Institute for their permanent use. The building, by Shepley, Rutan, and Coolidge, remains the core of the Art Institute's complex of buildings. It has since been named to honor Robert Allerton, long a trustee, officer, and benefactor of the museum.

An examination of the paper of incorporation shows that the purpose of the school, as well as of the museum, reflected the thinking which had received its main impetus in the Great Exhibition in London in 1851; that is, there was a strongly didactic motivation which, in its turn, represented a genuinely ethical purpose. Thus, in keeping with such feelings, there was acquired, very early in the history of the Institute, a large and fine collection of plaster casts which survived intact till the late 1950s, when, in accord with the change of taste in teaching and a different view about the value of reproductive works, the collection was dispersed. By 1900 there was also a collection – albeit a rather small one - of Egyptian and Classical material. The former was later abandoned as a field for pursuit, mainly because of the emergence of the work of the Oriental Institute of the University of Chicago. The latter group remains a small one, but a choice one with a number of superb Greek pots. In 1894 Mr Hutchinson, aided by Martin Ryerson who still remains the greatest single benefactor of the Art Institute, was able to secure thirteen major works, mostly Dutch, from the sale of the Demidoff Collection in Florence. Mrs Henry Field gave in her husband's memory, also in 1894, his distinguished collection of Barbizon paintings, among which works by Millet are outstanding. By 1900, the members of the Antiquarian Society, an ancillary group dedicated to helping the Art Institute, had bought a number of important items of decorative arts.

In 1906, the trustees voted, after some hesitation and by no means unanimously, to buy what still remains the greatest object in the collection: El Greco's Assumption. This was the master's first great Spanish commission and had formed the central part of the high altarpiece of the church of San Domingo el Antiguo in Toledo. Mr Hutchinson and Mr Ryerson had seen the picture at Durand-Ruel's in Paris and ordered it sent on approval to Chicago. The then Director, William M.R. French (brother of the American academic sculptor, Daniel Chester French), observed that he could not recall seeing any El Greco in a European gallery. He further noted that, while he felt the picture to be one of El Greco's best and that it made a valuable addition to the collections in the Institute, he could not say that he felt ready to pay \$40,000 for it. In terms of the buying power of the dollar in 1906 this was indeed an enormous amount of money to pay for the work of an almost completely unknown or, at least, forgotten master. It is interesting to note that the painting had been seen at

Durand-Ruel's by John Singer Sargent, Frank Duveneck, and Gari Melchers, among American artists, and by Degas among the French. It was Mary Cassatt who called the work to Ryerson's attention. She had found it in Spain while she was travelling with the Horace Havemeyers of New York. The Havemeyers found they could not use the picture and reluctantly asked Miss Cassatt to see if she and Durand-Ruel could find a buyer. This was still a period when painters were intensely interested in the art of the past, and it is not without meaning that Mr Ryerson and Mr Hutchinson appear to have been more impressed by Miss Cassatt's views and those of her colleagues than they were by that of their own professional staff member.

The next great group of pictures to come to the Institute was the bequest, in 1922, from Mrs Potter Palmer. Mrs Palmer had not only been the doyenne of the social scene in Chicago, but she was also one of the principal forces in the organization of the World's Columbian Exposition and served as President of its Board of Lady Managers. Bertha Honoré Palmer appears to have been a woman not only of great energy but also immense charm and a superb sense of business affairs; she greatly increased the family fortune - by more than 100 per cent - in the twenty years between Potter Palmer's death in 1902 and her own. Mary Cassatt was her friend and undoubtedly made suggestions to her, but Mrs Palmer was her own woman in matters of taste. She owned, of course, Barbizon pictures - everyone did in her time - but she began early to collect other things as well. She bought the great Corot figure-piece, Interrupted Reading, in 1889, hardly a fashionable choice at that moment. Then in 1892 she bought the beautiful early (1868) Monet, The River, again a most personal choice. One of Mrs Palmer's most beautiful pictures, which unfortunately did not stay in Chicago, was the ravishing small Veronese, Mars and Venus surprised by Cupid, which now rests in the Galleria Sabauda, Turin; one wonders why Mrs Palmer seems to have ordered the picture sold instead of including it in her magnificent bequest.

Also in 1922 the Kimball bequest came to the Art Institute. This group included the best Reynolds in the whole collection, Lady Sarah Bunbury Sacrificing to the Graces, one of the painter's finest works of all (certainly one of his two best in the United States). Also in the group is the great Constable Stokeby-Nayland, Romney's Mrs Francis Russell, and one of Sir Thomas Lawrence's finest portraits, that of the Danish consul's wife, Mrs Jens Wolff. The one non-English work in the Kimball Collection is Rembrandt's noble, early Portrait

of the Artist's Father.

When Mr Hutchinson died in 1925, he left his small group of Flemish and Dutch pictures, as well as Rossetti's 1872 replica of his Beata Beatrix.

The next great gift to the Institute was that given by Frederic Clay Bartlett in his second wife's memory, the Helen Birch Bartlett Memorial Collection. The most notable work of this collection is Seurat's finest painting, Sunday Afternoon on the Island of the Grande-Jatte, which, aside from the El Greco, is the most famous single item in the entire museum. Capital works by nineteenth-century masters such as Cézanne, Gauguin, van Gogh, and Toulouse-Lautrec are present as well as major pictures by such twentieth-century artists as Matisse, Modigliani, Picasso, and Rousseau. There are also three paintings by Hodler, who is rarely represented outside of Switzerland.

Arthur Jerome Eddy, a Chicago lawyer, bequeathed a notable group of Expressionist works in 1931. Some of these he had bought from the famous Armory Exhibition of 1913. The collection included a Franz Marc and four works by Kandinsky, as well as a major early Manet, and portraits of Eddy by both Whistler and Rodin.

Martin Antoine Ryerson, a Vice-President of the Art Institute and great friend of Charles L. Hutchinson, died in 1933, leaving his collection to the museum. His was the greatest single bequest yet to come to the Art Institute, and Ryerson must rank as one of the greatest of all collectors in the United States. Two hundred and twenty-seven pictures, as well as items of the Oriental and decorative arts, were included in the bequest which joined the Demidoff Rembrandt he had given in 1894, in addition to fine Greek pots. Ryerson's eye was infallible, and it is interesting and rather chastening for the professional art historian to learn that the only four debatable paintings Ryerson seems ever to have bought were the only two on which he had professional advice. Ryerson's eye could encompass painters as different as Giovanni di Paolo and Cézanne, Memling and Redon, Renoir and French primitives.

Another benefactor greatly to help the museum's holdings in nineteenth-century French painting was Mrs Lewis Larned Coburn, who died the same year as Mr Ryerson did. Two great Manets and two equally great works by Degas set the tone for the Impressionists. And Cézanne, van Gogh, Gauguin, and Picasso go with a group of fine Monets to complete the bequest.

One of the prime sources of benefaction for the Art Institute was the Buckingham family: Clarence, and his sisters, Lucy Maud and Kate Sturges. Clarence Buckingham was introduced to the art of Japanese prints at the World's Columbian Exposition, and was able later to acquire the collection of the well-known connoisseur from Boston, Ernest Fenollosa. On Buckingham's death in 1913, his sister Kate appointed his friend, Frederick Gookin, to be keeper of the collection and to continue its growth. To honor her sister's memory, Kate created the collection of ancient Chinese ritual bronzes

and, also in Lucy Maud's memory, donated the collection of medieval art and artifacts. In addition, in memory of her brother Clarence, Kate Sturges Buckingham built a fountain for the city, some two streets to the south of the Art Institute. Her crowning benefaction in 1937 was the bequest of a fund from which the income was to be spent in caring for the collections begun by her brother and sister as well as to augment them. And it was from this bequest that Clarence Buckingham's collection of European old master prints and drawings began seriously to be increased and improved.

Charles H. and Mary F.S. Worcester had built their collection systematically to correlate with the rest of the museum's holdings. They bought German and Italian masterpieces to go with their own group of Impressionists. This bequest came to the Institute on Worcester's death in 1947, along with

an endowment fund to augment the collection.

On Max Epstein's death in 1954, the Max and Leola Epstein Collection was added to the museum's holdings. Two Botticellis – one rather early, the other quite late – are in the group as well as some fine Flemish and Dutch pieces

and a great French primitive.

One of the curious and characteristic things about collecting in Chicago is the fact that, save for certain specialized collections – one thinks of Russell Tyson's Oriental art – most of it has been devoted to what was, at any given time, contemporary art. With Ryerson, Worcester, and Epstein, the only other serious and systematic collectors of old master paintings have been the Deering brothers, Charles and James, and the late Morris I. Kaplan. From Charles Deering and his descendants have come a number of major works of Spanish art. Chief among these are the Ayala altarpiece and the Burgo de Osma embroidered dossal and antependium. The Charles Deering heirs have also given major works by Velázquez, Mancini, van Gogh, and Ingres. James Deering gave the magnificent set of four canvases by G.B. Tiepolo which illustrate scenes of the *Story of Rinaldo and Armida*.

From collectors of contemporary art have also come a number of distinguished works. Chief among these is the bequest of Mr and Mrs Walter S. Brewster, and gifts from Mr and Mrs Leigh B. Block and from the late

Samuel A. Marx and his widow, Mrs Wolfgang Schönborn.

In 1921 Joseph Winterbotham set up a trust fund, the income of which was to be spent on modern European pictures, with the total number of paintings to be limited to thirty-five. It was understood that the quality of this group was always to be maintained and, if possible, improved.

In the later history of the museum there have been generous donors who have bought directly to enrich the collections of the museum. The first of these was

Robert Allerton, who was interested not only in the decorative arts but in twentieth-century sculpture and drawings; his trust is the largest yet to come to the museum. Mrs Tiffany Blake began, with her friend, the second Mrs Potter Palmer, to buy drawings in the 1940s in order to build up that department. Mrs Joseph Regenstein, who has done the same, has been equally generous to the Department of Oriental Art.

Mrs James Ward Thorne created a group of period rooms of breathtaking accuracy on a miniature scale. She gave this group along with an endowment to maintain it; always a popular attraction, its presence has relieved the Art Institute from any desire to emulate the cult of the period room, so popular in some American galleries.

The building of the museum's edifice has continued through the years. Martin Ryerson built the original library in 1900; it was rebuilt in 1967. After the First World War, the wing across the Illinois Central Railroad tracks was completed. And in 1925 the Kenneth Sawyer Goodman Memorial Theatre was built. This was conceived as a theatre with a resident professional company as well as a school of acting. After the abandonment of this purpose as a result of the great depression of the 1930s, it has been possible, in 1969, to return to the original concept of a professional theatre in residence.

In the late 1950s a new administrative block was built, and in 1962 a new wing to house twentieth-century art as well as special exhibitions was given by Mr and Mrs Sterling Morton. (His widow later gave a small lecture hall.) A new building for the school, a new auditorium, restaurant, galleries for Primitive Art and Twentieth-Century American Art were added in 1973–76.

Mrs Stanley McCormick provided the two gardens at the front of the building on Michigan Avenue, as well as funds to maintain them.

Mrs E. C. Chadbourne provided a generous endowment fund to augment her many gifts of objects of art. The late Grant J. Pick bequeathed objects of art and a generous fund. Mr and Mrs James W. Alsdorf have been generous in many fields.

Many other generous donors have given not only works of art but also money. The total roster of membership is the largest of any American museum's, in excess of 40,000. The ownership of the collections and control of the operations of the Art Institute of Chicago are vested in its Governing Life Members who elect the trustees and officers. In 1900 the total endowment was less than \$100,000. Seventy years later it is more than \$50,000,000. That this could be, is the result of Charles L. Hutchinson's energy and affection during his long Presidency, and the industry and activity of his successors, the second Potter Palmer, Chauncey McCormick, Everett Graff, McCormick's

cousin, William McCormick Blair, Frank H. Woods, Leigh B. Block, and, since 1975, James W. Alsdorf, as Chairman of the Board. But their task would have been an impossible one if they had not had the help of their fellow trustees. And, most of all, the Art Institute exists because of the affectionate interest of the people of Chicago who have given and still give amounts of all sizes, both large and small.

Museums of art, aside from any stated purposes they have proclaimed, always embody their own history and exemplify the taste of their benefactors and staffs. Further, they show the exigencies of collecting and possibilities of various epochs. These facts are particularly true of the Art Institute. In no sense does it have the completeness in its collection of pictures that the Metropolitan Museum or even the National Gallery of Washington have, not to mention such a consciously synoptic collection as that of the National Gallery of London. Nor does it have the completeness of specialization which is found in the Freer Gallery, Washington. Nor yet is it a catalogue of the taste of a single inspired collector, such as is found in Fenway Court, Boston.

What the Art Institute of Chicago has in its collections is a group of nineteenth-century French pictures of the greatest distinction as well as a major group of old Flemish pictures and old Italian paintings. Put another way, the collection does not cover the whole history of Western painting with equal emphasis. But what it covers in depth, it covers gloriously. The same may be said of the print room's holdings as well as the Oriental collections. In the case of the collections of ceramics and furniture, the original emphasis was on acquiring the typical rather than the exceptional, an attitude perfectly in line with the thinking which originated in the Great Exhibition of 1851, London; as modern taste no longer seeks to copy, the emphasis necessarily has had to change – and at a moment when many categories have skyrocketed in price.

THE DEPARTMENT OF EARLIER PAINTING AND SCULPTURE

The department ranks, in its way, as the oldest in the Art Institute of Chicago. William M. R. French, who was Director from 1888 till 1914, also functioned as the first Curator, and his successor, George W. Eggers, served during his directorship from 1916 to 1921 as both Director and Curator of the department.

The department's first major acquisition was the Jan Steen Family Concert in 1892. The Demidoff Collection of major Dutch works followed closely in 1895, when the Henry Field Collection of Barbizon pictures was also received

as a bequest. The four great decorations by Hubert Robert were acquired in 1900, and the first Impressionist painting to come to the Art Institute of Chicago was Monet's Cliffs at Pourville in 1903. The greatest of the old master-pieces in the museum, El Greco's Assumption, came in 1906. The bequest of Mrs Potter Palmer in 1922 established the museum's reputation in the Impressionist field, just as the Birch-Bartlett Memorial Collection established pre-eminence in Post-Impressionism, and the Arther Jerome Eddy Collection in the painting of the opening years of this century.

Principal exhibitions organized by the department have included the following: Monet and Manet in 1895; Gustave Doré in 1896; Rafaëlli in 1899; The 'Eight' in 1908; Cassatt in 1922; Laurencin and Braque in 1924; Toulouse-Lautrec in 1924; Morisot in 1925; Maillol in 1926; Chardin in 1927; Venetian paintings of the sixteenth to eighteenth centuries in 1928; Delacroix in 1930; Toulouse-Lautrec in 1930; and most important: fine arts exhibitions for the 'Century of Progress' celebration in 1933 and a Retrospective of American Art for the 'Century of Progress' in 1934; van Gogh in 1936; Cézanne in 1952 and 1971; Seurat in 1958; Manet in 1966; Renoir in 1973; Monet in 1974.

THE DEPARTMENT OF TWENTIETH/CENTURY ART

One of the glories of the collections is that of twentieth-century art. During Dr Harshe's directorship and that of Mr Rich, strong directions to acquire capital contemporary works were maintained. Further, the interest of collectors in Chicago has for many years been oriented toward the contemporary. Since 1961 the emphasis has been particularly to acquire the new and usually controversial. This same emphasis has prevailed in exhibitions of contemporary art, and was begun by Dr Harshe and continued by his successors. Dr Harshe, no man to suffer fools, serenely ignored squawks of rage both from hyper-conservative patrons as well as from artists who did not make it. Through the years Chicago has seen many innovative and controversial works shown and acquired for the collections.

THE COLLECTION OF PRINTS AND DRAWINGS

This collection was begun in 1887 with a gift of some five hundred miscellaneous items which were kept on deposit in the library. Additions were made to this group only on the most haphazard basis. At the beginning of June 1911, three trustees, Wallace L. DeWolf, Clarence Buckingham, and Kenneth

Sawyer Goodman, organized the print collection as a separate department, with Mr Goodman to function as curator. In these early days the representation of the great European masters was slight; more attention was paid to McLauglan, Joseph Pennell, and the English makers of mezzotints than to Goya, Dürer, and Rembrandt. The French masters of the nineteenth century, however, were cultivated, especially Meryon, of whose works an exemplary group was formed; and a major group of Redon prints was bought from the painter's widow as early as 1919.

In 1938 the nature of the department's holdings was transformed by the arrival of the Buckingham Collection, which included fifty-seven prints by Dürer, fifteen by Lucas van Leyden, twenty-one portraits by van Dyck, as well as ninety-five by Rembrandt, among many others. And Miss Kate S. Buckingham's establishment of a purchase fund has made it possible to enrich and build upon this foundation. From 1946 through 1957 came the Potter Palmer II bequest, which included some three hundred items of the greatest sophistication of taste. Mr Palmer preferred Schongauer to Dürer, and he had even acquired seven prints by Master E.S. as well as an important group of early Italian engravings.

The whole tenor of the collection was further altered with the arrival of the late Carl O. Schniewind during whose curatorship, 1940–57, the collection ceased entirely to be provincial in its character and became one of the great printrooms of the world. This character has been even more strongly emphasized during the tenure of the present curator in the generation since Schniewind's death. The French collections of the nineteenth century had been emphasized by the gift in the 1920s from Walter Brewster of a major group of works by Bresdin. And a former mayor of Chicago, Carter H. Harrison, helped materially to form the great group of prints by Toulouse-Lautrec. The present curator has kept up these collections, and it was he who had the foresight to buy the bulk of the unparalleled collections of prints by Edvard Munch from the architect, Miës van der Rohe, in 1963. In addition, the German Expressionists and American and European contemporary artists have not been neglected.

Schniewind began to develop the collection of drawings. Prior to his time the main groups consisted of the miscellaneous but interesting groups in the Gurley Collection as well as a number of major late nineteenth, and twentieth-century works given by Robert Allerton. Schniewind made a fine start in acquiring major works, mainly through the help of the second Mrs Potter Palmer and Mrs Tiffany Blake, as well as purchases through the Buckingham Fund. His successor has been able to build brilliantly upon that foundation

through the continuing help of Mrs Blake and through the dazzling generosity of Mrs Joseph Regenstein.

PHOTOGRAPHY

Work with photography began as an extension of the activities of the Department of Prints and Drawings. This activity was dormant from 1957 to 1959, when the collection was again activated and a serious program of exhibitions and collection carried on and maintained. Not only have programs of temporary exhibitions been continued, but a small but superlative collection has been formed.

THE DEPARTMENT OF ORIENTAL ART

This department was organized in 1921, although objects had been acquired before that time and some memorable exhibitions had been held, notably one installed and planned by the famous Chicago architect, Frank Lloyd Wright, in 1905. With the establishment of the department as a separate entity, the collections began to assume something of a form in which they now exist. Chief among these are the collection of Japanese prints and ancient Chinese bronzes, both of which owe their impetus and continuation to the Buckinghams. Among his many other administrative functions in the institution, the late Charles Fabens Kelley served for thirty years as the second Curator of the department after 1926. During his later years and during the tenure of his continuing successor, the department has continued to grow and has, especially in the last fifteen years, made major acquisitions in the fields of Japanese and Indian sculpture. Again Mrs Joseph Regenstein and the late Robert Allerton have been key people in making these acquisitions possible, as well as the late Bertha Brown and the Buckingham Fund.

THE DEPARTMENT OF DECORATIVE ARTS

The serious work of the department began in 1896 with the help of the Antiquarian Society as ancillary body; this group had been established a generation earlier, actually before the incorporation of the Art Institute. Textiles were the principal early gifts and purchases, and between 1901 and the First World War oriental, medieval, and Renaissance objects were added. The depart-

ment became an entity in 1921, and its main currents were aided and substantially encouraged by Robert Allerton with the constant help of Mrs E. C. Chadbourne. The acquisition of the Lucy Maud Buckingham Collection of Medieval Art added some solid distinction. A new seriousness of purpose was given by Hans Huth, who brought a broad European outlook to his task as did his colleague, Oswald Goetz. In recent years the department has acquired major pieces of eighteenth-century Italian and French origin. Curiously, French furniture and sculpture have been the difficult and expensive purchases of the last decade, with generous aid.

THE DEPARTMENT OF TEXTILES

This department has been a separate one only in the last decade, but, as noted before, textiles were among the earliest acquisitions of the museum. Mildred Davison served for many years in the old Department of Decorative Arts and became the museum's first Curator of Textiles, only to retire in 1967.

THE DEPARTMENT OF PRIMITIVE ART

This department began as an auxiliary activity of the Department of Decorative Arts, and was organized as a separate department only in 1956. Its emphasis has always been artistic and never merely ethnographic. It has had during its existence only two curators.

THE DEPARTMENT OF CLASSICAL ART

This department was established in 1974 to use the income of the bequest of the Chicago architect, David Adler, in memory of his wife, Katherine. The previous holdings have been reassembled and restudied. With further aid from Mrs Eugene Davidson the department is proceeding modestly but upholding high standards.

THE ADMINISTRATION

The museum was first directed by William M.R. French. The Acting Director for two years was Newton Carpenter till George W. Eggers became Director. Robert Harshe, a sensitive minor painter, was Director for sixteen years. He

was succeeded by Daniel Catton Rich, who served till 1958. From 1959 till 1966 Allan McNab was Director of Administration and the present writer Director of Fine Arts. Charles G. Cunningham then became Director and served till 1973. At that time the corporate structure was changed, and E. Laurence Chalmers, Jr became President and the present writer again was put in charge of the museum as Vice-President for Collections and Exhibitions. That the professional administrators have been effective is due to the fact that they have had the aid of sympathetic and gifted curators who have had a major share in the systematic development of the collections, and the wise help of our generous donors.

The Museum is about to commence its second century of existence, and undoubtedly there will be changes in emphasis (supreme quality always assumed for the acquisitions), and, equally, there will emerge a more diversified support for the activities. Already, we have a membership of more than fifty-five thousand, and equally important is the growth in the group who annually give money, in amounts both small and great, to help defray the enormously and increasingly expensive process of maintaining and advancing this great institution as well as the subvention of the Chicago Park District.

John Maxon

THE PLATES

PAINTING AND SCULPTURE

MASTER OF THE BIGALLO CRUCIFIX Crucifix, c. 1260 Tempera on panel, $75\frac{3}{8} \times 50\frac{1}{4}$ in (191.5 \times 127.7 cm) Acc. no. 1936.120 Italian

The earliest European painting in the collection is this large painted crucifix, which was probably done in Florence around the middle of the thirteenth century. The style, still in the strongly linear tradition of Romanesque, is handsome in its quality and peculiarly adapted to the portraying of an austerely hieratic religious image. The name of the painter is still unidentified, and though his style has strong affinities with the Lucchese painter, Berlinghiero Berlinghieri, specialists believe that the Chicago crucifix was painted in Florence by a Florentine painter who worked closely in the manner of the Lucchese master. The combination of austerity and elegance applied to a severe religious theme can, in cruder hands, be off-putting. In the hands of a securely professional painter who belonged in the midst of a great and accepted tradition, the combination works to make a hauntingly impressive image. A closer examination of the painting will remind the viewer that its style derives from the transformation of the illusionist methods of late antique painting into a system of areas and lines which are combined to describe form. In the Late Romanesque style, however, this system carries only systematized reminiscences of the illusionist manner which lies many layers behind the style of this crucifix. After the changes that have taken place in painting during the seven centuries since this picture was executed, it is difficult to recall that, to the artist, this was a realistic painting.

The picture came from a private Austrian collection, and was bought for the A. A. Munger Collection.

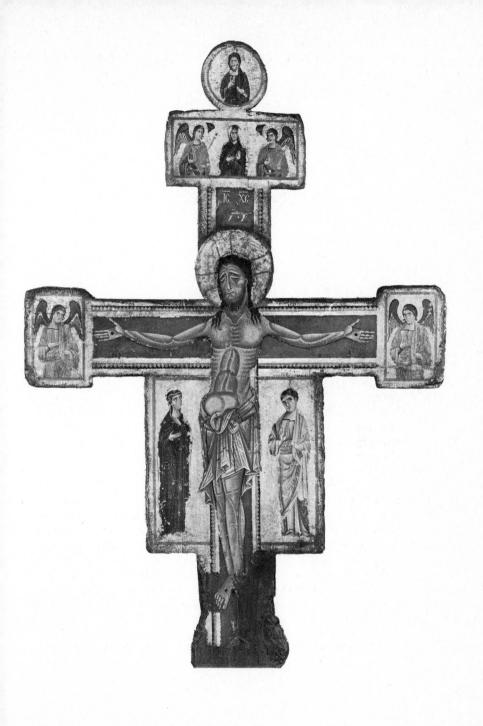

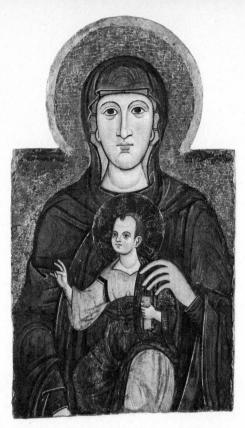

MELIORE TOSCANO Virgin and Child Enthroned, c. 1270 Tempera on panel, $32\frac{1}{4} \times 18\frac{3}{4}$ in $(82.0 \times 47.7 \text{ cm})$ Acc. no. 1933.1034

Italian

This painting is by the same hand as one in the gallery at Parma which is signed 'Meliore 1271'. On the basis of this signature, a number of other paintings which seem to be by the same hand have been attributed to the same artist. He may have worked in Pistoia, and his work shows familiarity with that of the Berlinghieri and the other painters of the time in Lucca, as well as with contemporary painters in Florence itself. As with the Bigallo Crucifix, one sees the final perfection of the Byzantine-Romanesque style in central Italy. The costumes, of course, are late antique, of a sort familiar from Rome and Byzantium; their representation as the garments of sacred personages persisted even after togas ceased to be worn as everyday clothing.

From the Collection of Achille Clémente, the picture is part of the Mr and Mrs Martin A. Ryerson Collection.

3.50

VENETO – BYZANTINE Enthroned Virgin and Crucifixion, 13th century Tempera on panel, each $11\frac{1}{2} \times 8\frac{3}{4}$ in $(29.2 \times 22.2$ cm) Acc. no. 1933.1035 a and b

This pair of devotional panels (diptych) represents Italian art at its most Byzantine form. The two panels were probably painted in Venice and are richly ornamented in gold and silver leaf and raised ornamentation in gesso (the ash of plaster of Paris mixed with glue). The forms are ceremonious and reflect the splendor of Byzantium as it was diffused over the Western world, particularly after the Venetian conquest of 1204.

UNKNOWN ARTIST (14th century) Crucifixion (probably 1390–1415) Tempera on panel, $20 \times 9_4^1$ in $(50.9 \times 23.5$ cm) Acc. no. 1933,1032 Italian

This small panel (which is painted on its back to resemble porphyry) was certainly a devotional object of great luxury; presumably what remains is the top part of a pax, the base of which has been broken. The panel, surprisingly, is almost totally unabraded, so that the surface one now sees must be remarkably close to what it was when new. Perhaps one of the most intriguing things about the painting is the fact that, so far, scholars have reached no agreement as to who the artist was. The fact that he was a Florentine seems reasonably sure. But the names proffered for the attribution have ranged from Bernardo Daddi to Starnina, Matteo Torelli, and even the young Don Lorenzo Monaco.

Mr and Mrs Martin A. Ryerson Collection.

UNKNOWN ARTIST (14th century)

Spanish

The Ayala Altarpiece, 1396

Tempera on panel, Altarpiece: $99\frac{3}{4} \times 251\frac{3}{4}$ in $(253.6 \times 639.4$ cm); Antependium: $33\frac{1}{2} \times 102$ in $(85.2 \times 259.2$ cm)

Acc. no. 1928.817

This altarpiece and its antependium are among the most imposing monuments of medieval Spanish art outside Spain itself. They were painted in 1396 for the

Chancellor of Castile, Pedro López de Ayala, who had ordered the work for his mortuary chapel in the Convent of San Juan at Quejana, Province of Ayala (about 40 miles south of Bilbão). (The convent – of Dominican nuns – had been founded by his father.) This reredos remained in place for 520 years, the panel over eight yards wide neatly joined into one plane. It was sawn into three parts for removal from the chapel. (The carved effigies of Don Pedro and his wife, born a Guzman, still remain in the chapel.)

The compartments into which the reredos is divided show (in the lower tier) the Annunciation, the Visitation, the Nativity, the Epiphany, the Purification, and the Flight into Egypt, and (in the upper tier) Christ among the Doctors, the Marriage Feast at Cana, the Resurrection, the Crucifixion, the Ascension, Pentecost, and the Assumption (with Donation of the Virgin's Girdle to St Thomas). The antependium shows the scenes of the Angel appearing to the Shepherds, the Nativity, and the Epiphany. The frames of both parts repeat the López arms, two wolves passant, and the Guzman arms, two kettles. The whole scheme is visualized on a background of white (perhaps in recollection of manuscript pages). The gilding on the reredos is in gold leaf, whereas that on the frontal is in silver leaf which has lost most of its orange varnish. The narratives are straightforwardly presented with a directness which is rather like that of a modern comic strip. The sparing use of gold against the white background gives the work a quality which is both austere and luxurious at the same time. The effectiveness of the color scheme becomes apparent when the Ayala altarpiece is compared to the St Catherine of Alexandria (Munger Collection, 1932.989), which comes from the same workshop; the complete use of gold in the small work makes it seem much less impressive in both design and color than the Ayala panels.

Gift of Charles Deering.

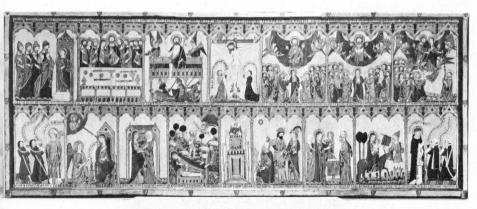

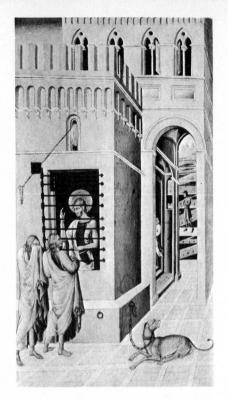

GIOVANNI DI PAOLO (c. 1403–1482/3) St John the Baptist in Prison, c. 1450–60 Tempera on panel, 27×14^1_4 in $(68.7 \times 36.3 \text{ cm})$ Acc. no. 1933.1012

Italian

Giovanni di Paolo's are among the most appealing and lovely of Sienese Renaissance paintings. His style came from Taddeo di Bartolo and Sassetta, and he was influenced by the example of Gentile da Fabriano who worked in Siena. He also seems to have been influenced by the example of Fra Angelico. This panel is one of six in the Art Institute, and there are four more extant (two in the Landesmuseum für Kunst und Kulturgeschichte, Münster, West Germany; one in the Metropolitan Museum, New York; one in the Collection Carvallo, Tours, France) and two certainly lost, not to mention the missing backs of the panels of which only one has survived. Together these formed the wings of a large altarpiece of which the center panel may have been a large painting, or, more probably, a piece of sculpture.

Giovanni has presented the beholder with an imaginary, toy-scaled Siena, gloriously clean and silvery, with figures which remind the viewer of late medieval painted wood sculpture. Beyond the empirically realized perspective

of the architecture, is a symmetrical landscape of ploughed and worked fields and fantastic mountains. In his rather toybox image, Giovanni has presented his fragment of sacred legend with an intensely felt sense of the situation. Though Jerusalem at the beginning of the Christian era and its inhabitants were not elegant in the Sienese taste, Giovanni convinces the beholder of the rightness of his mode of seeing, and his preciousness of manner merely emphasizes the sacred aspect of the story and its function as part of a decoration for an altar.

This panel and its pendants are part of the Mr and Mrs Martin A. Ryerson

Collection.

BERNARDO MARTORELL (active 1427–1452) St George killing the Dragon, c. 1438 Tempera on panel, 56×38 in (142.3×96.5 cm) Acc. no. 1933.786 Catalan

Bernardo Martorell was the principal painter in Barcelona during the second quarter of the fifteenth century and with him Catalan painting reached its zenith. He painted altars and miniatures; this is a panel of an altarpiece, four other panels of which are in the Louvre. Spain had strong connections with

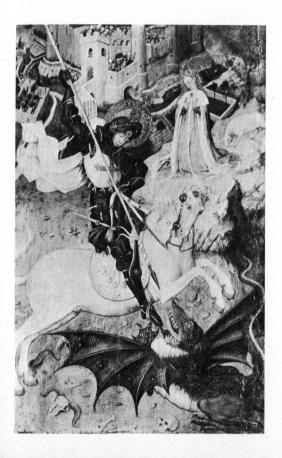

Flanders and northern Europe at this time and Flemish influence can be seen in the technique and in the use of egg yolk for the paint. The style is still International Gothic with no hint of the Renaissance style which was already the norm in Italy. In fact, the picture might well, at first glance, be taken for a

page of a Late Gothic manuscript.

It is particularly the scale of the figures which is Gothic. They are depicted in a size relative to their importance for the narrative; thus the castle is tiny, the people crammed inside it disproportionately large (people are, after all, more important than buildings). The princess, large in relation to the castle, and portrayed in full detail with her jewels and ermine, is, in her turn, subordinate to St George who is the dominant figure in the composition, representing the triumph of good over evil, impersonated by the dragon (which is, rightly, also on a large scale). St George's horse, on the other hand, is a miniature beast in terms of the knight.

It is a pleasant picture, not only for the clarity of the narrative, but also for the details – such things as the staring eyes of the horse, the hair and jewelry of the madonna-like Princess Cleodelinda, the ducks and swans swimming in the moat. It is the kind of picture that is rewarding to look at again and again.

From the Roccabruna, Vidal Ferrer y Solar, and Charles Deering Collections. Given by Mr Deering's daughters, Mrs Richard Ely Danielson and Mrs Chauncey McCormick.

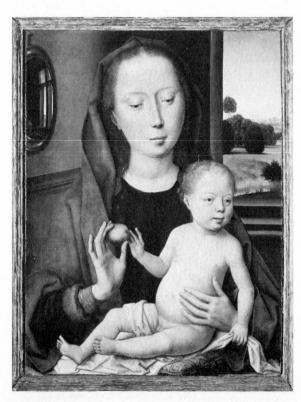

Hans Memling (c. 1433-1494)

Madonna and Child with Donor, c. 1485

Oil and tempera on panel, $13\frac{1}{2} \times 10\frac{1}{2}$ in $(34.4 \times 26.7 \text{ cm})$; $13\frac{3}{4} \times 10\frac{5}{8}$ in $(35 \times 27 \text{ cm})$

Flemish

Acc. nos. 1933.1050; 1953.467

Memling may have had his first experience as an artist in Cologne, but he later worked in the shop of Roger van der Weyden. He became the leading painter in Bruges after 1465. This diptych exemplifies his mature style, which is medieval and Renaissance, though primarily the latter. The action takes place in a wainscotted room, and it is possible to see both a bull's-eye looking-glass, in which two girls are reflected, and a cupboard with a vase of flowers on it. Behind the action is an open mullioned window. The donor's position is directly behind the picture frame, and his sleeve and the clasp of his book are painted to appear to rest on the sill of the frame in *trompe-l'œil* perspective; so, presumably, once did the drapery and cushion of the Christ child, but the frame of the left wing has been scraped.

The painting is a devotional object of great luxury; on the rear of the donor panel is a painted representation of St Christopher and the Christ child as sculpture in a niche; the back of the left wing is marbleized.

The Virgin and Child are in the Mr and Mrs Martin A. Ryerson Collection. The Donor was given by Arthur Sachs.

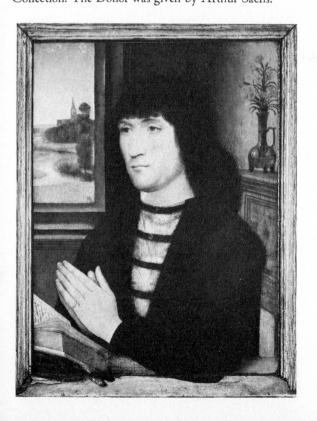

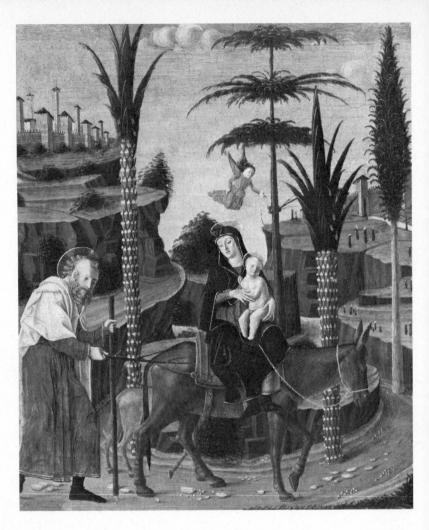

BERNARDINO BUTINONE (before 1436–after 1507) Flight into Egypt, c. 1480 Egg tempera on panel, $10\frac{3}{16}\times8\frac{11}{16}$ in $(25.9\times22.1$ cm) Acc. no. 1933.1003

Italian

This panel once formed part of the predella (base part) of a large and typical late fifteenth-century altarpiece. The painting was done by a diligent, intelligent workman who reflected the best traditions of his day and, in the doing, proved that a great tradition can mean, in a minor work, almost as much as a great personality. This picture was part of the Martin A. Ryerson Bequest.

SANDRO BOTTICELLI (1444–1510)

Madonna and Child with Angels, c. 1490

Tempera on panel, D. 13¹/₈ in (33.4 cm)

Acc. no. 1954.282

Italian

This small tondo is to be dated around 1490. That it was intended to be a very luxurious object is emphasized by the use of gold line work in the drapery and also in the scene of the Annunciation and the candelabra which are inscribed on the architectural plinths. In the very rear a landscape is discernible, and before it is a group of trees which form a kind of bower. Vasari, in his Lives of the Painters, in the second edition, notes that the Epiphany and the Calumny of

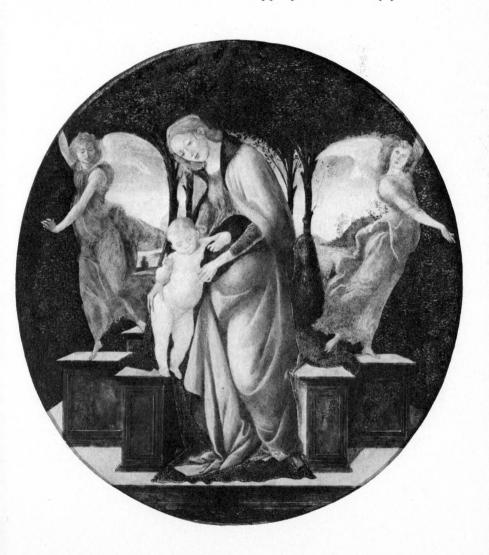

Apelles and a small tondo to be seen in the room of the Prior of Santa Maria degli Angeli received more praise than any other works by the master. E. Fahy has suggested that this small tondo is the only surviving work to answer Vasari's description, and the extremely precious nature of the picture bears out his

suggestion.

This little picture already anticipates the Mystical Nativity in London, with its combination of small-scale figures and elaborate garden decoration. If the almost heraldic angels epitomize the common notion of Botticelli's grace and suavity, the Virgin and the Christ child remind one in their bulk and breadth (in spite of the slenderness of the parts) that Botticelli was a Florentine painter with an essentially Florentine feeling for form and solidity. The picture also has the great advantage of being all of a piece and apparently, entirely by the master's own hand, except for the angel's head at the viewer's left, done by a much younger man, who may have been an even greater painter.

The picture is part of the Max and Leola Epstein Collection.

MASTER of AMIENS (active after 1475) St Hugh of Lincoln, c. 1480 Oil and tempera on panel, $46\frac{1}{8} \times 20$ in (117.2 × 50.9 cm) Acc. no. 1933,1059

French

Hugh of Avalon, a monk from the Grande Chartreuse, became Bishop of Lincoln in the late twelfth century, died in 1200, and was canonized in 1220. As one of the most famous Carthusian saints, he was chosen to figure in the altarpiece made for the Chartreuse of Thuison, near Abbeville - a large composition of carved and gilded panels and eight paintings. (The Art Institute has seven of them; the eighth is in the Hermitage, Leningrad.) The white Carthusian habit can be seen beneath St Hugh's richly decorated robe.

The swan was one of his pets and became his symbol in art.

Amiens is in the north of France, close to Flanders, and the style of this master is an amalgam of French and Flemish influences. Typically Flemish are such details as the carved niche and canopy and the tiled floor. Everything is closely observed and rendered with meticulous accuracy - the crozier, the vestments, above all the very engaging swan – although the bottom edge of the chalice was evidently something of a problem for the artist. The total effect is one of elegance and charm.

Mr and Mrs Martin A. Ryerson Collection.

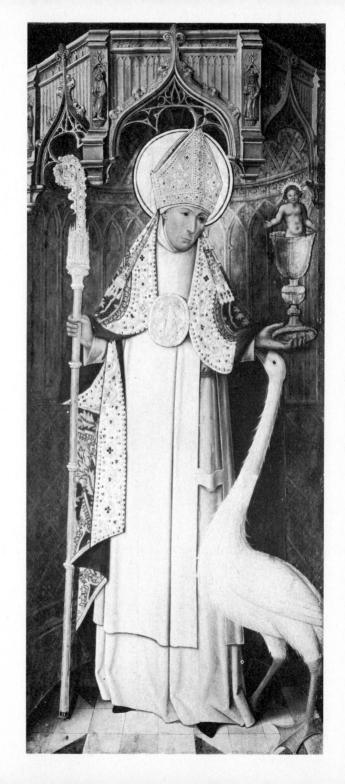

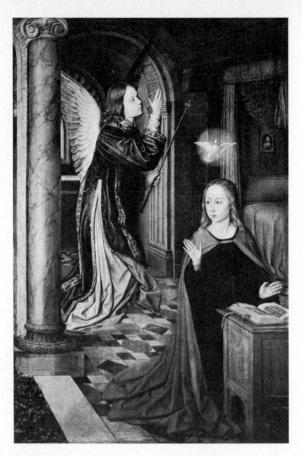

MASTER OF MOULINS (active c. 1500) Annunciation Oil on panel, 29 × 20 in (73.7 × 50.9 cm) Acc. no. 1933.1062

French

The Master of Moulins was the most important of French painters at work on either side of the year 1500, though he was strongly influenced by Flemish art, especially Hugo van der Goes. He takes his name from a triptych of the Madonna and Child with Angels and Donors in Moulins Cathedral. This panel is a pendant to a Meeting at the Golden Gate in the National Gallery, London.

The Master's mode of seeing was one of the greatest suavity and elegance, and his imagery of feminine beauty, though a bit hearty, is persuasively lovely. The general mode is late medieval in construction, although the details of the architecture are already touched by an awareness – even at third hand – of the Renaissance as it affected architectural ornament. It is hard to say whether or

not the picture is Renaissance or only late medieval; and such a question merely serves to emphasize that stylistic pigeon-holing is mostly a meaningless pastime. Put another way, the picture illustrates very aptly the notion of some German art historians of the last generation that the Renaissance, as such, really did not exist save for the briefest of moments in Raphael's career, and that art went straight from the late Middle Ages into Mannerism.

Mr and Mrs Martin A. Ryerson Collection.

GERARD DAVID (c. 1455–1523) Lamentation at the foot of the Cross, c. 1511 Oil on panel, $21\frac{1}{2} \times 24\frac{1}{2}$ in $(54.7 \times 62.4$ cm) Acc. no. 1933.1040 Flemish

Though David was of Dutch birth he settled in Bruges and took on strong Flemish characteristics. His style was clearly formed under his experience as an illuminator of manuscripts.

This panel is cut at the top and on the right side, and was once part of a much larger whole. The painting exemplifies David's style which is rétardataire,

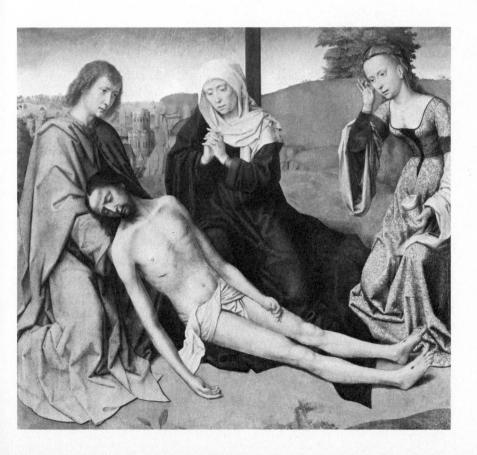

without much understanding of the waves of influence to be felt from Italy. Yet one notes that there is a centrally planned, domed church set into the landscape in the rear, and the various parts of this building have Renaissance detail.

Gerard David's strength lay in his capacity to combine obvious elegance with a convincing rendering of tenderness and sobriety. One does not find in his work the tormented passion of Hugo van der Goes or the majesty and compression of van Eyck. What is to be seen is a group of carefully composed elements, combined to create devotional pictures of considerable beauty. The parts of this picture are indeed conventionalized, but they are beautiful parts, and the spectator is convinced.

Mr and Mrs Martin A. Ryerson Collection.

Antonio Allegri called Correggio (c. 1494–1534) Virgin and Child with St John the Baptist, probably 1515 Oil on panel, $25\frac{1}{4} \times 19\frac{3}{4}$ in $(64.2 \times 50.4 \text{ cm})$ Acc. no. 1965,688

Italian

Correggio worked all his life in the district around Parma, but seems to have been fully aware of artistic developments in Rome, Venice and Florence. Probably a pupil of F. Bianchi Ferrari, he early came under the influence of L. Costa and Mantegna. Soon, however, these influences were superseded by that of Leonardo: from the hard, enameled and sharply focused world of Mantegna he moved to a softly focused but firmly felt world of reality which is bathed in veils of colored light. But where Leonardo created unearthly beauty, Correggio's subjects, however idealized, are sensuous and very much of this earth.

In this picture the Virgin with her son are placed against a hilly landscape from which they are cut off by a trellis of lemon trees. The young St John the Baptist is part of the narrative scene, and he is neatly differentiated from his fellow protagonists by his suntanned skin which contrasts with the ripe coloration of the Virgin's skin and the healthy glow of the skin of the infant Jesus. In the forms of the Virgin, Correggio is here remembering the Virgin and Child of Mantegna's Epiphany in the Uffizi as well as, obviously, Leonardo himself. There are also recollections of the prints of Albrecht Dürer in his Madonna of the Monkey (c. 1498, Bartsch 42) or his Madonna of the Pear (c. 1511, Bartsch 41). This work seems to be just a step beyond the St Francis altarpiece now in Dresden, for which the contract was signed 30 August 1514 and for which the final payment was made on 4 April the following year; one assumes that this panel was done by the end of 1515. What one has here is a small but perfect altarpiece of the north Italian High Renaissance.

Clyde M. Carr Fund.

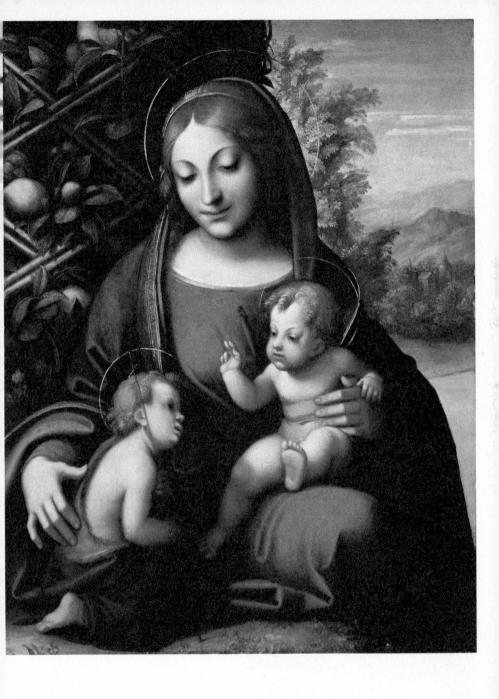

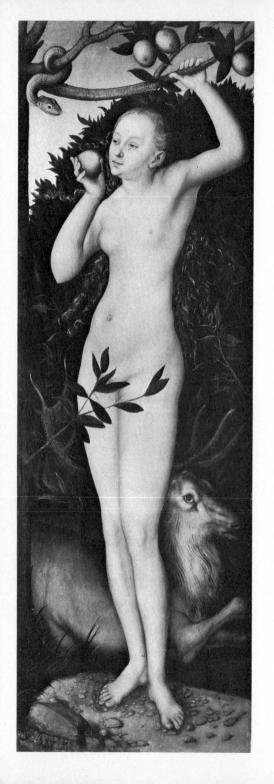

German

LUCAS CRANACH THE ELDER (1472–1553) Eve tempted by the Serpent, c. 1530 Oil on panel, $42\frac{3}{8} \times 14\frac{3}{8}$ in (107.7 × 36.6 cm) Acc. no. 1935.295

Not much is known about Lucas Cranach the Elder's early life, but in 1500 he settled in Vienna where he was active as a painter of holy pictures, portraits and as an artist for woodcuts. His work already showed a strong influence from the prints of Albrecht Dürer. In 1504 he was called to the court of Saxony, and remained a court painter to the end of his life. He was very successful and there was no shortage of commissions. He was also a close friend of Martin Luther

and the artist par excellence of the Reformation.

The story of Adam and Eve was a popular subject at the time – perhaps because of the legitimate scope it gave the artist for portraying female beauty in the nude (it has been reckoned that Cranach painted Eve thirty-one times, Venus thirty-two times and Lucretia thirty-five times). This is a particularly fine version. Cranach has rid his style of lingering Gothic traces and the painting is Renaissance, although Germanic in its flavor and emphasis on narrative detail. The type of woman portrayed is typical of Cranach's style – blonde, slim, with high small breasts and curving belly.

There is in Cranach's work a rather agreeable sense of material well-being, which is quite hedonistic. Along with the sense of human pleasure there is a matter-of-factness that seems completely in tune with the world of Luther and

the Reformation.

Charles H. and Mary F.S. Worcester Collection.

JACOPO DA PONTE called BASSANO (c. 1510–1592) Madonna and Child and infant St John the Baptist, c. 1565–68 Oil on canvas, $29 \times 33\frac{1}{4}$ in $(73.7 \times 84.5 \text{ cm})$ Acc. no. 1968.320 Italian

Jacopo Bassano was one of the great masters of the second half of the sixteenth century in Venice, a worthy companion of Tintoretto and Veronese, and the continuator of the innovations of Titian. More than that, Bassano was a formative influence on the young El Greco. But it is not merely his place in the historical situation which makes him an important figure. Bassano, and his sons after him, brought a note of straightforward *genre* painting into the heroic form of later sixteenth-century Venetian painting. Beyond that, Jacopo invented a type of feminine beauty which was to survive him by two centuries, for it is his concept of female beauty – visible in the Madonna in this picture – which prefigures the types of Giambattista Tiepolo and even of the latter's son, Domenico.

This painting shows the tender and rather domestic side of Jacopo Bassano's art combined with his concept of heroic form. Though it is hardly a monumental painting, the feeling of monumentality is present, accomplished through the simple device of putting the whole action slightly above the viewer's eyelevel so that he is forced to look up at the action. There is a richness of form and color in the canvas which reinforces Jacopo's reputation as a colorist, though as with all great Venetians of his century, the actual range of the palette is limited in hue and somber in tonality.

Wilson L. Mead Fund.

DOMENICO THEOTOCOPULI called EL GRECO (1541–1614)

The Assumption of the Virgin, 1577

Oil on canvas, 158 × 90 in (401.4 × 228.7 cm)

Acc. no. 1906.99

This is the most famous picture in the Art Institute and, in some terms, far and away the greatest, not only for its enormous size but for the very grandeur of its concept and execution. Greco is today one of the most popular of all old masters, but this is a development which has occurred in this century.

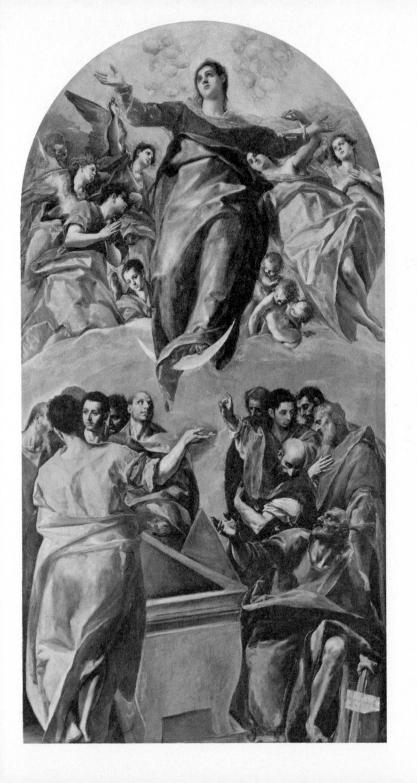

In looking at this picture it is well to remember that part of the curious nature of Greco's style can be explained by his origins: he was a provincial Greek twice expatriated. Born in Grete and trained there, he went at an indeterminate date to Venice (where he was much influenced by Titian, Tintoretto, and the Bassani) and then was established in Rome by 1570. By 1577 he had again removed himself, this time to Toledo in Spain. The impact of the great Venetians on him was enormous; he was also affected by his stay in Rome where he was much absorbed by late Roman Mannerism as well as by the example of Michelangelo himself (no matter what El Greco may have said about the latter).

This picture was painted for the high altar of S. Domingo el Antiguo in Toledo and was El Greco's first commission in Spain. It is surely influenced by Titian's great altarpiece of the same subject in the Frari, Venice. But if the two, modern, lateral strips, 3 in wide on each side, are removed (as in our reproduction) it will be noted that El Greco has compressed his spaces, and the positions of the figures within the spaces, into Mannerist terms so that they seem to burst from the canvas onto the viewer. The color scheme reflects Venetian precedent, particularly Veronese's, but the whole picture already reflects and embodies El Greco's mature development and is, in fact, his first truly great work.

Originally the picture was crowned by a Trinity (now in the Prado) and surrounded by other panels. The original frame is still in the conventual church of S. Domingo el Antiguo.

Gift of Nancy Atwood Sprague in memory of Albert Arnold Sprague.

Bartolommeo Manfredi (1587–1620) Cupid Chastised, c. 1605–10 Oil on canvas, $69 \times 51\frac{3}{8}$ in (175.3 × 130.6 cm) Acc. no. 1947.58 Italian

Manfredi was a close follower of Caravaggio and preserved much of that great innovator's manner. What he did not preserve, however, for it was Caravaggio's own private idiomatic expression, was the latter's sense of terror and urgency and occasional overtone of intense sensuality. The difficulty with the work of all truly great innovators is that the shell of the innovation is usually quite easy to imitate, but the inner tension and drama, which are peculiar to the innovating master's own vision, are not only inimitable but usually not even noticed by his followers.

While there were sources for Caravaggio's great innovative mode – for example, in certain late works by Tintoretto – his innovations burst on Italian art almost without precedent so far as the public was concerned. The manner, of course, was much imitated, simply because it is a gloriously simple idiom. What was and remains not at all simple was Caravaggio's use of the idiom and

his concept of life as seen in his painting. For example, Caravaggio frequently included the beholder by implication not only in the picture but as an actual participant: in the Vatican *Entombment* the spectator is conceived as a grave-digger who stands in the grave ready to receive the body of Christ (which brings up all sorts of theological implications); and in the so-called *John-Baptist* in the Doria, Rome, (really *Isaac with the Sacrificial Ram*) the beholder is thought of as father Abraham armed with the knife. There is none of this dramatic identification of the spectator and relating him to the action in Manfredi's work. There is only brilliantly observed and dramatically lighted action.

Charles H. and Mary F.S. Worcester Collection.

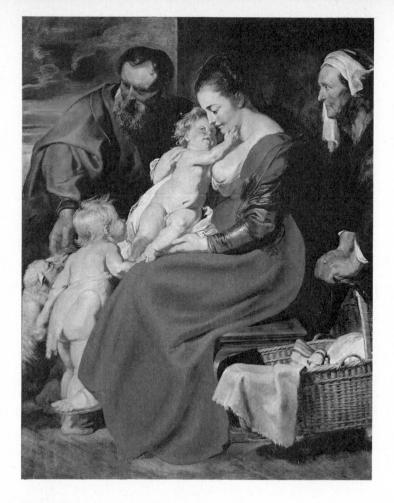

PETER PAUL RUBENS (1577–1640) Holy Family with St Elizabeth and St John the Baptist, c. 1615 Oil on panel, $46 \times 35\frac{1}{2}$ in (116.9 × 90.2 cm) Acc. no. 1967.229

Flemish

Rubens was not only the supreme Flemish painter of the seventeenth century, he was also the most important artist in northern Europe and the greatest northern exponent of the Baroque. He was extremely successful during his lifetime and employed a large number of assistants to help him complete the numerous commissions which kept pouring in. Consequently not many of his pictures are entirely by his own hand, although he always designed them himself and closely supervised their execution.

This painting is entirely by the master's hand. The action is set within a very shallow space and the color, in spite of a rather limited palette, is brilliant. The people shown are Flemish types, and in the pink coloring and texture of the flesh of the Virgin and the two children we have a foretaste of the sensual exuberance of Rubens' later style. There is great charm in the depiction of the children, especially St John the Baptist; the adults, too, are sensitively portrayed. Although the picture is of rather modest format, the way in which the action fills the whole scene gives an impression of monumentality.

Major Acquisitions Fund.

PETER PAUL RUBENS (1577–1640) The Triumph of the Eucharist, 1626–27 Oil on panel, $12\frac{1}{2} \times 12\frac{1}{2}$ in (31.8 × 31.8 cm) Acc. no. 1937.1012 Flemish

The daughter of Philip II of Spain, the Archduchess Isabella Clara Eugenia, who was Regent of the Netherlands, had received her education at the convent of the Discalced Carmelites in Madrid. She remained devoted to the Order and wore its habit during her widowhood after 1622. The ladies of this Order were (and still are) especially devoted to the cult of the Blessed Sacrament, and in the later sixteenth century the convent used to borrow tapestries from the Royal Collection on occasions of special devotion to the cult. Apparently in 1625 the Archduchess had commissioned from Rubens designs for a series of tapestries for the sole use of the convent. The tapestries seem to have been delivered by the

summer of 1628. Part of the set was apparently destined for use in the conventual church during Holy Week, particularly for the observances of Maundy Thursday and Good Friday, especially the latter when the tabernacle is empty.

This little panel represents five tapestries as they would have been hung around a stripped altar. The top, central section shows two cherubs holding up the monstrance with the Sacrament within; the top side sections show adoring music-making angels; the bottom sections show the ecclesiastical and secular hierarchies. (In the latter group may be recognized Philip IV and his queen, Isabella of Bourbon, as well as the Archduchess in her religious habit.) The historical importance of the small panel lies in the insight it gives into Rubens' design schemes. Artistically it is important because not only does every brushstroke appear to be the master's own, but the panel is in a pristine state of preservation with no sign of restoration upon it. It is toned in a light warm grey, and it is on this unevenly graded surface that the painter has touched in his design unerringly and with absolute sureness of touch.

Mr and Mrs Martin A. Ryerson Collection.

Guido Reni (1575–1642) Salome with the Head of John the Baptist, probably 1638–39 Oil on canvas, $97\frac{3}{4} \times 68\frac{1}{2}$ in (248.5 × 173.0 cm) Acc. no. 1960.3

Guido was the most important Bolognese painter of the seventeenth century, the most famous in his own day, and from his death till roughly the beginning of the last third of the nineteenth century he was ranked as one of the very giants of European art. Roger de Piles refers to his 'style so grand, so easy, and so gracious', while Goethe noted his 'divine ingenuousness able to paint only the most perfect things to be seen in this world'. Stendhal saw in him, in a felicitous phrase, an 'absolutely Mozartian sensibility'.

Italian

What Guido has done in this late masterwork is to transform the naturalism he had learned from his great Bolognese elder fellow citizens, the Carracci, into a grand and noble style which he used with such freedom, in this phase of his career, that he anticipates the cool elegance of the Rococo was well as the serenity of Renoir, and, even, certain aspects of the Neo-classical side of Picasso. The colors are cool to icy, with the tones and hues laid onto the canvas in diaphanous veils and luscious touches of rich pigment. In some ways the picture may be considered unfinished in that the final laying in of some of the paint is not accomplished. It is the intensity of expression married to the element which Stendhal related to Mozart which makes this still a compelling master-piece. It was bought by Girolamo Cardinal Colonna on Guido's death. Lord

Darnley bought it from the Colonnas early in the nineteenth century. Frank H. and Louise B. Woods Purchase Fund.

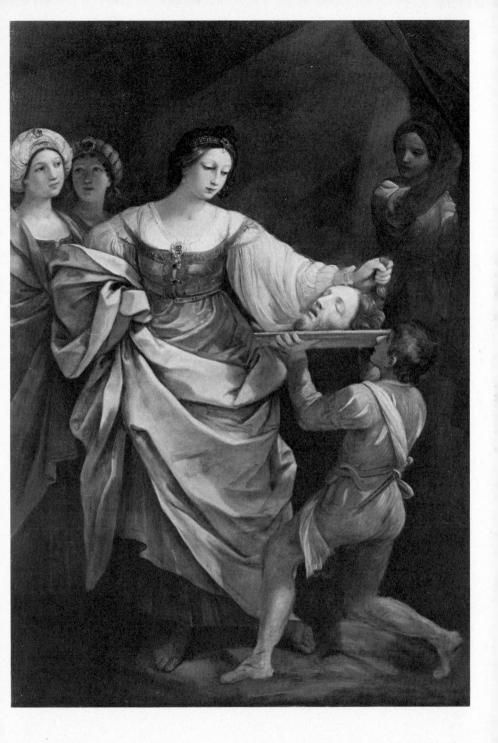

NICOLAS POUSSIN (1594–1665)

St John on Patmos, c. 1650

Oil on canvas, 40 × 53½ in (101.7 × 135.9 cm)

Acc. no. 1930.500

Poussin is one of the giants of French painting and, indeed, one of the most influential of all painters. He represents the absolute triumph of reason and logic, combined with a rare sensitivity for visible phenomena. Put another way, his art combines a Cartesian clarity of mind with an Apollonian sensibility of the spirit. But his work is so ordered, the beholder sometimes forgets that there lies beneath the order a grace and passion which are breathtakingly intense.

Most of Poussin's active career was spent in Rome, and in spirit he belongs to the world of late antiquity. But it is always an imaginary antiquity, for what Poussin recorded of antiquity was a carefully considered record of the world of the Roman countryside as *reordered* and clarified by a man of logic and sensibility. In other words, the Alban Hills never looked either as glamorous or as studied as their progression recedes from view in the distance of this painting. Nor did Roman ruins ever seem so solid in texture as they do here. St John is a figure of Michelangelesque majesty, who dresses as an orator and reclines like a river god among the fragments of antiquity.

The landscape is the thing in this picture, and Poussin's vision of the Roman campagna is noble and serene. He has seen through the casual accidents of nature

in order to record the truth of the idea of the campagna.

The picture was bought for the Munger Collection.

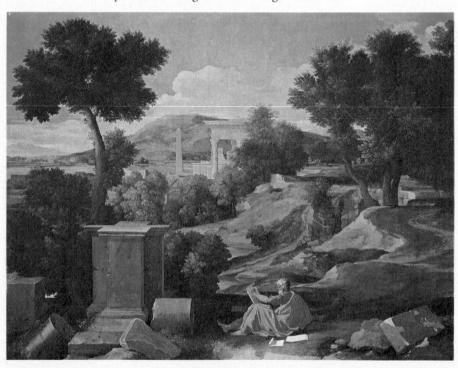

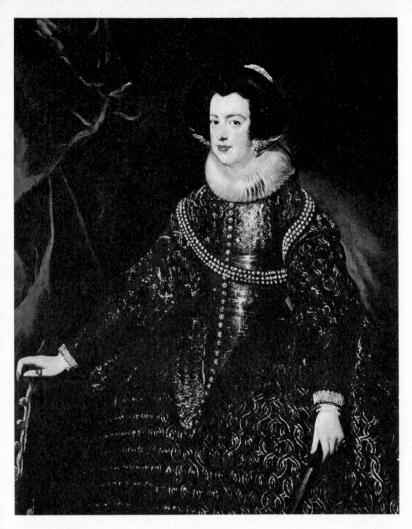

DIEGO RODRIGUEZ DE SILVA Y VELÁZQUEZ (1599–1660) Spanish Isabella of Spain, c. 1632 Oil on canvas, $49\frac{3}{4} \times 40$ in (126.4 × 101.7 cm) Acc. no. 1954.302

Velazquez was not merely the greatest of all Spanish portraitists, he was one of the supreme masters of all painting. His particular genius lay in his unbelievable capacity to achieve the subtleties of optical truth, and thus to re-create the very appearance of reality. In this capacity his only equal was his younger Dutch contemporary, Vermeer.

But Velazquez was more than painter to the most ceremonially bound court of Europe; for much of his career he was also a functionary involved in ceremonial niceties. The result is that he painted a number of masterpieces, copyright paintings, so to speak, and his large and disciplined shop painted replicas, some of which the master himself touched up. This painting is a case in point. It repeats a version in Vienna, which went to that city in 1632, and which itself is also slightly unfinished, though perhaps hardly as much as this one seems to be. The Vienna version, also, seems in part – even great part – to be by the hand of an assistant. But the head and the hands of the Vienna picture are surely painted by Velazquez himself, presumably from life. As there seem to have been two hands at work in the Chicago canvas, and as the painting of the face and the hands are materially superior to the rest of the picture, one may suppose that the master himself at least touched them up if not completely reworked them from the first laying in.

The picture shows the rather dour color scheme employed by Velázquez and the richness which he achieved with so unpromising a palette. The effect

of the luxurious silver embroidery is most striking.

The picture is part of the Max and Leola Epstein Collection.

Francisco de Zurbarán (1598–1664) St Roman, 1638 Oil on canvas, 97 × 63 in (246.5 × 160.1 cm) Acc. no. 1947.793 Spanish

Zurbarán was one of the principal masters of the Spanish Baroque School, the ablest, perhaps, after Velázquez and Murillo. (Ribera functioned mostly as a Neapolitan painter.) This is an impressive work by him and illustrates his style, which was of an enamel-like hardness and crispness. The figures are St Roman, Deacon of Caesarea, and the boy, Barulas, who were put to death in Antioch in 303, both by especially disagreeable methods. Zurbarán has shown them as straightforwardly seen Spaniards of his own time, with the elder dressed in monastic habit surmounted by a splendid cope. The saint holds a book with the collect of his day upon it and in his other hand his ripped-out tongue. Both figures are isolated in the front of the scene, with a somber landscape stretched out far behind them. In the farthest distance a rainstorm is visible, a curious and rather unexpected piece of nature-painting and observation.

The basic vision of the picture is essentially sober and the color scheme is apposite. Zurbarán's color is never riotously bright in any sense, but it is usually rich and warm. On this occasion it is rich but very cool in its tonality, and the individual hues are quiet in each case. He has managed to interpret the super-

natural by means of a closely observed realism.

Gift of Mrs Richard E. Danielson and Mrs Chauncey McCormick.

REMBRANDT VAN RIJN (1606–1669) Presumed Portrait of the Artist's Father, c. 1631 Oil on panel, $32\frac{7}{8} \times 29\frac{3}{4}$ in $(83.5 \times 75.6$ cm) Acc. no. 1922,4467

Rembrandt is so celebrated and has been famous for so long, that it is hard to look at his works with a fresh glance, the pieces are so familiar. Furthermore, as his pictures are too often covered with an amber-hued varnish, the effects of his cool tonalities and soft colors are often vitiated. But no matter how darkened his pictures may be, their power and the vision of the artist always shine

through.

This picture is usually considered to be a portrait of the painter's father who often sat for his son, though in this case the painting would be a posthumous likeness, done apparently about 1631. This work is in Rembrandt's tighter, earlier – though not his earliest – style, and it is a cool, silvery likeness with creamy flesh to set off the armor of the silvery grey background and the dark of the costume. Though the brushwork is tight, there are already intimations of the breadth to come. Rembrandt's concentration upon the material effects of aging and the loss of all youthful appearance contrasts sharply with the suave elegance and freshness of the steel gorget and the smoothness of the background. And the contrast of the costume with the plain, aged face is touchingly striking.

Mr and Mrs W. W. Kimball Collection.

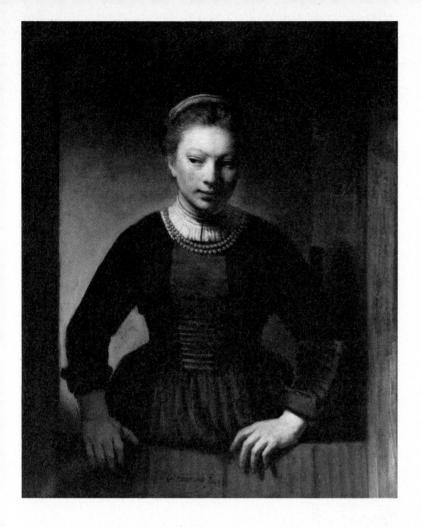

REMBRANDT VAN RIJN (1606–1669) Young Girl at an open Half-Door, 1645 Oil on canvas, $40_8^8 \times 33_8^1$ in (102.0 \times 84.2 cm) Acc. no. 1894.1022 Dutch

This painting is an early example of Rembrandt's mature style and exemplifies its noble breadth as well as its simplification of form and surface to achieve the utmost monumentality and grandeur of concept.

It can be seen that the young woman is full of figure, and the fulness of her face is emphasized by the braid of hair which is wrapped around her skull to

emphasize its solidity and bulk. She is clad in the habit of an inmate of the Amsterdam Municipal Orphanage, but the concept is one of monumental

grandeur and hardly girlish.

The subject may have been the painter's second wife, Hendrickje Stoffels, whose portrait he painted at this time. Whoever she was, she is seen with the greatest of human sympathy and tenderness. But Rembrandt was always the conscious professional, and here, even while he painted a nominally local subject in a local scene, he has gone back to the monumental half-length female figures of Titian which he certainly knew through engravings. The resulting influence lends a Venetian greatness of form and impersonality of concept which intensify the nobility of Rembrandt's vision and his image. The young woman thus stands out as far more than merely a young woman in the clothing of an orphanage at a door and becomes, rather, an evocation from the Venetian past as well.

The picture came from the Demidoff Collection through the generosity of

Mr and Mrs Martin A. Ryerson.

GIOVANNI BATTISTA TIEPOLO (1696–1770) Madonna and Child with St Dominic and St Hyacinth Oil on canvas, 108×54 in $(274.4 \times 137.2 \text{ cm})$ Acc. no. 1933.1099

Italian

Tiepolo was the last major old master of Venice, one of the giants of eighteenthcentury art, the greatest monumental decorator of his century. He sums up all the virtues of Venetian Baroque art and established the Venetian Rococo tradition in its ripest form. This noble altarpiece epitomizes his mature style of the 1740s.

The format of the altarpiece goes back to Titian and the early sixteenth century, but Tiepolo puts the scheme into Rococo terms. The Virgin is seated just above eye-level in a pose which, in its twisted gesture, goes directly back to one commonly used by Tintoretto and his shop; the Virgin herself has the type of sullen beauty which was Tiepolo's own contribution to sacred legend, while the holy infant is a beguiling little Venetian boy. The pose of St Dominic even quotes that of a Michelangelo Slave (though such had long been common artistic property). St Hyacinth is shown genuflecting to the Virgin as he holds the host in a monstrance (his conventional attribute in art). By St Dominic's left foot the head of a black and white hound is just visible, a symbol of the Dominicanes as the Latin pun, the Dogs of the Lord. St Dominic is shown carrying a book and a lily and with a star over his head. In front of the Virgin's podium is a hanging cloth decorated with a series of ravishingly painted small scenes of the life of Christ, a whole series of pictures within a picture.

Collection of Mr and Mrs Martin A. Ryerson.

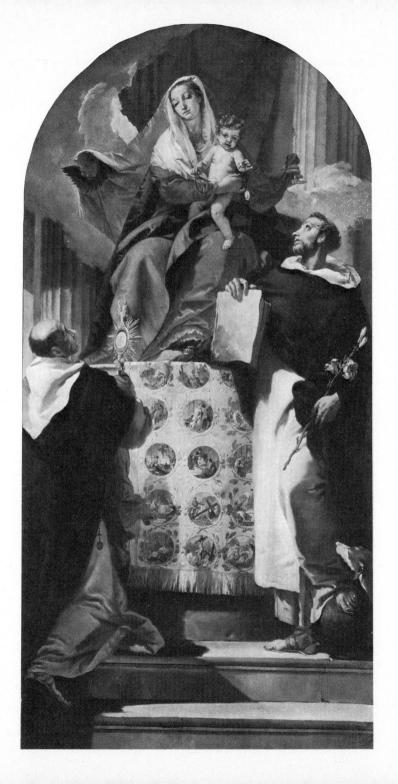

Acc. no. 1925.700

This picture is one of a set of four done by Tiepolo about 1740 to illustrate episodes from Tasso's Jerusalem Delivered, a romantic epic dealing with the First Crusade. This scene occurs in the sixteenth canto: Armida – a pagan woman and the Late-Renaissance version of Dido – entices the Christian, Rinaldo, by her magic and holds up the capture of Jerusalem. Tiepolo did another set of these paintings in 1751–52 for the castle at Würzburg, and a third set for the Villa Valmarana in 1757. The popularity of Tasso's poem lasted over two hundred years and retreated into literary history only within the last century.

Tiepolo used precisely the same methods and outlook on this secular, almost pagan subject as he did in his depiction of sacred themes, but he has adjusted the mise-en-scène to accord with his story. So one sees the amorous couple reclining among the hollyhocks set into the empty foreground. Their spectators hide behind the wall set into the middle distance, while behind stretches a misty valley with hills covered by ilexes, Lombardy poplars, and weeping spruce trees, in the midst of which is a round building with a tiled conical roof. That this landscape seems exceedingly familiar in its way, is the result of thousands of paintings and old-fashioned stage decorations done since Tiepolo after his innovation.

Gift of James Deering.

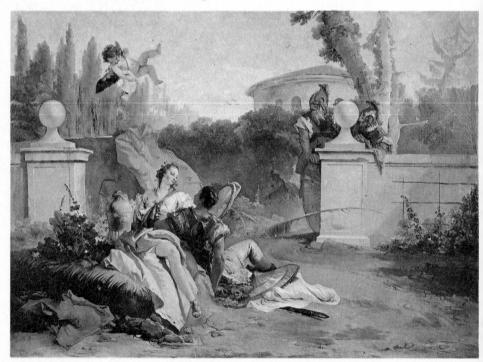

GIOVANNI BATTISTA PIAZZETTA (1683–1754) Pastoral Scene, c. 1740 Oil on canvas, $75\frac{1}{2} \times 56\frac{1}{4}$ in (191.8 × 143.0 cm) Acc. no. 1937.68

Italian

Piazzetta is one of the great masters of Venetian painting in the transition from Baroque to Rococo. His first teacher was the minor Venetian, Antonio Molinari, but his real master was his second teacher, the great Bolognese, Giuseppe Maria Crespi, and from him he gained his feeling for large-scale genre scenes. But Piazzetta, whose manner anticipates that of Giovanni Battista

Tiepolo, always kept something heroic about his work, and there is an amplitude and a nobility of form which is characteristically his own. Further, there is a type of face which is as much Piazzetta's as there is one which is Tiepolo's. There is in each man's types a kind of radiance and warmth which is particular.

larly human and humane, even sensual.

This large and elegant canvas shows Piazzetta at his most monumental (short of his great church decorations). The subject is nominally a pastoral scene, although there are strong literary suggestions, and it is not impossible that the picture still retains something of the concept of a *Rest of the Holy Family*. There is a sobriety, even a sadness, about the mother and the child which strikes a note of elegiac poetry and reminds the viewer of the old European tradition of the pastoral idyll.

Charles H. and Mary F.S. Worcester Collection.

JOHN SINGLETON COPLEY (1738–1815) American-British Mary Greene Hubbard, 1764
Oil on canvas, $50\frac{1}{4} \times 39\frac{7}{8}$ in (127.7 × 101.3 cm)
Acc. no. 1947.28

John Singleton Copley ranks as the first important 'old master' to emerge in the United States. He was essentially self-trained, for his only serious tutelage was under his stepfather, a minor engraver, Peter Pelham. He had, of course, seen the works of the various limners who practised in Boston before the Revolution, all of whom were distinguished for their earnestness if not for their competence. Indeed, the limners, for all their worthiness, never really rose above the level of English provincial practitioners. Copley, by reason of his intense observation and meticulous care, did, and what he achieved was a representation of natural appearances which even two centuries later is always convincing. He had, of course, his sources, in this case a mezzotint of John Faber Jr's after Thomas Hudson's portrait of an English noblewoman. But in his own simplification of surfaces and textures, he manages to invest his sitter with liveliness as well as a sense of solidity. Graceful and suave the painting is not, but, instead, the directness with which it is done triumphs over the somewhat inconsistent artificiality of his source with its memories of the Grand Manner – a manner disconcertingly elegant for the exigencies of the provincial, let alone the colonial, life. What Copley himself thought about his American manner is best gauged by his rapid development of a new, cosmopolitan style in England after his move there on the eve of the Revolution. But his sturdy, earlier style with its forthrightness has always endeared itself not only to cultural chauvinists but also to perceptive critics.

The painting was in the possession of Mrs Hubbard's descendants; it and its pendant of Daniel, her husband, were bought through the Art Institute

Purchase Fund.

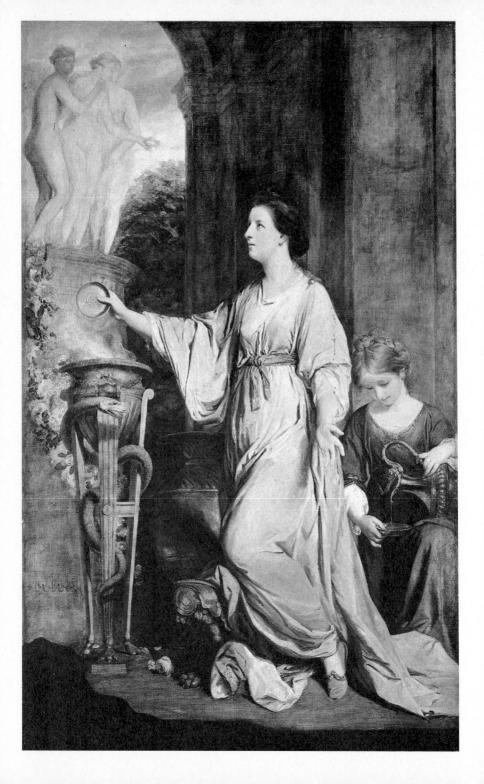

SIR JOSHUA REYNOLDS (1723–1792) Lady Sarah Bunbury Sacrificing to the Graces, 1765 Oil on canvas, 94 × 60 in (238.9 × 152.5 cm) Acc. no. 1922.4468

Sir Joshua Reynolds was not only the most famous English painter of the eighteenth century, he was surely the most intelligent and infinitely the most learned. He was not, however, the most sensitive, and his very intellectual curiosity led him to make technical experiments which have since proved disastrous so far as the staying power of his pictures is concerned. But if Reynolds took second place, for example, to Gainsborough in sensibility and feeling for his medium, his intelligence and the character of this intelligence made him peculiarly suited to his position in London in his time; indeed, it was through them that he occupied his place. What Reynolds had, of course, was that kind of British common sense which absorbed from the Enlightenment and also from his own brilliant milieu. In a word, Reynolds was an intellectual. It need not be thought that this really hindered him as an artist. What his intellectuality hinders is latter-day understanding of him as an artist. Because he rarely beguiles the modern eye with ravishing brushwork and because his color is frequently sadly faded and distorted, the viewer today is all too often bored. And here the viewer is dead wrong, because Sir Joshua, like Poussin, always had precise reasons for everything which he did - and they were always good reasons, if not always concerned with visual matters.

Sir Joshua has presented his noble sitter (a duke's daughter) in a bit of playacting, but the *play* in the playacting should not be overlooked. He has here applied the grand manner of van Dyck to an elegant charade, both seriously and mock-seriously. And where his color has survived unfaded it is ravishing.

The picture came as part of the Mr and Mrs W. W. Kimball Collection.

Hubert Robert (1733–1808) Villa Medici, Rome, 1785 Oil on panel, $12\frac{3}{8} \times 10\frac{3}{8}$ in (31.5 × 26.4 cm) Acc. no. 1968.616 French

Hubert Robert (nicknamed 'Robert des Ruines') went to Rome at the age of twenty-one and spent eleven years in Italy, becoming the friend of Piranesi and Panini whose type of Romantic ruin-painting he introduced into France. He was also a friend of Fragonard and the two friends influenced each other's styles. On his return to Paris he was elected a member of the Academy and became one of the first curators of the Louvre.

Robert's pictures illustrate all the virtues of classic French painting: probity of drawing and scale, nobility of sentiment, discreet and well-adapted coloring. But Robert also evolved his own personal version of antiquity and of the mythical present. Mrs Albert Beveridge gave the small picture in memory of Adelaide Ryerson in 1969.

FRANÇOIS BOUCHER (1703–1770) Pense-t-il aux Raisins?, 1747 Oil on canvas, $31\frac{5}{8} \times 27$ in $(80 \times 68.5$ cm) Acc. no. 1973.304

French

Boucher was a consummate observer as well as the perfect craftsman. The boy, the girl, and the child are elegantly observed and slightly stylized by technical tricks with the brush; the boy's head is quoted (either directly or from memory) from a pastel portrait which is also in the Art Institute Collection. In the painting, he is the familiar type of boy on the make, which, as if it were not

clear enough, Boucher reinforces by the title, is he thinking about the grapes? The landscape is similarly generalized but remains based on a close study of nature. It is in the sheep and goats that Boucher allows himself the pleasure of close and specific rendering, while direct observation makes the humans in the picture all the more generalized so as to become figures from pastoral poetry. The painting was bought from the bequest of Martha E. Leverone.

Pompeo Batoni (1708–1787) José Muñoz, Duque de Florida Blanca, 1777 Oil on canvas, 39½×29½ in (99.5×75.3 cm) Acc. no. 1974.386

Batoni, a superb painter of mythologies, histories, and religious subjects, was the most famous portraitist in the eighteenth century, as his many portraits of Englishmen on the Grand Tour and other notables show. (He also was a great teacher; his most celebrated pupil, to whom he willed his palette, was J.-L. David.) In this portrait of a Spanish diplomat, one sees Batoni's grand style on a reasonably intimate scale. The painter was a superb draughtsman, and as he was celebrated in his time for his uncannily accurate likenesses, one may suppose that the duke looked precisely as he appears here. The costume, gloriously elegant even to the tricorne carried under the arm or the reading glasses in the hand, establishes the fastidious character of the personage, even as the letter, inkpot, and quill, and the three books suggest his intellectual and professional attainments. The luxurious character of this portrait and its Spanish subject may give the thoughtful viewer an idea of how Count Almaviva might have looked. Bought from the income of the Charles H. and Mary F.S. Worcester Fund.

JACQUES-LOUIS DAVID (1748–1825) Mme Pastoret and her Son, c. 1791–92 Oil on canvas, $52\frac{3}{8} \times 39\frac{3}{8}$ in (133.1 × 100.0 cm) Acc. no. 1967.228

French

David is the great painter of moral passion and ethical concepts as interpreted by the French in the generation after the Revolution. In the pictorial arts ethical concepts are the least lasting of matters, and moral passion in one generation may easily turn into the moral idiocy of another or, much worse, into the absolute silliness of still another epoch. The result is that David is all too often quite unapproachable for the modern viewer. It is most agreeable, therefore, to be able to approach this portrait by a very great painter of histories and to notice what a superb portraitist he was. Here one sees David with his moral scruples parked outside the studio along with his sitter's outer garments, as well as the pictorial rhetoric of his time.

What David has done is to present his noble sitter in a moment of serene domesticity, even if it rather suggests that she was as much a nursemaid as Marie-Antoinette was a milkmaid. Actually, of course, Mme Pastoret may frequently have done some sewing while rocking the cradle of her infant son. (The only unfinished detail of the picture, incidentally, is the fact that David never got around to putting in the needle and thread which Mme Pastoret was in the act of threading; the picture otherwise is completely done, but in David's 'soft' or blotchy style, without the seemingly airbrushed finish he sometimes employed.)

This painting was left in David's studio, because Mme Pastoret felt she could never complete her sittings to a regicide. Her scruples, however, did not prevent her having her son bid on the picture at the sale of the contents of

David's studio after the artist's death.

The painting was bought from the income of the Clyde M. Carr Fund.

Francisco Goya y Lucientes (1746–1828) Capture of Maragato by Fray Pedro, c. 1807 Oil on panel, $11\frac{1}{2} \times 15\frac{1}{8}$ in (29.2×38.5 cm) Acc. no. 1933.1076

Spanish

The set of six paintings to which this panel belongs illustrates an event which occurred in 1806: a monk, Fray Pedro de Zaldivia, was attacked by the bandit, Maragato, but managed to resist and overcame the villain. Here he is shown tying the bandit up. The episode was enormously popular and inspired many prints and popular songs. Goya seems to have done the set for his own pleasure, for it was still in his possession in 1812.

The pictures illustrate Goya's skill as a narrative painter. The subject is presented in a very direct manner with no unnecessary detail. There is no reworking of the paint to achieve subtlety of effect or lusciousness of surface. The impression gained is one of the artist's strength and supreme confidence.

The painting is also reminiscent of Goya's prints and drawings. In fact, the panels read as well in a black and white photograph as they do in color, and color seems to have been of secondary importance to Goya. The painting is

extraordinarily modern in style and technique. In fact Goya had an important influence on Manet and the step from this panel to the directness of the early Manet is small.

Mr and Mrs Martin A. Ryerson Collection.

SIR THOMAS LAWRENCE (1769–1830) Mrs Jens Wolff, 1803, 1815 Oil on canvas, $50\frac{3}{8} \times 40\frac{1}{4}$ in (128.0 × 102.2 cm) Acc. no. 1922.4435

English

Lawrence was not only the best portraitist of Regency England, he remains one of the finest of all English portraitists. And the portrait of Mrs Wolff is one of his greatest works. Lawrence began it in 1803 when Mrs Wolff was wife to the Danish Consul in London. Her house in Battersea housed a fine collection of casts, and there she entertained a distinguished group of writers and artists. The Wolffs were separated in 1813, and the collection was sold. The portrait was

not actually finished till 1815 when Lawrence showed it in the Royal Academy. A quick glance at the finished painting shows that it was certainly reworked,

especially around the head and neck.

The painting is fascinating. While there is an obvious quotation of the collection of casts in the background and in the pseudo-antique setting with the hanging lamp, there is also another set of quotations in the picture: Mrs Wolff's pose is derived from one of the figures from the Sistine Chapel ceiling, and one notes that Mrs Wolff is leafing through Alderman Boydell's publication of that same chapel. The picture also evokes portraits by Pontormo. A further examination reveals that Lawrence's portrayal of Mrs Wolff's anatomy is rather unorthodox – she appears to have no clavicle. But the picture is extremely elegant and, in the pose and the costume, anticipates Victorian styles.

Mr and Mrs W. W. Kimball Collection.

J. A. D. INGRES (1780–1867) Amédée-David Marquis de Pastoret, 1826 Oil on canvas, $39\frac{3}{8} \times 32\frac{1}{4}$ in (99.5 \times 82.0 cm) Acc. no. 1971.452

French

The baby in the cradle in the splendid David portrait (page 65) grew up to be this elegant man; about the time Ingres painted him, his mother despatched him to buy her portrait at the David sale. On the face of it the picture is the epitome of naturalistic representation, but it is not quite so. Only after scrutiny does one notice that the portrait is highly arbitrary, as a glance at Ingres's great drawing of Gounod (page 157) shows. The head is too large for the body, the neck is too long, and the structure of the body is impalpable. Further, one sees that Ingres has lengthened the fingers a bit (their original form is still visible), presumably to fulfill the marquis's vanity. This is a somewhat rare instance of Ingres's 'boned shad' concept of form, endemic in all his later females, seldom in his men. One may suspect that not only was the marquis very vain but also stubbornly difficult. All the same, having given us Amédée as the latter wanted to be seen, Ingres has created a stunning image and brilliant portrait.

The painting was bought from the Dorothy Eckhart Williams Bequest, the income from the Robert Allerton Purchase Fund, the Bertha E. Brown Fund,

and the Major Acquisitions Fund.

J.B.C. COROT (1796–1875) View of Genoa, 1834 Oil on paper, $11\frac{5}{8} \times 16\frac{3}{8}$ in (29.5 × 41.7 cm) Acc. no. 1937.1017 French

Corot did many small views of Italian scenes during his trips to Italy, especially in his earlier years. Although he regarded them as studies, to be incorporated later on in larger pictures, they are in fact full of charm and perfectly satisfying on their own. They are quite remarkable for their rendering of atmosphere, space and light. Although they are basically accurate recordings of the countryside, the composition is careful and there is the occasional slight adjustment of the visual facts for the sake of artistic perfection. This is the case here.

Corot only painted nature in the months of spring and summer, finding no attraction to the other seasons; here, in cool and blond colors, we have a lucidly presented view which perfectly evokes the beauties of a Mediterranean summer's day.

Mr and Mrs Martin A. Ryerson Collection.

J.M.W. TURNER (1775–1851)

Valley of Aosta – Snowstorm, Avalanche, and Thunderstorm, 1836–37

Oil on canvas, $36 \times 48\frac{1}{4}$ in $(91.5 \times 122.6 \text{ cm})$

Acc. no. 1947.513

A third of Turner's life was lived during the eighteenth century, and the impact of the cult of sensibility and the picturesque stayed with him to the end. He grew up in a world which had discovered the phenomena of nature and natural terrors. His art was based on Richard Wilson and on Claude, and his earliest works are predictably in the vein of the end of the eighteenth century.

In his late period, from the early 1830s on, Turner was concerned with the painting of light, the ostensible subject matter seemingly taking second place. Forms and details were suggested and painted on previously prepared broad areas of yellows, whites, pinks and reds, or cool greys and blues. This painting was probably done in this manner. It was worked out in his studio from sketches and watercolors Turner had made in the Italian Alps in 1836; yet the artist has managed to preserve the freshness of an immediate experience of the greatest intensity and impact.

Frederick T. Haskell Collection.

Eugène Delacroix (1798–1863) The Lion Hunt, 1861 Oil on canvas, $30\frac{1}{16} \times 38\frac{3}{4}$ in $(76.5 \times 98.5$ cm) Acc. no. 1922.404 French

On the defeat of Algeria by the French in 1832, Louis Philippe sent a special diplomatic mission to the Sultan of Morocco. Delacroix, who was a friend of Charles de Mornay, the Ambassador, accompanied the mission as historical painter. The visit marked a turning-point in his life, and provided him with subjects for paintings for the rest of his career.

Thus Delacroix had actually seen Arab riders in action and combats with wild animals. He made many sketches and studies on this trip and what he did not record he could check in later years from observations in the zoological gardens. His observation was acute and the painting is extremely life-like.

Mrs Potter Palmer Collection.

JEAN-FRANÇOIS MILLET (1814–1875) A Horse, c. 1841 Oil on canvas, $65\frac{1}{2} \times 77\frac{1}{2}$ in (166.4 × 196.8 cm) Acc. no. 1976.30

French

Millet's traditional reputation is deceptive. He belongs properly in the mainstream of the French tradition. His technique looks backward to the late Fragonard and beyond him to Salvator Rosa and seventeenth-century Italy. The breadth of the landscape, the softness of the sky, and the richness of texture and depth of color in the foreground road and foliage (all of which reflect an awareness of Rembrandt) serve to set off the splendid horse. The horse's head reflects the painter's memories of classical sculpture. The painting is one of bravura skill, and Millet has, as he always did, ennobled his subject matter. The picture is said to have been painted as a sign for a veterinary.

It was bought from the Charles H. and Mary F. S. Worcester Fund Income.

Courbet has painted a rather uncompromising portrait of the Swiss patronne of the Brasserie Andler. One sees her seated at her change desk, where she habitually presided over the establishment. Here she is in her occasional act of offering a flower to a favorite customer.

This is a work of Courbet's early maturity, and though his career had yet a generation to run its course, one can see precisely what he was equipped to do in painting. This equipment, which was so admirably turned to a straightforward presentation of the visible world, is, all the same, not uninfluenced by the humanistic passion of the Romantics. Courbet was antipathetic to much of the

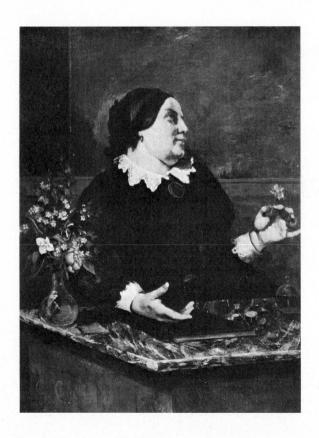

Romantic view of the world, but the part of that world which heard the insistent (if often very quiet) voice of man has registered with him. Physically Mme Andler is not an attractive presence, but the viewer feels that her personality was probably sympathetic. Exactly how Courbet accomplishes this still remains his secret, but it lies as much as in anything in his care to present Mère Grégoire in a typical attitude and action. In addition, by the time he painted this portrait Courbet had acquired a technical finesse which, for all of his rebellious views, looked backwards to earlier masters, to Chardin by way of Vallayer-Coster, and even to the seventeenth-century Dutch. In other words, Courbet was on the way to becoming himself an old master. If Mère Grégoire is not really a lovable picture, it is an unforgettable one.

The painting was bought from the Wilson L. Mead Fund.

ÉDOUARD MANET (1832–1883)

The Mocking of Christ, 1865

Oil on canvas, 75\(\frac{1}{8} \times 58\)\(\frac{3}{8} \) in (190.8 \times 148.3 cm)

Acc. no. 1925.703

French

Manet ranks as one of the rare artists in the history of Western art who was also, paradoxically, a real conservative. For all of his revolutionary impact upon his contemporaries, he seems today to be in the dead center of French artistic tradition, the inheritor – as he himself seems to have wanted – of the Classic tradition of painting. In this work, as well as in the two canvases of the *Philosophers*, Manet is evoking the form of seventeenth-century Spanish painting and the world of Velázquez. This picture proves on careful examination to be a mid-nineteenth-century restatement of a big, Spanish Baroque religious piece. Moreover, it is Manet's version of the big salon machine, his own translation of the salonnier's grand-coup. It is a grand painting, heroic in concept, heroic in scale. Yet for all its true technical brilliance and learned assimilation of the grandeurs of the middle period of Velázquez, it not only retains the smell of the salon, but even more the smell of the studio. Brilliant the painting is, but the viewer is never quite convinced of its validity as a piece of Biblical illustration.

Manet refers in this work not to the art of the past but also the world about him. Christ is not really a self-portrait, but there is a strong reminiscence of the artist's face in that of Christ. The executioner in the yellow turban resembles remarkably (though again it is not a real portrait) the young Clemenceau

whom Manet had painted twice within twelve months of the *Mocking of Christ*. It is this sense of the topical and familiar, coupled with what Manet's academic contemporaries detested as bad drawing, which is indeed curious, rather personal, and surprising. These details, together with the curiously direct, even rough, handling of the surface of the paint, count among Manet's contributions to painting and make him one of the great innovators. But in the end it is not his newness but his very traditional oldness which make him one of the mainstream French giants.

The painting was given by James Deering in 1925.

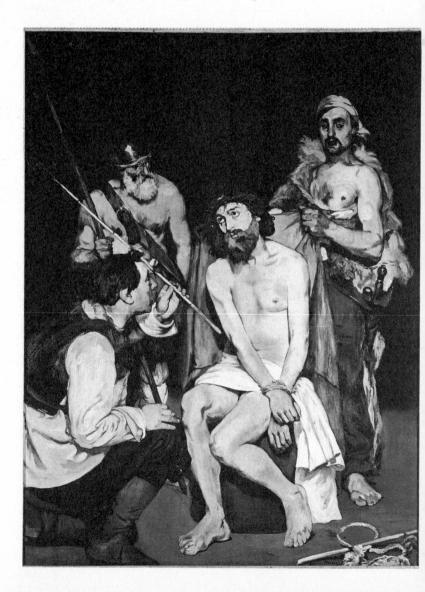

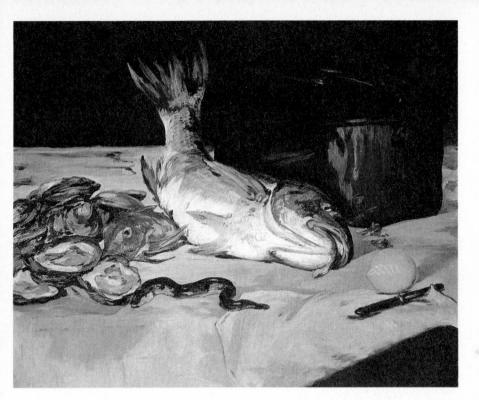

ÉDOUARD MANET (1832–1883) Still-life with Carp, 1864 Oil on canvas, $28\frac{8}{8} \times 36\frac{1}{4}$ in (73.4 × 92.1 cm) Acc. no. 1942.311

French

Manet painted this picture at Boulogne during the summer of 1864. A year later he showed it with five other pictures at a cooperative exhibition gallery, Martinet's. This is Manet's version of a typical Chardin subject, and the derivation of the type is clear enough. The technique and color, however, are Manet's own. In spite of his occasionally tentative drawing style, Manet always manages to communicate a sense of formal structure.

It is this historical type of work by Manet which establishes his claim to a real place in the mainstream of traditional French painting. But when Manet lightened his palette he pushed his own innovations forward, though they were still supported not only by his traditionalism but also by his formal sense. And in this early work there are intimations of his later manner to be noted in the tonalities of grey and white with warm colored accents.

The painting was added to the Mr and Mrs Lewis Larned Coburn Collection.

Eugène Boudin (1824–1898) Approaching Storm, 1864 Oil on panel, $14\frac{3}{8} \times 22\frac{3}{4}$ in (36.6 × 57.9 cm) Acc. no. 1938.1276

Boudin is the perfect minor master, the exquisite painter whose lovely, smallish, minor works are precious and cherishable, always infused with ravishing surfaces. He is also important in the evolution of the Impressionists, who were slightly younger. Born in Honfleur (a place much loved by Corot, who often painted there), Boudin grew up in a city with a wonderful light which seems peculiar to that part of the French coast. He was a pupil of the academic Romantic, Eugène Isabey, but, save for an admirably sound technique, little of Isabey seems to have rubbed off on Boudin. Boudin was much his own man, and though he knew and reacted to the works of Corot, Courbet and Jongkind (with whom he had much in common stylistically), he remains very much an original in nineteenth-century French art. He was a realist, even a factualist, but always managed to see his subject/matter - even in his still/life paintings - with a kind of elegiac and poetic intensity. For many years collectors craved his late harbor and shipping scenes, but within the last generation the beach scenes, done in his late thirties and early forties, have become most admired. This small picture shows a group of fashionably dressed people at the beach, standing or talking beside the small portable huts which were used by sea-bathers at the period and which are still not unknown on northern European beaches. What Boudin has portrayed and caught exactly is the quickly changing light which occurs on a late spring or early autumn day just as a rainstorm is arising. The piece has the instantaneous quality of a snapshot, and it is easy to see in it how Boudin was to influence the young Manet.

Mr and Mrs Lewis Larned Coburn Memorial Collection.

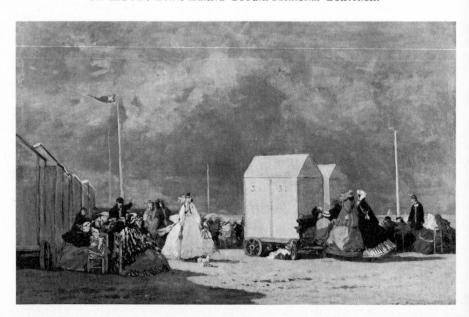

Frédéric Bazille (1841–1870) Self-Portrait, 1865 Oil on canvas, $42\frac{3}{4} \times 28\frac{3}{8}$ in (108.6 × 72.0 cm) Acc. no. 1962.336 French

Bazille's works are the rarest among those of the Impressionists for the simple reason that the artist was killed, when still a very young man, in the Franco-Prussian War. Among the Impressionists he was one of the most talented and one of the most interesting socially, being a member of an old Protestant family. It is hard to categorize his work, for while he somewhat resembles the young Monet, even the young Pissarro, there is a straightforward sobriety in Bazille which sets him slightly apart from his peers. Such things are hard to justify on merely visual evidence – and indeed are probably impossible to document – but the spectator gets a definite feeling that Bazille's work shows an attitude which is not only uncompromising but full of almost harsh ethical values. This attitude is manifest in the very directness and method of his style.

This directness is evident in this self-portrait, wherein the skin of the arm is visible beneath the cambric of the sleeve by way of a subtle alteration in the color itself. The illusion is one of the use of a glaze, but it is accomplished with direct painting worked wet into wet.

The painting was bought from the Frank H. and Louise B. Woods Purchase Fund in memory of Mrs Edward Harris Brewer.

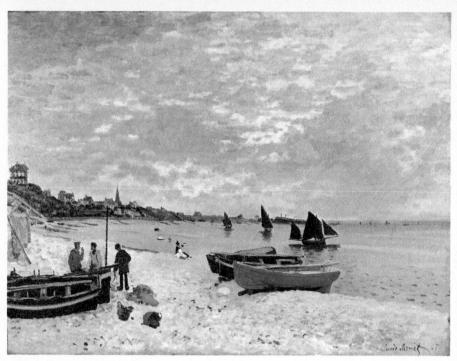

CLAUDE MONET (1840–1926) The Beach at Sainte-Adresse, 1867 Oil on canvas, $29\frac{3}{2} \times 39\frac{3}{4}$ in (75.0 × 101.0 cm) Acc. no. 1933.439

Monet was the leading member of the Impressionist group and it was from his painting Impression, soleil levant, exhibited in 1874, that Impressionism got its name. He was born in Paris but the family soon moved to Le Havre, where he met Boudin who encouraged him to paint nature on the spot; he was the first of the Impressionists to do so. In 1859 he returned to Paris and studied under Gleyre for a time, getting to know Renoir, Sisley, and Bazille; the latter described him as 'a very competent landscape painter' and was to become a good friend, often helping him out of his financial difficulties. These were frequent as his family was for ever stopping or reducing his allowance. This happened again in 1867 and he was forced by lack of money to return home to Sainte-Adresse near Le Havre. The year was a worrying one in other respects, for in July his mistress, Camille (whom he was later to marry), gave birth to their son. But Monet seems to have found some consolation in his art and this is one of the pictures painted during the period.

Cézanne is said to have called Monet: 'Only an eye, but my God, what an eye!' and there is considerable truth in the remark. The present picture belongs

to that early group of Monet's paintings in which he records natural scenes in broad and simple terms – he has not yet become obsessed with the effects of light, with representing (in his own words) 'that which lies between the object and the artist, that is the beauty of the atmosphere – the impossible'.

Mr and Mrs Lewis Larned Coburn Memorial Collection.

CLAUDE MONET (1840–1926)

French

The River, 1868

Oil on canvas, $31_8^7 \times 39_2^1$ in $(81.0 \times 100.3 \text{ cm})$

Acc. no. 1922.427

This is another of Monet's early pictures and shows his mistress, Camille, sitting on the banks of the Seine in which the hills of Bennecourt are reflected. The scene is full of radiant serenity and it is difficult to see how such a picture could ever have been considered revolutionary: the reason was, of course, that Monet painted as he saw and not according to two centuries of academic thinking about how an artist ought to see. The paint is boldly applied and the artist seems to have been more concerned with conveying the atmosphere of the scene than in the depiction of detail.

Mrs Potter Palmer Collection.

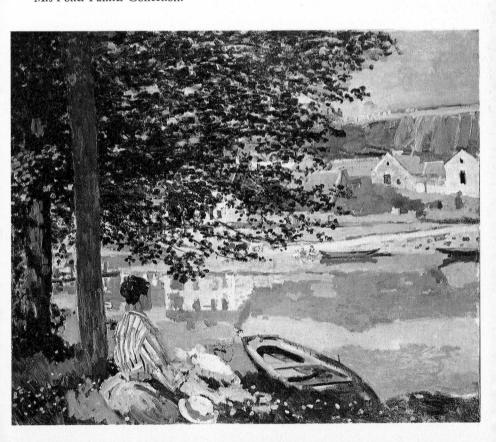

CLAUDE MONET (1840–1926) Old Saint-Lazare Station, Paris, 1877 Oil on canvas, $23\frac{1}{2} \times 31\frac{1}{2}$ in (59.6×80.2 cm) Acc. no. 1933.1158

By the time Monet painted his several views of the interior of the train shed of the Gare Saint-Lazare, two things had happened. The first was his discovery that anything made a suitable subject for a painting, no matter what conventional minded people thought. The second was that his brushwork was becoming even looser than it had been before, and he began to emphasize simple strokes of his brush rather than to organize them into broad areas of color. The result of this technical development was a glittering and lively, three-dimensional surface even though the subject portrayed might be entirely quiet in its actual visual texture.

In this picture Monet has conveyed a very real sense of the interior of the train shed with the open space beyond, suffused by a soft, diffuse light. The sense of the interior space is achieved partly through the actual perspective drawing but even more through the rendering of the steam from the locomotives as it rises to block the view of the world around. Monet has rendered the humans in the scene as blobs and strokes of paint, but each of his strokes, whether to depict a man or the network of cables overhead or the skylights above the network, is calculated to describe a tacitly understood form or set of forms.

Mr and Mrs Martin A. Ryerson Collection.

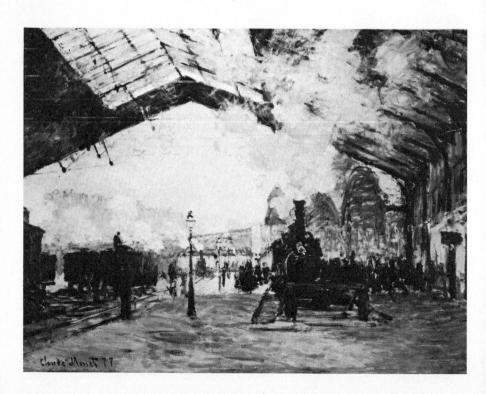

Alfred Sisley (1839–1899) Sand Heaps, 1875 Oil on canvas, $21\frac{1}{4} \times 28\frac{7}{8}$ in (54.1 × 73.4 cm) Acc. no. 1933.1177 French

Alfred Sisley was born of English parents in Paris where he was educated and grew up a Frenchman. He studied painting under Gleyre, along with Bazille, Monet, and Renoir. Monet's example and certain phases of Corot largely determined his style, though his stay in England in 1870 made him familiar with the works of Constable and Turner, both of whom he much admired.

This work, dated 1875, shows Sisley's mature style. Though not an artist of the first rank, he was a major craftsman with an exquisite taste for the surface of the painting and a remarkable feeling for forms. In one sense, Sisley was completely unimaginative, but this very fact makes him a perfect recorder of observed fact, more elegant than Monet, more observant than Boudin. Without dramatization and with only the direct observation and recording of what he saw, Sisley makes the spectator see for himself the pictorial drama inherent in the scenery.

This painting, once in Dr Georges Viau's collection, was bequeathed to the Art Institute by Martin A. Ryerson.

PIERRE AUGUSTE RENOIR (1841–1919) Lady at the Piano, 1875 Oil on canvas, $36\frac{3}{4} \times 29\frac{1}{4}$ in (93.4 × 74.3 cm) Acc. no. 1937.1025

The Lady at the Piano represents the first phase of Renoir's mature style, during which he painted mainly scenes from everyday life – pretty women from Montmartre who used to pose for him in his studio, the wives and daughters of the rich bourgeoisie; and the friends he used to meet in the Café Nouvelle Athènes. He showed this picture in the second Impressionist exhibition in 1875.

In it the spectator sees Renoir's loose but carefully plotted brushwork, applied to the old-fashioned academic drawing he learned from Gleyre. What is peculiarly Renoir's own is the technique of painting so that the white ground always shows through the paint. This is an inheritance from his apprentice days as a chinaware painter which were to have a continuing influence on his attitude and technique. The picture is pleasant, full of a happy attitude towards life. Somber subjects had no place in Renoir's repertoire: according to his idea, art lay in the depiction of light and joy.

Mr and Mrs Martin A. Ryerson Collection.

PIERRE AUGUSTE RENOIR (1841–1919) Two little Circus Girls, 1879 Oil on canvas, $51\frac{1}{2} \times 38\frac{3}{4}$ in (130.8 × 98.5 cm) Acc. no. 1922.440

This picture was painted in 1879. The subjects are Francisca and Angelina Wartenberg, who, according to Angelina, the younger, were at the start of their careers in the circus. These children performed as jugglers in the Cirque Fernando, which was set up in Paris in 1875 in the Boulevard Rochechouart. This is Renoir at his very best as a simple and direct observer of the world, making use of his chinaware painter's technique, but not yet spoiled by his

desire to emulate old masters. In its simplicity and genuine charm, the painting must rank as one of Renoir's masterpieces. It was, incidentally, the favorite picture of its owner, the first Mrs Potter Palmer who kept it with her at all times: it followed her from Chicago to London and finally to Sarasota, Florida. It entered the collection of the Art Institute on her death in 1922.

Potter Palmer Collection.

PIERRE AUGUSTE RENOIR (1841–1919) The Rowers' Lunch, c. 1880 Oil on canvas, $21\frac{1}{2} \times 25\frac{3}{4}$ in $(54.7 \times 65.5$ cm) Acc. no. 1922.437

French

This picture was another of Mrs Palmer's favorites and was acquired by her after she had become acquainted with the works of the Impressionists through her friendship with Mary Cassatt. However, it must never be thought that Mrs Potter made purchases merely because Mary Cassatt told her to buy. What Mary Cassatt did was to call Mrs Palmer's attention to various works by her Impressionist friends, and then Mrs Palmer herself unerringly and cheerfully exercised her own choice.

Potter Palmer Collection.

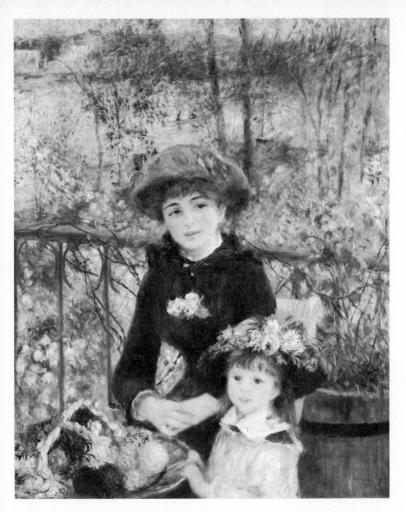

PIERRE AUGUSTE RENOIR (1841–1919) On the Terrace, 1881 Oil on canvas, $39\frac{1}{2} \times 31\frac{7}{8}$ in (100.3 × 81 cm) Acc. no. 1933.455

This picture is today probably the most popular painting in the collection of the Art Institute and occupies a place in the heart of the public just as Breton's *Song of the Lark* did eighty years ago. It is a straightforward and effective likeness of a pretty woman with an equally pretty daughter. The spectator is conscious of the radiance and glow of a warm and lovely day in France.

Mr and Mrs Lewis Larned Coburn Memorial Collection.

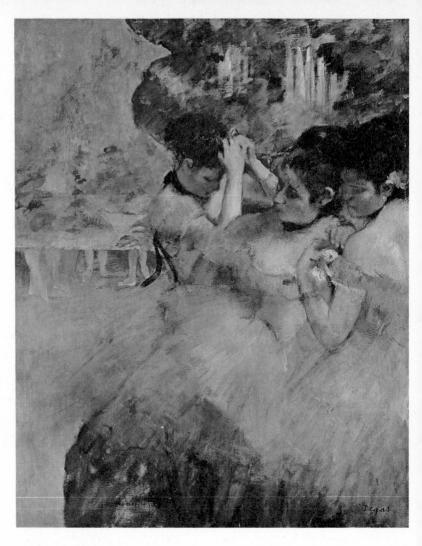

EDGAR DEGAS (1834–1917)

Dancers preparing for the Ballet, c. 1880

Oil on canvas, $29\frac{3}{16} \times 23\frac{3}{4}$ in $(74.1 \times 60.5$ cm)

Acc. no. 1963.923

Degas has presented here a seemingly casual arrangement, as though it were a snapshot or something seen in passing from the corner of the eye. One notices a curtain going up or descending in the rear of the scene, with several pairs of ballet dancers' lower legs and feet, and in the foreground three dancers in the

process of adjusting their dress. The gestures are observed with absolute understanding, so that the viewer feels emphatically the movements in each body and even the weight of the costumes. What is rather more surprising is the sense of physical beauty in the women, for Degas frequently gave the impression of emphasizing the ugly in the faces he drew.

This picture, from Mrs Potter Palmer's Collection, was given by her descendants, Mr and Mrs Gordon Palmer, Mrs B. Palmer Thorne, and Mr

and Mrs Arthur M. Wood.

EDGAR DEGAS (1834–1917)

The Millinery Shop, c. 1882

Oil on canvas, $39_8^1 \times 43_8^3$ in (99.5 × 110.3 cm)

Acc. no. 1933.428

French

Degas was in many ways the greatest master of the nineteenth century in France, certainly in any traditional sense. He never broke through to the future as Cézanne did, nor, as Cézanne did, did he ever falter. Indeed, of any painter of the last two centuries, Degas left the most fastidious body of work. This is

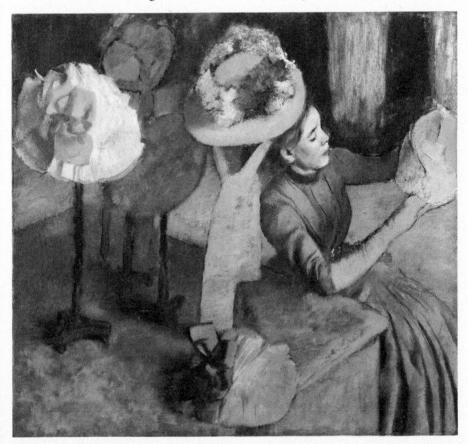

because he was ruthless in maintaining his standard of quality and simply never let trash accumulate. He always tried to recover work with which he was unsatisfied. Degas knew his Louvre and, as a collector, also knew artists not found there. (Important works by El Greco as well as Ingres were sold with the contents of his studio.) Degas was also attuned to all sorts of novelties, was himself a good photographer and knew how to use his photographs in his work. (It is from Degas' example that Toulouse-Lautrec also used photographs.)

As he grew older, Degas increasingly strove to render the body in motion as well as at rest. His very earliest oils, as well as the brothel scene monotypes late in his career, prove that he could have been the greatest of all illustrators. But the course of Degas' art was the continuing pursuit of the most fastidious vision of his century. It is sadly ironic that his eyesight failed and that he died a blind man.

This remarkable canvas is brilliantly constructed with the solidest of forms seen in an ambiguous environment. The seemingly casual design owes a good deal to the precedent of Japanese prints, but the solidity goes back to Poussin and the Renaissance. Though this is a casual scene of domestic triviality, the structure establishes Degas as the last great master of the old tradition.

The picture came as part of the Mr and Mrs Lewis Larned Coburn

Memorial Collection.

Jules Breton (1827–1906) The Song of the Lark, 1884 Oil on canvas, $43\frac{1}{2} \times 33\frac{3}{4}$ in (110.6 × 85.8 cm) Acc. no. 1894.1033 French

Jules Breton was trained, in the survival of Neo-classicism, by a follower of David: he first showed in the Salon at the age of twenty-two and continued to be a popular exhibitor for the rest of his long career. Today Breton seems a dull and rather lifeless figure in the history of nineteenth-century French painting; in his own time, however, he was not only widely esteemed professionally but was immensely popular with the public at large. This popularity seems hard to understand now, and his paintings seem for the most part merely boring. This estimation is just as unfair to Breton's real but small talent as the enormous overesteem he enjoyed within his own time.

Breton's talent was truly a small one, but within his range he was a superior craftsman and a painter of exquisite sensibility. The trouble with the *Song of the Lark* is that it is too familiar, not from one's own childhood but from that of one's grandparents. This overfamiliarity blinds the observer to the virtues the painting has. The first virtue is that of carefully comprehended form expressed in terms of precisely observed and thoroughly understood drawing. The second

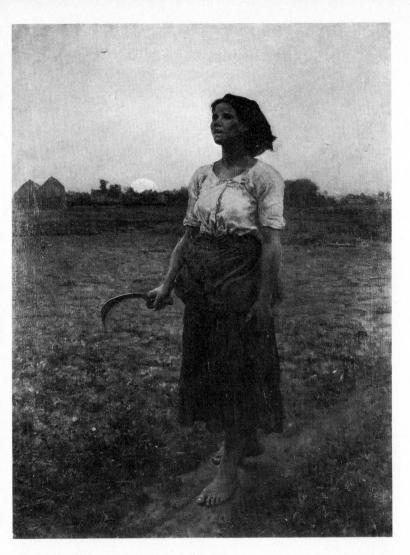

virtue is that of beautifully observed light, not in the way the Impressionists understood light, but thoroughly noted and perceived all the same. The third virtue is one hard to accept today but nevertheless a virtue: carefully considered sentiment, which is intense but not mawkish. These solid virtues account in part for the picture's popularity throughout the years; it was the most popular painting in the World's Columbian Exposition of 1893.

The painting is signed and dated 1884. It was painted at Courrières. It came to the museum as part of the Henry Field Memorial Collection in 1894.

GEORGES SEURAT (1859-1891) Sunday Afternoon on the island of La Grande Jatte, 1884-86 Oil on canvas, $81 \times 120^{\frac{3}{8}}$ in $(205.7 \times 305.8 \text{ cm})$ Acc. no. 1926,224

This picture was shown in May 1886 at the Salon des Indépendants where it caused great controversy. But Felix Fénéon recognized its merit and described it in La Vogue: 'It is four o'clock on Sunday afternoon in the dog-days. On the river the swift barks dart to and fro. On the island itself, a Sunday population has come together at random, and from a delight in the fresh air, among the trees. Seurat has treated his forty or so figures in summary and hieratic style, setting them up frontally or with their backs to us or in profile, seated at right angles, stretched out horizontally, or bolt upright: like a Puvis de Chavannes gone modern.'

But of course it was not the subject that was revolutionary - although the stillness and dreamlike quality of the painting are remarkable. What was so new was Seurat's technique - his pointillism based on his studies of optical theory, by which he tried to convey the flickering summer light by dots of color which would be reconstructed into shapes and forms by the eye when the

picture was observed from a distance.

Seurat painted this picture only after he had done numerous studies and sketches for it, one of which is in the Institute (see p. 161).

Frederic Clay Bartlett gave it for the Helen Clay Bartlett Memorial Collection in 1926.

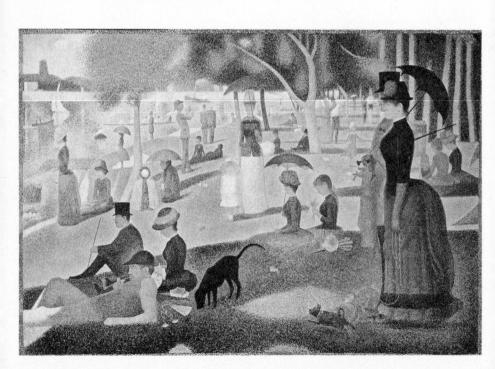

VINCENT VAN GOGH (1853–1890) Bedroom at Arles, 1888 Oil on canvas, $28\frac{3}{4} \times 36$ in (73.0 × 91.4 cm) Acc. no. 1926.417 Dutch

Van Gogh's pathetic life is too well known to recount here. What is meaningful about him is that he was the first great Dutch artist since the seventeenth century, one to rank with Rembrandt and Hals not only for his human appeal but for his accomplishment as an artist.

Van Gogh had that touch of genius which allowed him to see things in a new way, as if the old familiar things had never been seen at all. His bedroom here is a case in point. The quality of the plain interior, with its painted deal furniture and its scrubbed if respectable poverty, is simple enough, but van Gogh has invested it with freshness, he has even turned the tricks of perspective to his own uses and intensity of meaning.

That van Gogh died in a state of derangement is sad but irrelevant to his art, for in his paintings and drawings he was lucid and infinitely observant of

the life of the mind and the world about him. His problem was simply that he was so filled with ideas (and pictorial ones at that) that he literally did not have the time to produce them, nor the occasion for serene withdrawal for the sake of renewal. One feels that the illustration he cast on the world about him was not unlike that of an arc light of fullest intensity, which may have burnt out for lack of staying power, but was totally revealing while it endured.

The picture came with the Helen Birch Bartlett Memorial Collection.

VINCENT VAN GOGH (1853–1890) Self-Portrait, 1886–88 Oil on cardboard, $16\frac{1}{2} \times 13\frac{1}{4}$ in (42.0 \times 33.7 cm) Acc. no. 1954-326 Dutch

During the two years van Gogh lived in Paris, 1886–88, he painted twenty-four self-portraits. At this time he became fascinated by the pointillist theories of Pissarro and Seurat, whose work he much admired, and tried to adopt them. Characteristically, however, he used loosened, longish strokes rather than dots, so that the effect is expressive and emotional rather than cool and objective. Form, too, as distinct from pattern, plays a more vital part. Notice, for instance, how the strokes round the head and nose elucidate the structure beneath the surface. Only in the background has he managed to stay with the dots of the pointillists, but not at all in their disciplined and careful way.

The final impact of the portrait is its emphasis on the artist's eyes and the

intensity of their glance at himself in the mirror.

Joseph Winterbotham Collection.

GUSTAVE CAILLEBOTTE (1848–1894)
The Place de l'Europe on a Rainy Day, 1877
Oil on canvas, $83\frac{1}{2} \times 108\frac{3}{4}$ in (212.2 × 276.2 cm)
Acc. no. 1964.336

Caillebotte was by profession a civil engineer. As a well-to-do man he could afford to buy the works of his friends, the Impressionists, and, indeed, with Victor Chocquet, he was one of their first great patrons. On his early death, he bequeathed his collection to the State: to the everlasting disgrace of the museum professionals of his time and equally everlasting despair of their successors today, only a portion of the collection was accepted for the Louvre.

This picture is Caillebotte's finest work, and it is constructed with the same skill that he devoted to his steel construction. The observation is of the subtlest, and the construction is comparable. For example, only by actually measuring does one discover that the central lamp-post precisely bisects the canvas. After careful examination one also notices that Caillebotte has condensed his perspective and adjusted his figures into the two-dimensional pattern so that the eye fails to note on first glance with just what care as well as fakery the painting is composed. Interestingly enough, this picture was painted seven years before Seurat began the Grande-Jatte.

Charles H. and Mary F.S. Worcester Collection.

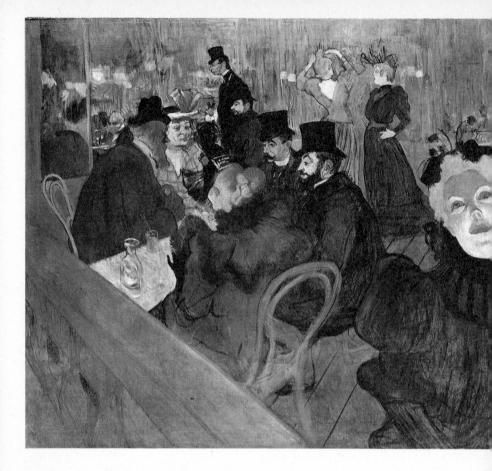

HENRI DE TOULOUSE-LAUTREC (1864–1901) At the Moulin Rouge, 1892 Oil on canvas, $48\frac{3}{8} \times 55\frac{1}{4}$ in (122.9 \times 140.4 cm) Acc. no. 1928.610

French

The Moulin Rouge was about the most popular dance hall in Paris in the 1890s and Toulouse-Lautrec painted many pictures of it.

Here his interest has shifted from the dance floor to the spectators. Seated at the table he shows the critic Edouard Dujardin (with a yellow beard), La Macarona, a Spanish dancer, Lautrec's friends Sescau and Guibert, and, with her back to the viewer, an unidentified woman. The woman arranging her hair in front of a mirror is La Goulue (The Glutton), a dancer at the Moulin, to the left of whom Lautrec himself can be seen, accompanied by his lanky cousin and constant companion, Gabriel Tapié de Céleyran.

This is undoubtedly one of Lautrec's greatest and most imaginative pictures. The influence of Degas can be seen in the seemingly casual arrangement of the subjects – e.g. the woman in the bottom right-hand corner who is half out of the picture. His use of the converging diagonals of the floorboards and the balustrade to create an illusion of space owes much to the example of Japanese printmakers.

Helen Birch Bartlett Memorial Collection.

PAUL GAUGUIN (1848–1903)
The Day of the God, 1894
Oil on canvas, $27\frac{3}{8} \times 35\frac{5}{8}$ in (69.6 × 90.5 cm)
Acc. no. 1926.198

French

Gauguin began as an amateur painter in the manner of the Impressionists, with whom he exhibited in 1880. Three years later he turned professional, and by the time of his final removal to the South Seas in 1890, he had achieved his own highly decorative manner of painting, which was completely adapted to the things he chose to communicate in his work.

This painting was executed in Paris but epitomizes his feelings about the primitive and archaic world of the Maoris and the South Seas. The point to remember about Gauguin is that, while his style is occasionally primitivistic, he was never in any sense a primitive, and he was always the complete professional, totally equipped for what he wanted to accomplish.

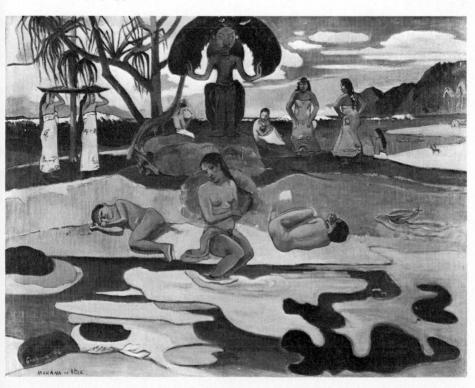

One sees a wooden figure set up in the rear of the painting with women votaries approaching. In the foreground are bathing and sleeping women. Far in the distance can be seen a seashore, with sea and surf plainly in evidence. This painting is as artificial a reconstruction of reality as Poussin's landscapes, and it is a private and mythic Arcadia which is recorded, with a validity comparable to the older man's.

The painting is part of the Helen Birch Bartlett Memorial Collection.

CAMILLE PISSARRO (1830–1903)

Place du Havre, Paris, 1893

Oil on canvas, 23\frac{5}{2} \times 28\frac{13}{16} \text{ in (60.1 \times 73.5 cm)}

Acc. no. 1922.434

French

Pissarro may be considered in some ways to be the typical Impressionist. He was strongly influenced by Corot, Millet, Manet, and Monet, and he took elements from each of them. In the early 1870s he had a strong influence on Cézanne. Pissarro exhibited with the Impressionists from 1874 to 1886. For a short time after 1885 he adopted the pointillist technique of Seurat and retained traces of that method to the end. This painting illustrates his brilliant use of color and a remarkable understanding of the effects of light and atmosphere. It also demonstrates his rather casual sense of composition.

The painting came from the bequest of Mrs Potter Palmer.

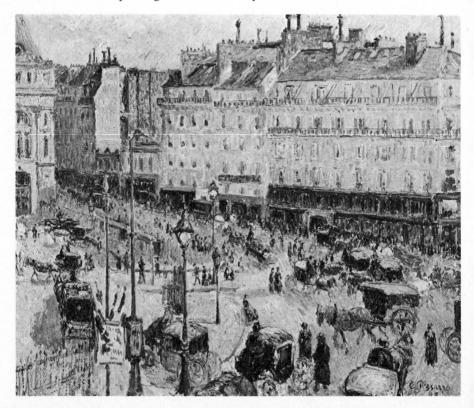

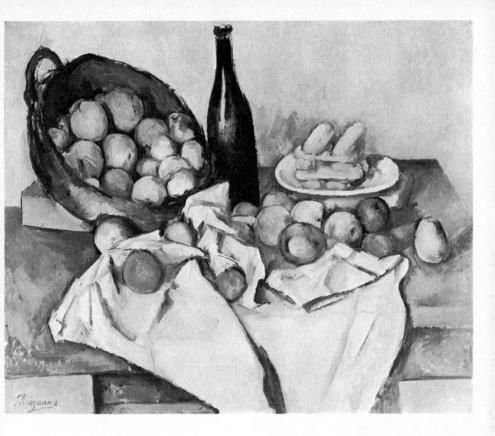

PAUL CÉZANNE (1839–1906)

The Basket of Apples, 1890–94

Oil on canvas, $25\frac{3}{4} \times 32$ in $(65.5 \times 81.3$ cm)

Acc. no. 1926.252

French

Cézanne's rather intractable genius is always interesting to trace even in his unsuccessful works (and there are many) as well as his slightly unfinished ones. But his brilliance, even magnificence, bursts out with compelling power in his finished and successful paintings, the ones which can truly be called masterpieces. The Basket of Apples is such a work of this last category. In it, the viewer may see the fullest manifestation of the master's method; not one brushstroke has been put down without due regard for its impact – not only on every other brushstroke but also on the whole surface of the canvas. Each brushstroke is carefully considered for itself, as well as for its description of surfaces in space, but the very drawing is considered in the same way. That is to say, Cézanne's drawing evolved over the surface of the canvas so that areas of what can be

called local truth are fully realized, even if, by merely academic standards, the method of drawing seems hesitant or inconclusive. Thus, the edges of the table, both in front and in back, are neither consistent nor continuous, but the relationship of these edges to the bottle, the basket, the plate, and the napkin is intensified in each case so that a greater feeling of solidity seen in a luminous void is achieved.

Cézanne's use of color is analagous to his drawing method. The intensity of a local situation seen in the light of the room is adjusted to the surface and space he was describing at the moment. The result in this, one of his greatest still-life paintings, is a sense of timeless solidity seen in glowing color.

The painting, part of the Helen Birch Bartlett Memorial Collection, was

probably painted before 1894.

PAUL CÉZANNE (1839–1906)

The Vase of Tulips, 1890–94

Oil on canvas, $23\frac{1}{2} \times 16\frac{5}{8}$ in (59.6 × 42.3 cm)

Acc. no. 1933.432

French

If The Basket of Apples shows Cézanne's noblest style applied to the simplicity of a homely kitchen still life, The Vase of Tulips shows the same method applied to a more suave drawing room subject. As it happens, there is only the slightest difference between the two paintings, except for the fact that Cézanne's method in this picture achieves an even happier result than in the other, and, though considerably smaller in actual format, this painting seems even larger.

Cézanne's remarkable accomplishment is to make such fragile things as flowers from the garden seem both delicate and, paradoxically, eternally solid at the same moment. His method of drawing and composition, even when applied as it is in this painting to a fragment of an interior, achieves the soberest and grandest of results. It has been said that it made no difference to the master of Aix what he was painting, when indeed it did, for he obviously preferred immovable objects to those which move. The thing which fascinates the beholder is that, even though Cézanne obviously preferred the motionless in nature, he never failed to give a liveliness of touch and reality to the simplest subject. In this canvas the surface of the top of the table, as well as that of the wall, is handled with the subtlest variations of hue and tone and with the most varied and lively of touches. The result is not only an intense evocation of the very nature of the wall and the top of the table, but also an achievement of a lovely painted surface in itself.

The painting was formerly in the collection of Cézanne's great friend, Chocquet; it came to the museum as part of the Mr and Mrs Lewis Larned

Coburn Memorial Collection.

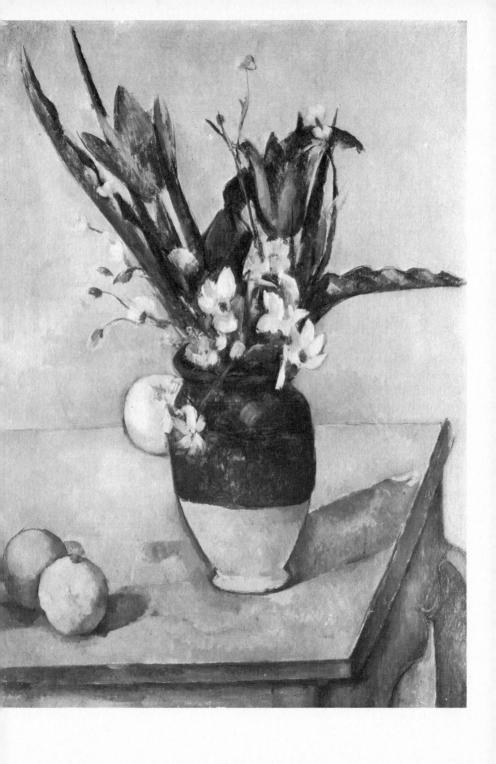

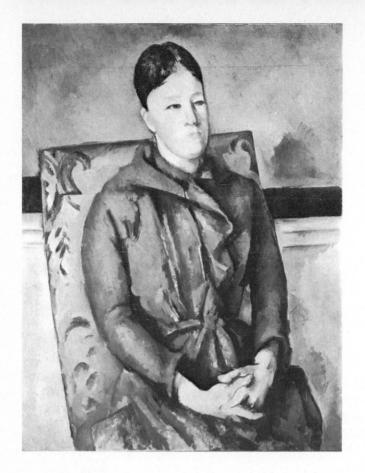

PAUL CÉZANNE (1839–1906) Mme Cézanne in a Yellow Chair, 1890–94 Oil on canvas, 31\(^2_8\times 25\)\(^1_2\) in (81.0\times 64.8 cm) Acc. no. 1948.54

This work is a major figure piece by Cézanne. One hesitates to say portrait, for by the time that this work was painted, Cézanne had but the slightest interest in likenesses as such, if, indeed, he ever did. What the painter does here, with the aid of his patient wife and kindest sitter, is to give the viewer a concentrated image of a personage seated and composed on a chair. This personage is painted in such a way as to suggest the greatest mass and, with the concommitant result, the impression that the subject might just as well be made of painted stone as of flesh and bone. Cézanne has subjected his wife to the same intense and analytical scrutiny which he used both for plates of apples and the

Montagne Sainte-Victoire or the avenue of chestnut trees in his garden at the Ias de Bouffan.

Cézanne's accomplishment in such a work as this great picture is to recreate in his own terms the whole art of figure painting. These terms were, of course, the adjustment of the drawing employed to the exigencies of the overall pictorial structure in both two and three dimensions, and the adjustment of the paint strokes so as to describe not only the effect of light on objects but to relate these patches as they were portrayed to the same overall pictorial structure. The method was infinitely laborious, and in Cézanne's occasional failures merely labored. In this monumental work, the slow, even tedious, method has produced an intensely felt and observed image.

The picture, which belonged to both Ambroise Vollard and Alphonse

Kann, was bought from the Wilson L. Mead Fund.

Paul Cézanne (1839–1906) Bathers, c. 1900 Oil on canvas, $20\frac{3}{16} \times 24\frac{1}{4}$ in (51.3 × 61.7 cm) Acc. no. 1942.457 French

Throughout his career of almost half a century, Cézanne was obsessed by a desire to create monumental decorations portraying nudes in landscape. In view of his prudishness – not to say nervousness – in the presence of nude models,

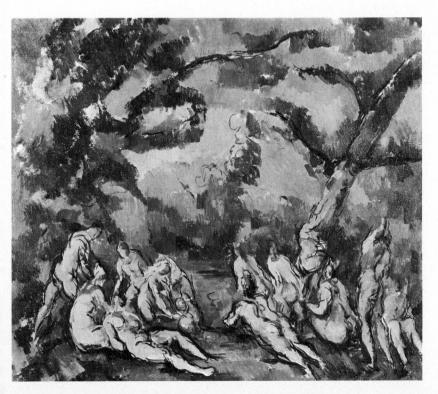

this seems odd. But it is a classical theme and quite in character with his expressed aim to 'make of Impressionism something solid and durable like the art of the Museums'.

By the time Cézanne began to paint his bathers in the woods, the opportunity to see such in fact had been gone for many centuries in France, if, indeed, it had ever been possible. The result is that a man so stubbornly dedicated to drawing from close observation of the world was almost certainly going to have trouble in painting such subjects. After all, even Manet had trouble, even though he quoted from Marcantonio and the sixteenth century, so it is hardly surprising that the less sophisticated Cézanne would, also, even if for different reasons.

This version of the subject, painted towards 1900, ranks as one of his successful treatments of it, partly perhaps because it is small in scale and does not try to be heroic. But, paradoxically, even though this picture is in small format, it gives the impression of being monumental.

The picture came as part of the Amy McCormick Memorial Collection, and it was formerly in the Zoubaloff and Hessel Collections, Paris.

MARY CASSATT (1844–1926) The Bath, c. 1891-92 Oil on canvas, $39\frac{1}{2} \times 26$ in (100.3 \times 66.1 cm) Acc. no. 1910.2 American

Mary Cassatt was in many ways the most consistently able of American painters, and on occasion one of the two or three best. This picture is one of those occasions. She was diligent in her work and profited much from Degas' advice and example; she knew exactly what to borrow by method from the Japanese printmakers and from Degas as well. What she got from both was an extraordinary quality of line, decoratively and functionally used.

In this picture the viewer sees a carefully composed composition in which the typically Far Eastern point of view of seeing from above puts the spectator into a curious position of not quite knowing his own place vis vis the action. Thus the viewer is present at a most intimate moment of existence without actually being part of the scene itself. This device, also used by Toulouse-Lautrec as well as Degas, is one which permits communication of an intimate sense of private reality without destroying the impersonality of subject or spectator. Mary Cassatt's approach was always a cool one, and it is this detachment which has baffled and occasionally infuriated sentimentally minded folk who hope to be involved in all they see. Miss Cassatt's temperament and taste were too elegant to permit any such vulgarism.

The painting was bought from the income of the Robert A. Waller Fund.

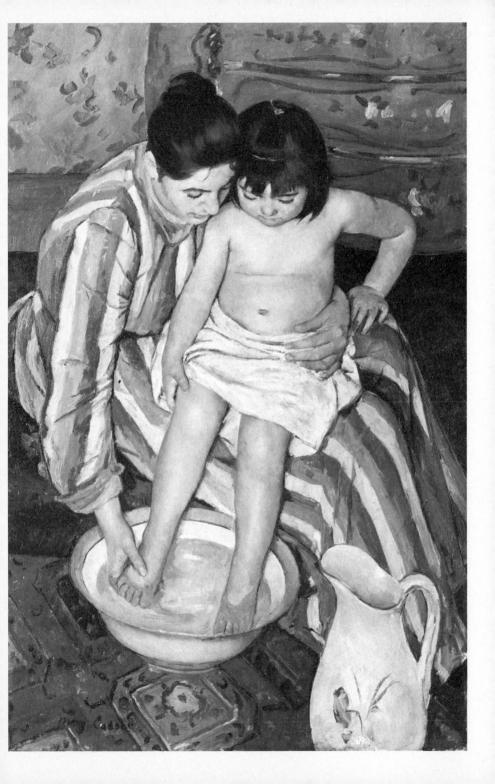

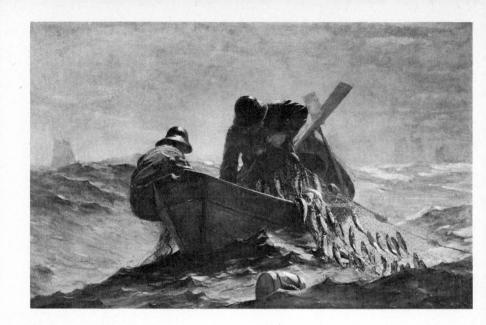

WINSLOW HOMER (1836–1910) The Herring Net, 1885 Oil on canvas, $29\frac{1}{2} \times 47\frac{1}{2}$ in $(75.0 \times 120.6$ cm) Acc. no. 1937.1039

American

Homer began his career as an illustrator and did brilliantly evocative water-colors. His reputation was made during the Civil War as a reporter and illustrator for *Harper's Weekly*. Homer visited both France and England and was in France during the height of the Impressionist furore, but his work is almost completely uninfluenced by foreign styles. In fact, he seems to have neither understood nor liked the Impressionists' innovation. The result is that his own style is rather hard in its earlier phase and, though looser in its later manner, at no point shows any real feeling for the way in which light can be used in the portrayal of scenery and people.

This sea piece belongs to Homer's most famous *genre* of painting. The fact that he was followed by a host of bad imitations merely serves to emphasize his own brilliance of performance. By the time Homer did this picture he had broadened his manner and achieved both a scale and a sense of dramatic concentration which remain his particular contribution to American painting. This concentration upon the action, which is clearly rendered but made into so hermetically closed a pattern that the picture seems almost abstract, is not only Homer's own but was to become, in the best sense, typically American.

Mr and Mrs Martin A. Ryerson Collection.

Acc. no. 1942.50

Harnett was born in Clonakilty, Ireland, but came to the United States at an early age and studied at the Pennsylvania Academy and at the Cooper Union, New York. Between 1879 and 1885 he lived in Europe, being especially influenced by Dutch still-life painters of the seventeenth century and by certain German artists of his own time in Düsseldorf and Munich. Harnett's strong suit was the development of a style of trompe-l'œil realism which is sometimes uncannily persuasive in its statement of visible truth.

This painting illustrates the best of Harnett's talent. His rendering of surfaces and simple appearance is adroit in the extreme, and in this work the composition is successful, which it is not in every case. The elegance of the rendering is a little light in its touch and accords nicely with the whimsy of the title. Yet there is something else which is mildly (perhaps intentionally) disturbing: this is the rendering of light, for it is almost as if the scene were

illuminated by a flash of lightning.

The painting was added to the Friends of American Art Collection in 1942.

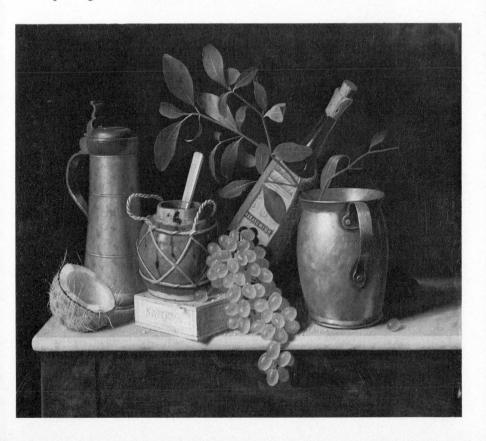

THOMAS EAKINS (1844–1916)

Addie, Woman in Black, 1899
Oil on canvas, 24×20 in (61.0×50.9 cm)
Acc. no. 1929.548

American

Eakins was trained first at the oldest art school in the United States, the Pennsylvania Academy, and then in Paris under Gérôme and Bonnat; his formal artistic education was finished with a trip through Spain where the great masters of the Spanish Baroque made a lasting impression on him.

This portrait of an intimate friend, and subsequently a member of the Eakins household, Mary Adeline Williams, was painted in 1899. It illustrates very clearly both the artist's immense and solid virtues as well as his equally real limitations. The limitations were partly of his own choosing. Neither his color nor his handling of paint are interesting in themselves, but are always subordinated to the honest portrayal of his subject. Honesty, sobriety, seriousness, are indeed his chief virtues. His style does not lend itself to prettiness or charm, and he was therefore more successful with plain than with beautiful women. Miss Williams was plain, but Eakins, in his obviously uncompromising statement of visual fact, convinces us of her reality as a person.

The painting belonged to Mrs Eakins, and was bought for the Friends of

American Art Collection.

The Old Guitarist is an early painting which belongs in Picasso's 'blue period', so called because of the predominant use of blue in his paintings between 1901 and 1904. These pictures, usually depicting pathetic characters, such as poor women, blind beggars or absinthe drinkers, reflect a fin-de-siècle melancholy. The characters seem full of despair and isolated from the rest of the world.

In this picture it is easy to see how the use of blue accentuates the coldness and hunger of the old man. Because the background is of the same color it offers no relief – one gets the impression that its quality is dependent on the state of the man, so here it reflects his cold despair. Only the guitar has some living color and takes up a central role in the painting.

Helen Birch-Bartlett Memorial Collection.

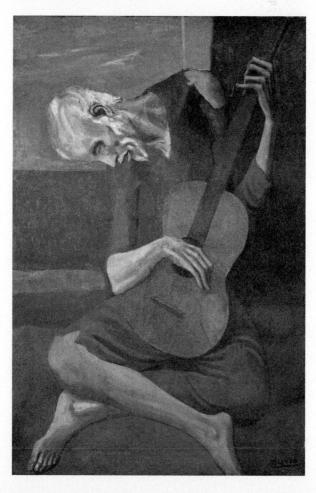

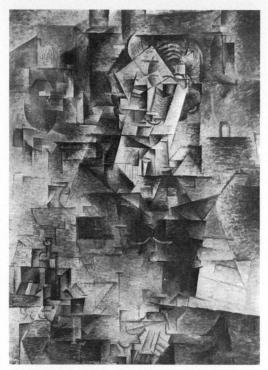

Pablo Picasso (1881–1973)

Daniel-Henry Kahnweiler, 1910

Oil on canvas, $39\frac{5}{8} \times 28\frac{5}{8}$ in (100.6 \times 72.8 cm)

Acc. no. 1948.561

Spanish

Picasso's great innovation, after his heroic and personal Fauvism of 1906 through 1909 with his discovery of African tribal art, was the invention and perfection of the system called Cubism. The obvious source for this style was the latest manner of Cézanne, but Picasso and his colleague Braque abandoned the lovely glowing colors of the last phase of the master of Aix and substituted in their stead a sober style of coloration based essentially upon raw umber, black, white, and a very few touches of ochers.

The principle of Cubism is the systematic analysis of aspects of visual phenomena in terms of diagrammatic lines, with fragments of individual surfaces suggested through highly conventionalized local modeling. To this direct study of a model Picasso added, through the so-called principle of simultaneity, an examination of various aspects of his model from different points of view all at once. The result is as if the entire view of the model from 360 degrees had been projected onto a cylinder and then unrolled.

Gift of Mrs Gilbert W. Chapman.

ROBERT DELAUNAY (1882–1941)
Champ de Mars, the Red Tower, 1911
Oil on canvas, 64 × 51½ in (162.6 × 130.8 cm)
Acc. no. 1959.1

Delaunay, who exhibited regularly in the Paris Salons of 1910–14, began his Cubist career with studies of two Parisian architectural landmarks – the Late Gothic church of Saint-Sévérin and the late nineteenth-century monument to technology, the Eiffel Tower, which had become a symbol of modernity to many French artists and writers.

Delaunay inscribed this painting on the rear of the canvas, and after his signature he added the revealing words époque destructive. In other words, at this period he conceived the Cubist idiom in destructive terms – he has attempted the destruction of form as normally experienced and understood. The shapes of the buildings are fragmented and this lends the painting a sense of dynamism. The painter has used color in a tasteful, elegant way which lends a highly decorative feeling to the scene. What comes as a surprise is the fact that his palette here is essentially that of the aged Delacroix, and only its very different disposition hides this fact from the viewer's immediate awareness.

Joseph Winterbotham Collection.

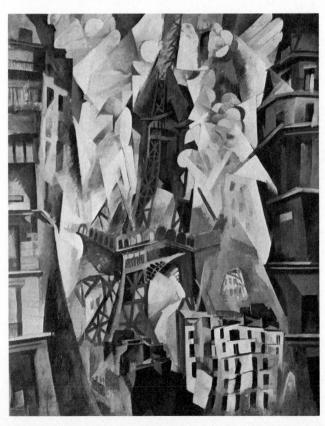

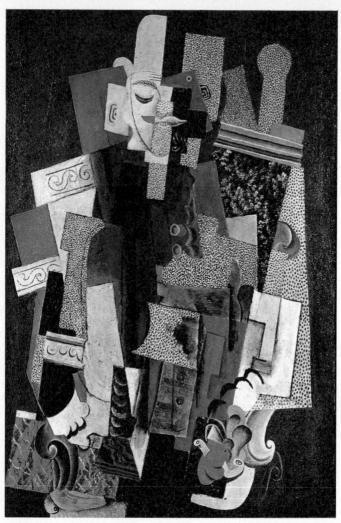

Pablo Picasso (1881–1973) Man with a Pipe, 1915 Oil on canvas, $51\frac{1}{4} \times 35\frac{1}{4}$ in (130.3 \times 89.5 cm) Acc. no. 1952.1116

Spanish

After his revolutionary accomplishment in the creation of Analytic Cubism in the years just before the First World War, Picasso began to experiment with collages – pictures constituted from pieces of wood, wire, paper, and string, their forms distorted by the artist into a flat composition whose inherent third dimension is alluded to at the same time as it is suppressed. When he reproduced these

effects in painted versions he created what is now known as Synthetic Cubism. Along with this change in style, Picasso abandoned the austerity of feeling in Analytic Cubism and used, instead of mainly grey and umber, beautifully glowing but soft hues.

Mrs Leigh B. Block gave this painting in memory of her father, Albert D.

Lasker.

Wassily Kandinsky (1866–1944) Improvisation with Green Center (No. 176), 1913 Oil on canvas, $43\frac{1}{4} \times 47\frac{1}{2}$ in (109.9 × 120.6 cm) Acc. no. 1931.510 Russian

Kandinsky is generally considered to be the founder of non-representational art. Born in Moscow, he trained in Munich after giving up his legal studies. He eventually established the 'Blaue Reiter' group and also taught at the Bauhaus. He painted his first abstract work, a watercolor, in 1910. The one shown here, called *Improvisation* like so many of his other paintings, was done in 1913. What

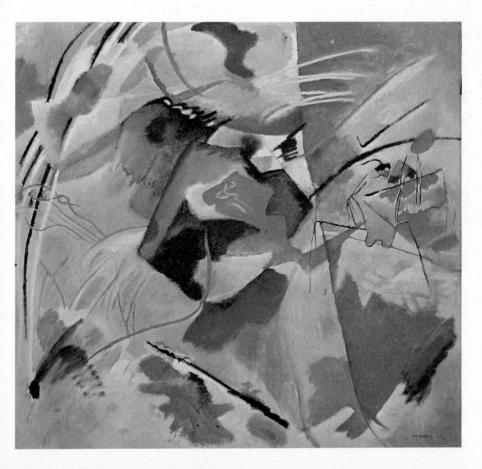

Kandinsky has done is to play freely with his colors and his two-dimensional forms to achieve a display of painted areas seen in relation one to another, so that

the spectator receives an impression of light, movement, and color.

The invention of non-representational painting, which was really the development of freely brushed in patterns of pure color and shape onto a picture surface, was one of the crucial developments of twentieth century art. It has been destined to infuriate the Philistine, that mythical 'man in the street' who claims to know what he likes and allegedly likes a story with a moral. Right-wing Philistines always suspect left-wing propaganda, whereas the Philistines of the left see 'bourgeois formalism' in the same works. The argument has continued for more than half a century without either camp's having noticed that Kandinsky was a great colorist and decorator; nor have they realized that beauty is not necessarily à propos of anything. The abstract painting of the 1950s and 1960s would have been impossible without the impact of Kandinsky's inventions.

Arthur Jerome Eddy, who bought the picture from the 1913 New York

Spanish

Armory Exhibition, bequeathed it as part of his collection.

JUAN GRIS (1887–1927)

Portrait of Picasso, 1912

Oil on canvas, $36_8^7 \times 29_4^1$ in (93.7 × 74.3 cm)

Acc. no. 1958.525

Juan Gris was born and raised in Madrid and moved to Paris in 1906, joining Picasso and the other avant-garde painters and poets in the *bateau-lavoir*. He developed his own particular type of Cubism, more severe and more lucid than

the Analytic Cubist work of Braque and Picasso.

This portrait of Picasso, painted in 1912, exemplifies Gris' particular type of Cubism. Although there is the typical Cubist disjunction of planes, the vivid luminary definition of edges gives the form solidity and precision. Amid the abstract regularity of the planes – from the prisms of the background to the triangular shaped buttons – the sitter's head asserts its uniqueness: there is a strange tension between the concept of formal structure imposed on the picture and the actual facts of Picasso's appearance which asserts itself. In fact this regard for concrete reality is a typical aspect of Gris' work. In this portrait, Gris has abandoned all color in favor of a severely limited use of black and white. The black appears to be ivory black, and the white is lead white.

The step from Gris' decorative stylization of the Cubist aesthetic to the simplification of the postermaker and the illustrator is but a tiny one. The results of such stylization were to appear rampantly in the magazines of the

decade after that of this picture.

Gift of Leigh B. Block.

HENRI MATISSE (1869–1954)

Apples, 1916

Oil on canvas, 46 × 35 in (116.9 × 88.9 cm)

Acc. no. 1948.563

French

Matisse was the most important of the Fauve group of painters, to whom color was the most vital element in art. This still-life belongs to that phase of Matisse's work when he was creating a series of austere masterpieces and making fewer concessions than usual to prettiness. What Matisse has done in this picture is to concentrate his attention upon a dish of apples set upon the top of a circular Louis XVI table. That is all there is to the subject and in essence all there is to the picture. Technically he has adjusted the perspective until it is a kind of isometric projection, preserving the sense of space and spatial reality while at the same time forming a satisfactory two-dimensional design on the canvas. The fruit itself becomes a generalized symbol rather than actual apples at a specific time and place.

Gift of Mrs Wolfgang Schoenborn and Samuel A. Marx.

HENRI MATISSE (1869–1954)

Bathers by a River, 1916–17

Oil on canvas, 103 × 154 in (261.8 × 391.2 cm)

Acc. no. 1953.158

French

This monumental canvas belongs to Matisse's greatest period. It is austere and uncompromising in its composition and just as uncompromising in its color. What Matisse has done in this canvas is to simplify and alter his forms till they function almost as symbolic icons or ideograms. The figure on the verge of

diving, for instance, has been analyzed and rearranged to emphasize the lines of the clavicles, the column of the throat, and the ellipsoid character of the head. The same is true of the seated figure immediately to the left in which the simplification of the forms has reached an extreme, though vestigial traces of modeling in light and shade remain. The water of the pool or river has been reduced to a broad black band, just as the foliage of the river bank has been reduced to a green band with black lines to indicate the vegetation.

It is in paintings such as this that Matisse's rank as a great formal innovator

in the history of French painting is completely apparent.

Charles H. and Mary F.S. Worcester Collection.

LOVIS CORINTH (1858–1925) Self-Portrait, 1917 Oil on canvas, $18\frac{1}{8} \times 14\frac{5}{8}$ in (46.2 × 37.2 cm)

German

Acc. no. 1968.608

Lovis Cornith was one of the leading German Impressionists. An East Prussian, he studied at Königsberg Academy (1876–80) and the Académie Julian, Paris (1884–85). He subsequently worked mainly in Paris, Munich and Berlin and joined the Munich Secession. He was greatly influenced by the old masters, especially Velázquez, Rembrandt and Frans Hals. In 1911 he suffered a very severe stroke and was paralyzed on one side. But with great determination he continued to paint, his pictures becoming more Expressionist and often having a deep spiritual quality. He painted numerous self-portraits during his lifetime (only Rembrandt painted more) which provide a fascinating record of his development, both as an artist and as a man.

This Self-Portrait is characteristic of Corinth's late maturity. His style has broadened and the color has been reduced to dull, clay-like earth tones which are of great beauty and work together to create an effect of great richness. The expression of the face is one of determination and resignation. In its concentrated format it recalls the late works of Hals, as well as Carel Fabritius. The below eye-level point of view (achieved by placing the looking-glass at an angle) gives the beholder the impression of looking up at Corinth's image, with

the result that Corinth seems to set himself apart from his viewers.

L.L. Coburn Fund.

PABLO PICASSO (1881–1973) Mother and Child, 1921 Oil on canvas, $56\frac{1}{2} \times 64$ in (143.5 × 162.6 cm) Acc. no. 1954.270 Spanish

Whereas during the years just before the First World War Picasso invented the new formal expression of Cubism, thereby establishing a new visual idiom, the period just afterwards saw not only the surprise of Synthetic Cubism but also his own brand of Neo-classicism. This canvas is a monument of the latter style.

What Picasso has done is take one of the ostensibly stalest of pictorial idioms and express it in his own way. He has actually created a new style of monumentalism expressed by the simplest of pictorial means – simple, earth-colored, and broadly brushed drawing. How much this style was formed as a delayed reaction to Picasso's knowledge of Etruscan mirrors, Greek ceramics, or the Hellenistic sculpture he saw in Italy during the war is impossible to tell. He

has the most retentive eye of any painter of this century and every object he has seen may have nourished his repertory.

Originally there was, to the viewer's left, the seated, nude figure of a bearded father. Picasso cut part of the picture away and painted out the rest to achieve the monumental concentration upon the mother and the child. He later presented the cut-off piece to the Art Institute.

The picture was bought from the income of the Ada Turnbull Hertle Fund aided by generous contributions from the Mary and Leigh Block Charitable Fund, Inc., Mr and Mrs Edwin E. Hokin, Maymar Corporation, Mr and Mrs Chauncey McCormick, and Mrs Maurice L. Rothschild.

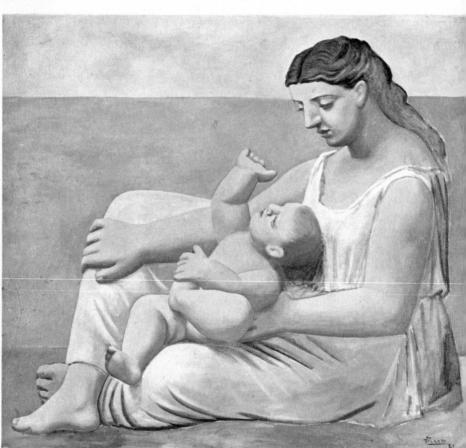

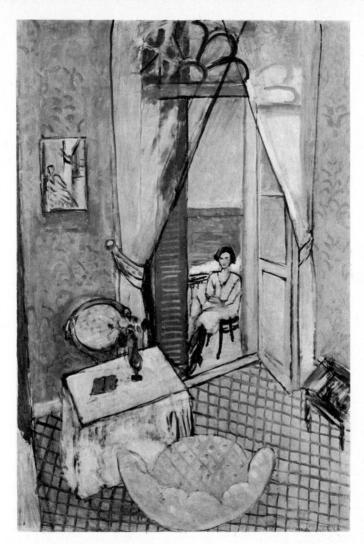

Henri Matisse (1869–1954) Interior at Nice, 1921 Oil on canvas, 52×35 in (132.2×88.9 cm) Acc. no. 1956.339

French

This painting belongs to the very end of the period of Matisse's great structural paintings, in which color is used for formal purposes as well as simply for itself. The emphasis here is still upon the space and planes rendered to achieve the maximum effect of breadth and spaciousness. The single parts are subordinated

to the whole. But there is in the picture a new component which was to dominate the bulk of Matisse's work in the 1920s, and that is the note of pure decoration. With this note has come a softening of the style of painting and a slight clouding of the color so that the viewer is conscious of the surface of the paint, where in the earlier works the effect was rather that of pure light.

Matisse is still aware of light in this painting, for the pattern of the sunlight on the muslin curtain is plainly indicated. He is also aware of the traditions of the Persian miniaturist and of the Japanese printmaker. The result is essentially a celebration of happiness – 'an art', as he wrote himself, 'of balance, purity and

serenity, devoid of troubling or depressing subject-matter'.

Gift of Mrs Gilbert W. Chapman.

PABLO PICASSO (1881–1973) Sylvette (Mlle D.), 1954 Oil on canvas, $51\frac{1}{2} \times 38\frac{1}{4}$ in (130.9 × 97.2 cm) Acc. no. 1955.821 Spanish

During the decade after the end of the Second World War, Picasso devoted himself to the painting of particularly intimate moments of domesticity (as here, with his model crouched upon the floor) and also to a systematic analysis of other artists' work. This statement must necessarily be qualified by recognition of the fact that everything the master has done has been a reflection of his primary absorption of the moment; in no sense has he ever been professionally involved in personal retrospection as such but has, rather, lived each day as a

new experience.

The pretty, golden haired model (a fact known from external evidence, although it may be safely deduced from this painting) is placed upon the floor with her left hand gracefully extended. She is wearing Algerian costume with a bodice and harem trousers. The colors are brilliant, decorative, yet completely descriptive. Picasso has examined his subject as searchingly as he did Kahnweiler forty four years before. But by the time he came to paint this picture the methods which were new discoveries to him in 1910 had become part of his normal repertory and even devices of pictorial rhetoric. For example, the young woman's profile is turned in and wrapped around onto the head. This is done simply and without overt emphasis. He has seen her feet and insteps as in a distorting glass, but records the distorted forms as if this is the way they were to be seen by all people. And so they now are.

The painting was given by Mr and Mrs Leigh B. Block.

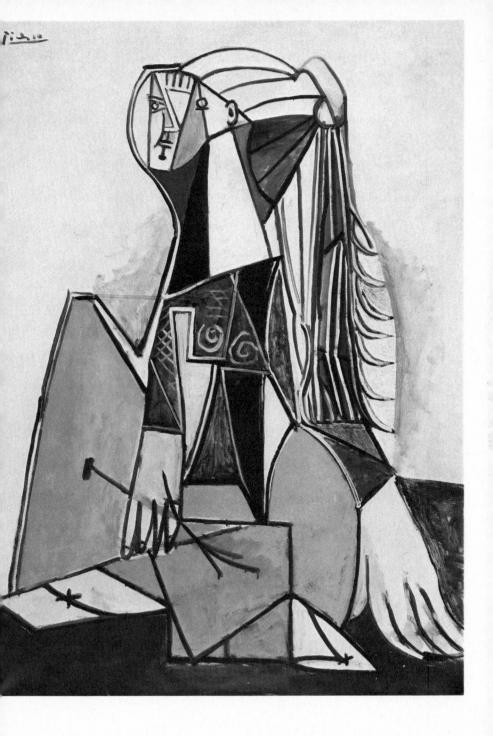

GRANT WOOD (1892–1942) American American Gothic, 1930
Oil on beaverboard, $29_8^7 \times 24_8^7$ in $(76.0 \times 63.3 \text{ cm})$ Acc. no. 1930.934

Grant Wood studied in Minneapolis and then at the Art Institute. In 1920, like many other young Americans, he went to Paris to pursue his studies and hopefully, in the phrase of the day, to find himself. Unfortunately, the self that Wood found was a watered-down Impressionist, and a thinned-out Fauve with nothing to say. But in 1928 he moved to Munich and here he discovered the German primitives, Albrecht Dürer and the fifteenth-century Flemings. The impact of this sharply focused art caused an about-face in Wood's thinking and in his work. He abandoned his earlier manner and set about evoking the methods of Holbein, Dürer, and van Eyck, but using them for his own satirical purposes. At least, this was the impression which his friends had at the time.

This portrait, supposedly of a farmer and his wife, actually represents the painter's sister and their local dentist. Wood has portrayed, in the rear of the painting, the façade of a Gothic house, and the forms of the window and the pitchfork are echoed in the seams of the overalls and elsewhere in the painting. It is the painter's best picture. Unfortunately, the attempt at satire backfired, for the painting has now become a folk-symbol of a long-dead (or imaginary) America. As such the painting has undeniable charm and an unintended

sweetness.

The picture was acquired for the Friends of American Art Collection.

PRINTS AND DRAWINGS

Anonymous Engraver (15th century)

Man of Sorrows, c. 1465–70

Hand-colored woodcut, $15\frac{3}{4} \times 10\frac{1}{2}$ in (40.0 × 26.7 cm)

Acc. no. 1947.731

German

This wood engraving with contemporary hand-coloring represents a rare type: the popular votive print done for domestic devotional use. The print is vigorous in its design and clear in its expression of the concept of the wounded Saving Victim. The strongly characterized design was to set a type of pictorial expression which was to influence German Expressionists four and a half centuries later.

The emphasis is on the image of the beaten and tormented Christ with all the marks of torture plainly visible upon him. The hyssop (according to St John, while Christ was on the cross, a sponge soaked in wine was held up to his lips on a stalk of hyssop; hyssop is also symbolical of purification) and the scourge are displayed on each arm of the cross with the nails used to nail Christ's hands. The spear is placed diagonally behind Christ. Although the picture is very stylized the face and posture of Christ are expressive and moving.

The print is not a luxury production and was probably reproduced on quite a large scale, although the hand-coloring would have added to its price. It is not designed as a work of art in the ordinary modern sense, but rather as a diagram to aid the devout in the contemplation of the sacred mysteries. It embodies the Thomist idea of the work of art as an object well made for a specific purpose.

The directness of expression, as well as the clarity of the design, makes this a most impressive document of late medieval popular devotion. That it is a work of art is incidental.

This print was acquired through the help of various donors.

Anonymous Printmaker (15th century) Man of Sorrows with Four Angels, c. 1470 Dotted metal cut print, $13 \times 9_8^7$ in $(33.0 \times 25.1 \text{ cm})$ Acc. no. 1956.3

It is interesting to compare this print with the preceding one. It is much more ornate with a more complicated iconography: in addition to the figure of Christ we see four angels holding the scourging pillar, the cross, the lance, and the nails. There is also a chalice into which the blood of Christ is flowing, the seamless robe for which the soldiers drew lots at the foot of the cross, and the open sarcophagus. The symbols of the four evangelists are shown in each corner of the decorative frame.

The figure of Christ is more sophisticated in its structure: the whole figure is articulated with a strong sense of anatomical function and presence. The contrast between the body and its loincloth is made more marked by the introduction of the highly foliated punched background, which is at once a conventionalized garden scene and an area of flat pattern.

The underlying effect of this print is the sense it gives of certain kinds of late medieval wood sculpture and engraved pattern. The designer has adjusted his pattern, through variations of texture and alterations between plain and fancy, to achieve the maximum effect of the Wounded Savior, the Saving Victim. While the print was designed for production in a relatively large edition, it is nevertheless a rarity and in its own terms a valuable object.

HANS BURGKMAIR (1473–1531) Maximilian I on Horseback, 1508 German

Woodcut printed in black ink and gold upon vellum, $12\frac{1}{2} \times 9$ in $(31.8 \times 22.8 \text{ cm})$

Acc. no. 1961.3

If the preceding two prints represent what was essentially German popular art, this is one of imperial splendor. Printed in black and gold size upon vellum, it is not only the portrait of an imperial patron, but done in appropriate terms.

The image of the Holy Roman Emperor is a figure in splendid court armor with a crest of peacock feathers emerging from the crown; he is mounted upon a richly caparisoned horse. An imperial banner is flung upon a gonfalon behind the Emperor and suspended from the spring of the Renaissance archway. The Emperor is seen as an unearthly figure far above mortal consideration. The splendor of the figure is equalled by the resplendence of the setting, which represents a grand marble pavement as well as architecture ornamented with beautifully Italianate arabesques.

The only infelicity of the whole print is that Burgkmair had some difficulty with the representation of the horse in action. The movement is not only tentative but downright unconvincing. This is curious in the light of everything

else which the artist got quite correctly.

PIETER BRUEGHEL THE ELDER (c. 1525–1569) The Hare Hunters, 1566 Etching, $8\frac{5}{8} \times 11\frac{1}{2}$ in (22.0 × 29.2 cm) Acc. no. 1966.183

Brueghel was the greatest of Flemish Renaissance artists, and this is the only print executed by his own hand. He here follows the kind of pictorial structure which he invented for his paintings, one which spreads before the beholders a great landscape, in which the space recedes in a seemingly endless progression.

In this plate the viewer sees first a copse at his right with a tall tree trunk and a lower one to the left of it. Around these trunks the hunters are deployed, and the principal figure is in the act of aiming a crossbow at a hare in the middle distance. Beyond the hare the land drops away into the second plane of the picture, and beyond that plane of the picture more recede in continuing diagonal progression, until the horizon with a town set upon it is finally to be seen. At the right a hill rises with a crenelated castle crowning its height.

The plate is executed with clear strokes of the burin or needle, and the tonality lightens progressively into the distance. The foreground is done with

the sharpest and most intense contrast of light and dark.

This landscape print is not only a clear indication of how a northern Renaissance man felt about nature, it is also a record of life in the Low Countries at that period.

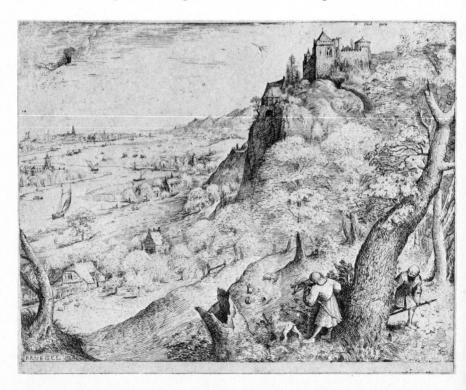

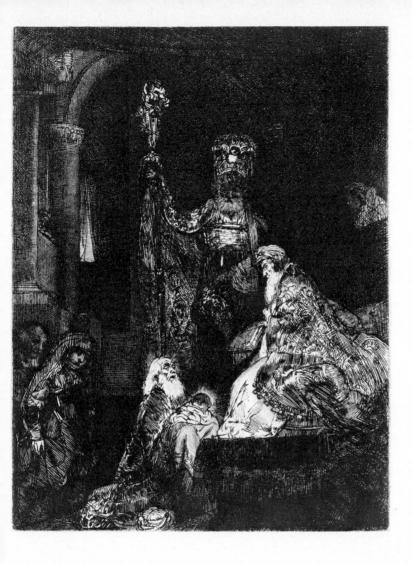

REMBRANDT VAN RIJN (1606–1669) The Presentation in the Temple, late 1650s? Etching and drypoint, $7\frac{1}{2} \times 6\frac{3}{8}$ in (19.1 × 16.2 cm) Acc. no. 1950.1508

Dutch

This plate illustrates that part of the gospel which describes the presentation by the Virgin and St Joseph of the Infant Jesus to St Simeon. Rembrandt has chosen the moment of greatest dramatic meaning in the episode, the point at

which St Simeon begins to recite the noble words of the *Nunc dimittis*, 'Lord, now lettest thou thy servant depart in peace, according to thy word.'

The figures are basically shrouded in darkness. It is only with difficulty that it may be seen that the Virgin is wearing a costume quoted from Dürer; both she and St Joseph are in half-light at the left near foreground. Behind them recede the forms of an apparently Romanesque interior. Above the altar in the right middle distance is an enthroned figure behind whom looms, in the shadows, a gigantic figure holding a plumed staff and wearing an enormous Oriental headdress. The full light falls upon the quietly noble face of St Simeon who is conceived of as an aged man. He is kneeling before the altar. The face of the Christ-child is cast into shadow, although the infant's head has an aureole around it.

What Rembrandt has done is to illuminate the human meaning of the narrative in a way which is curiously and insistently Protestant. The moment chosen is the infinitely personal one which has moved St Simeon, and the spectator at the event is drawn inexorably into the personal drama in the life of the aged saint: he has finally seen and received what he had so long hoped for and expected.

Clarence Buckingham Collection.

Adriaen van Ostade (1610–1685) The Family, 1647 Etching, $6\frac{7}{8} \times 6\frac{1}{16}$ in (17.5 × 15.4 cm) Acc. no. 1962.803 Dutch

Though Ostade, a man of Haarlem, was Hals's pupil, the principal formative influence upon his style and technique came from Rembrandt.

This interior records a scene from popular life, although the viewer may well wonder if a farmer's house in the late 1640s had a ground floor with quite such a high ceiling. What Ostade has done in this print is to reduce quite considerably the size of his human beings in order to give greater scale and seeming size both to the scene and to the print itself. The figures themselves are of the greatest interest. Ostade has given his mother and infant the pose, if not precisely the faces, of a Virgin and Child, while the father and the little boy seem quotations from a scene of the childhood of Christ. The only purely genre bit seems to be that of the dog and the old person bending over it. Ostade has put together his family scene so that the viewer sees it not precisely as it was but, rather, reorganized and adjusted for the sake of pictorial grandeur with quotations thrown in from sacred legend.

The print is part of the Stanley Field Collection.

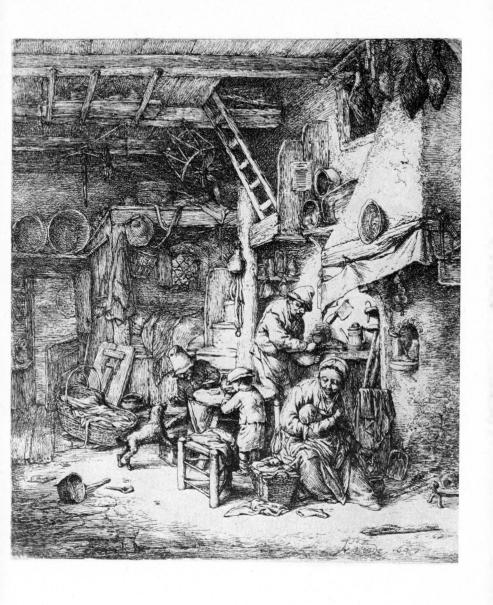

HENRI DE TOULOUSE-LAUTREC (1864–1901) Elsa, The Viennese, 1897 Colored lithograph, $22\frac{7}{8} \times 15\frac{3}{4}$ in $(58.2 \times 40.1 \text{ cm})$ Acc. no. 1958.529

By the time Toulouse-Lautrec did this lithograph of the balding and pasty-faced woman from Vienna, he had become the absolute master of the medium of lithography. His borrowings of Japanese techniques of composition had become second nature to him, and his use of color and line was completely his

own, perfectly adapted to any purpose he elected.

The impression Toulouse-Lautrec gives of his Austrian subject is one of perverse prettiness. The woman's rather Slavic bone structure does not lend itself to an expression of the obviously pretty or beguiling, and her face, by the time the artist rendered it, had become mask-like, so that he could concentrate upon an appearance which is lightly trivial and oddly chic. The impression of fashionable disreputability is hard to achieve, but Toulouse-Lautrec has done it here, and the effect is rather devastating. One does not quite know where the woman was going, whence she came, or who she was. Toulouse-Lautrec convinces the beholder that perhaps it were better not to inquire. And yet it is not at all an unsympathetic likeness.

The lithograph was bought for the Carter H. Harrison Memorial

Collection.

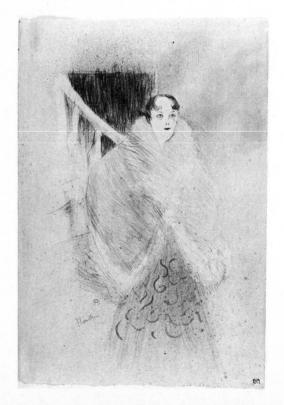

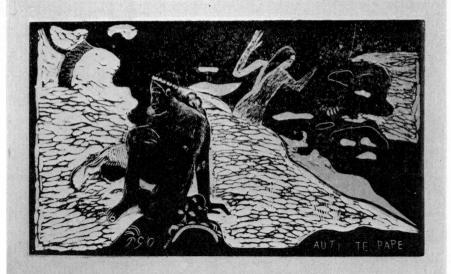

PAUL GAUGUIN (1848–1903)
Women at the River (Auti te Pape), 1893–95
Colored woodcut, 8×14 in (20.3 \times 35.7 cm)
Acc. no. 1948.264

French

As a maker of woodcuts Gauguin ranks with Dürer and the great German masters of the Renaissance. In some ways these woodcuts are among his finest productions, and in this curiously intractable medium he seems to have found the technical discipline which forced him to simplify and to establish the most subtly organized designs and patterns. The step from the remarkable patterns of this colored print to the qualities and methods of purely abstract art is only a short one. True, Gauguin has retained the human content, but he has reduced it to the role of pattern in a visual arrangement.

Gauguin's command of the wood engraver's knife was remarkable, for he managed to achieve extraordinary delicacy of touch and arrangement. He also realized what to leave of the wooden block itself to aid him in his patterning and what to remove to allow for the virtues of simple emptiness. He forces the beholder to realize how much can be accomplished not only with minimal means but with the simplest use of such minimal means. Perhaps his finest achievement in this block is the incredible integration of his light and dark patterns and the subsequent adjustment of his patterns of color to the black and the white. (This last is reduced to a rippling ribbon cutting diagonally across the picture.)

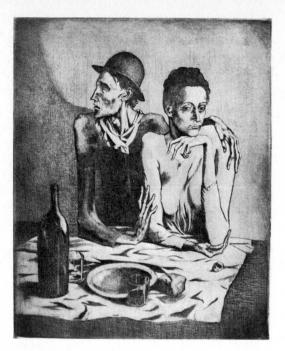

PABLO PICASSO (1881–1973)
The Frugal Repast, 1904
Etching printed in blue, $18_8^1 \times 15$ in $(46.2 \times 38.2 \text{ cm})$ Acc. no. 1963.825

Spanish

This is the most famous print Picasso made during his blue period, and this impression is a *unicum*, printed in blue. The curious morphological structure, with its borrowings from both El Greco and the Pre-Raphaelites, has been noted before in considerations of his work from this period. The iconography is still the curious one Picasso used at the time with its recurrent image of the scrawny blind man. The woman, who resembles an emaciated Fernande Olivier, epitomizes his notion of feminine beauty at the time.

The print is rather too famous to evoke an innocent or fresh reaction, and too much has happened in the world since it was done for us to see it with the startled but innocent eyes of 1904. Picasso's personal memories of being young, unsuccessful, and still unrecognized seem somewhat irrelevant in the light not only of his subsequent history, but of all history since then. What is left for the beholder is a personally inventive statement about the world of a young and unknown person. The invention lies in the private mythology but even more in the concept of emaciated beauty. Printed in blue, the note becomes persuasively tender in spite of the inherent silliness of the notion.

GASTON DUCHAMP-VILLON called JACQUES VILLON (1875–1963) French The Set Table, 1913

Drypoint etching, $11\frac{1}{4} \times 15$ in $(28.6 \times 38.2 \text{ cm})$

Acc. no. 1964.238

Villon, whose real name was Gaston Duchamp-Villon, was the half-brother of Marcel Duchamp, lived in Paris until he was over sixty, when he moved to the south of France. He was first an engraver and illustrator for journals, but he turned to painting in 1911. This print of a table set for a meal represents his early style as a printmaker after he had become a painter. He has developed his own version of the Cubist style, and to this version he remained faithful for the rest of his long career. The style did indeed change, but it changed very slowly, and his vision was always expressed in terms of faceted planes seen in lozenge-shaped patches of light or color.

The use Villon made of his technique is a remarkable one, because his etching technique is peculiarly and particularly that of a man who thought with a burin and an etcher's needle in his hand. His work as a commercial illustrator and for newspapers had established firmly in his mind the importance of reproductive media and their status in terms of art. From a formal point of view, however, he could express the same idea as an ink drawing, or indeed, using a different subject altogether – mountains and valleys instead of goblets,

jugs, and crumpled napkins.

Gift of Frank B. Hubachek.

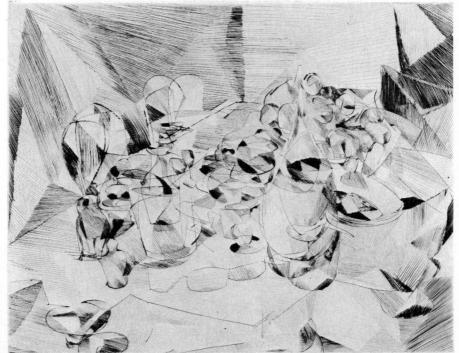

In this study of a German Swiss peasant in his village, Kirchner has consciously quoted from late medieval German engravings, such as illustrated on pages 127 and 128. The sharply angular forms of the head and the landscape beyond, with its cow and figures adjacent to wooden houses, are consciously conceived in the light of late medieval craft. But Kirchner emphasizes the nature of the wooden block on which he is engraving, whereas the man of the late Middle Ages took it serenely for granted; the latter was trying only to express a completely compelling sense of reality. The modern artist, on the other hand, was not only being self-consciously archaic, he was equally self-consciously stressing the fact of his craft. He was trying to remind the observer just how difficult and demanding the craft can be, and he wanted the beholder to be quite clear as to how well he, Kirchner, the printmaker, had mastered it. In no way was he content to pay the viewer the compliment of recognizing his intelligence and assuming that he would recognize Kirchner's skill.

The result is that half a century later the viewer of the print sees the piece as a competent working of the wood engraver's technique, a pleasantly archaicizing performance of a sort which looks well in a doctor's waiting room, or even on the walls of a psychoanalyst's consulting room. Unfortunately, the print is not one of universal appeal or staying power, and the world to which it

belongs seems even more remote than Burgkmair's.

This print was given by the Print and Drawing Club.

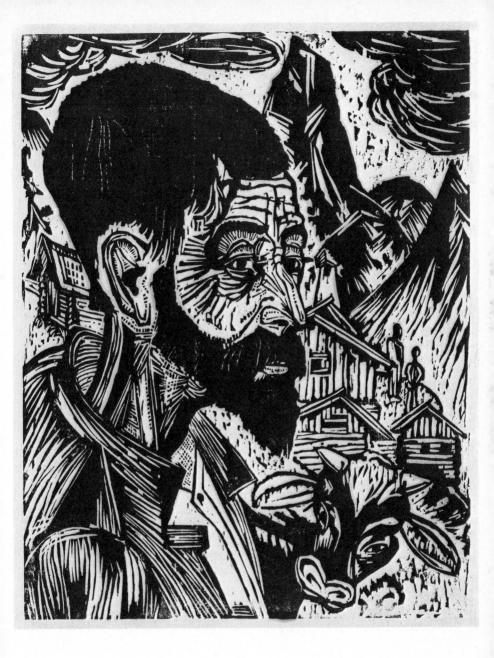

PISANELLO (1395–1455/56) Studies of the Eastern Patriarch, 1438 Pen and brown ink on paper, $7\frac{1}{2} \times 10\frac{1}{4}$ in (19.1 × 26.0 cm) Acc. no. 1961.331

Pisanello was the greatest Italian figure of the International style and one of the earliest of Renaissance artists. He is a typical case of an artist who can simultaneously be considered both late medieval and Early Renaissance in his character and production. He is late medieval in his preoccupation with local truths and details; he is Renaissance in his humanistic preoccupation.

This drawing can be safely dated to 1438, the year of a patriarchal visit to an abortive council, the political hope of which was to save Constantinople from the Moslem forces. Nothing of political or religious importance was accomplished at the council, but it did mean a fresh wave of Eastern influence in Italy and further contact with the traditions of late antiquity. Pisanello had a perfect opportunity to record what he saw and to prove himself journalistically competent, for this drawing (as well as a number of others done at the time) shows how clear his vision was and how capable he was of recording visual facts.

The obverse of the drawing records details of the patriarch's costume and of a scabbard, as well as the appearance of an Oriental horseman. The reverse shows details of the horse's paraphernalia. The manner of portrayal is such that it could have been done yesterday; only the costumes and the trappings of the horse show that it was in fact done in the fifteenth century.

Gift of Tiffany and Margaret Blake.

Anonymous North Italian Artist (15th century (?))

Profile Portrait of a Man, c. 1450 (?)

Silverpoint on prepared surface, $9\frac{3}{4} \times 6\frac{7}{8}$ in $(24.8 \times 17.5 \text{ cm})$

Italian

Acc. no. 1957.59

This drawing, which was once considered to be by a Flemish artist, is now usually recognized as being north Italian in origin, perhaps by an artist of Verona. The drawing epitomizes the style of rendering, particularly of portraits, during the second quarter of the fifteenth century in northern Italy.

The method is precise and completely linear. The medium of silverpoint – which consists of marking with a silver-pointed pencil (sometimes gold or lead) onto a surface coated with glue size and chalk (pale pink here) – is difficult in that it requires absolute precision and permits of no erasures. Shading can only be accomplished through a hatching technique, and no really dark

areas are possible.

The drawing shows a priest wearing a sleeveless rochet over a gown; part of the undergarment is just visible at the throat. The hand is tentatively indicated and appears to hold what is the beginning of a blossom or a flowering staff. The face is finely drawn and very expressive. It is not clear whether the drawing was done as a portrait or whether it was the beginning of a study for a supporting figure for an altarpiece. Although independent portraits had begun to be popular around this time, it was still common for rich donors to be depicted among other personages present at a sacred event.

Gift of Tiffany and Margaret Blake.

VITTORE CARPACCIO (c. 1450–c. 1522) A Young Nobleman Brushed grey ink heightened with white, $10 \times 7\frac{5}{8}$ in $(25.5 \times 19.4$ cm) Acc. no. 1962.577

Carpaccio was the preeminent narrative painter in Venice at the turn of the sixteenth century. He related legendary incidents against the background of an idealized version of the Venice and Venetian countryside he knew; the miraculous events he depicts have such impact, even today, because they are set in such a realistic setting and are related in a matter-of-fact way as though

Italian

they had taken place before the artist's very eyes.

From Late Byzantine times on, Venetian painting made its effect through color, mass, and area, rather than through linearity. This had its effect on Venetian drawings which never emphasized lines, but, rather, areas, masses and, by implication, fields of color. This study of a young man in the act of greeting someone is a case in point; on examination it will be noticed that what count for lines in the drawing are, essentially, areas seen in acute perspective. What has been emphasized is the effect of light and shade: the artist has applied white on his neutral blue background to achieve the effect of bright light (even of dappled sunlight), and broad lines of dark to achieve the illusion of shadow. The effect of the broadly brushed grey and white upon the blue gives the illusion of color.

The drawing was given from a gift from the Joseph and Helen Regenstein

Foundation.

Fra Bartolommeo (1475–1517)

Landscape: Hermitage upon a Hill Pen and ink on paper, $11\frac{7}{16} \times 8\frac{1}{2}$ in $(29.0 \times 21.7 \text{ cm})$

Acc. no. 1957.530

Fra Bartolommeo was the greatest artist in Florence purely of the High Renaissance style. Indeed, his art epitomizes the style. There was considerable excitement some years ago when a notebook of landscape drawings by him was discovered. This drawing is a fine one from that set.

What the artist has done in this drawing is to record the appearance of a bit of a Tuscan hillside with trees and rocks and a small part of a building. The trees are delineated with the clearest emphasis upon their structure, and, in the case of the palm trees to the viewer's right, with considerable care in rendering

the effect of foliage.

More interesting even than the effects of the natural terrain and its foliage is the Fra's study of the hermitage. What one sees is a simple, even rather crude, building partly of rubble masonry and partly of stucco. The tile roof is carefully rendered and the artist consciously shows the bits of timbering. One also can see the arched window in the principal gable with its colonette, as well as the bell in the belfry and two extruded crosses against the sky.

Fra Bartolommeo may have done this group of drawings for his own pleasure and profit, but they are hardly to be considered – at least in the artist's terms – as completed works of art, no matter what the modern connoisseur sees in them. They are means to an end, and it is from a drawing such as this one that Fra Bartolommeo constructed the ravishingly lovely backgrounds for his pictures of sacred subjects. One can understand through this drawing how he became one of the greatest of landscapists before his time.

The drawing was acquired for the Clarence Buckingham Collection.

REMBRANDT VAN RIJN (1606–1669) Noah's Ark Reed pen and wash, $7\frac{7}{8} \times 9\frac{1}{2}$ in (20.0 \times 24.2 cm) Acc. no. 1953.36

Dutch

Rembrandt's most intimate expression is to be found in his drawings, for it is in them that the spectator is allowed some insight into his working methods. His principal aim seems to have been to find the simplest and most direct way of conveying a particular subject, scene or event. Because of this insistence upon a clear statement, Rembrandt still remains a consummate illustrator, the perfect artist for those who see a kind of social realism as the artist's ultimate goal.

But he was much more than just a narrative artist. What makes him so awe inspiring is his command of his formal means, the skill with which he deploys his areas and lines, his darks and lights, and, finally, his color (which sometimes exists only by implication). This drawing demonstrates most clearly Rembrandt's virtues as a composer of a scene. In the far background a huge barge is visible, upon which is a large shed. Isolated at the gangplank and indicated only with the broadest of pen-scratches stands the patriarch. His sons are standing at the foot of the gangplank carrying up provisions and encouraging some animals to board the ark. Two of Noah's friends stand at the lower left to comment on the action and to serve as *repoussoirs* to increase the solidity of the composition.

The drawing was acquired for the Clarence Buckingham Collection.

Antoine Watteau (1684–1721) Studies of Figures from the Italian Comedy Red, black, and white chalk, $10_4^1 \times 15_8^5$ in (26.0 × 39.8 cm) Acc. no. 1954.1

Watteau represents that vein of early eighteenth-century French painting which was strongly under Flemish influence, and for which the influence of Rubens was paramount. It must be recalled that Flemish and Dutch painting of the seventeenth century had enormous prestige among French collectors of the eighteenth century, and artists very early copied the works of these schools.

Watteau also made his own the characters from Italian comedy; here the black-masked Scaramouche is visible to the spectator's left, a perfectly realized face which is clearly recognizable even under the three-quarters' black mask. There is a kneeling *Mezzetin*, as well as a caped figure and a profile head of a

man in a cap.

By the time Watteau did this page, drawings were in enormous demand from collectors, and these were being matted and framed to be hung upon the wall. (The ones which were not hung upon the wall have survived in an incredible state of unfaded freshness, as this one has.) What Watteau has done technically is to emphasize the effect of light as it plays upon the shimmering surface of white satin. The use of the three colors of chalk on the beige paper gives a close approximation of the colors of painting and its tones. The step from these figures to their painted versions is a slight one, and in one sense this drawing represents painting with chalk, only a moment before the use of full color in pastels.

The drawing was given by Tiffany and Margaret Blake.

Antoine Watteau (1684-1721)
The Old Savoyard

French

Red and black chalk, $14\frac{1}{4} \times 8\frac{7}{8}$ in $(36.3 \times 22.5$ cm) Acc. no. 1964.74

This remarkable touching likeness of an old man in ragged clothes is a haunting example of Watteau's ability to get to the heart of his subject/matter, to see it uncompromisingly, but with sympathy. Here he evokes — even quoting indirectly—some of the nobler drawings of Rubens himself. Technically he has done a most difficult thing, which is to present his subject frontally. This straight-on presentation is apt to reduce the subject to the equivalent of high-relief sculpture. (Watteau was fond of this frontal view: one of his most famous paintings, Gilles, embodies it, and there are many other examples.) But within this frontal presentation Watteau has composed a wonderfully rich set of variations upon the shapes of the solids of the body as seen beneath the clothing. He has also managed to present the heavy, coarse character of this clothing with amazing precision, still being limited to his two colors of chalk. Everything is stated in terms of light and dark, or, more accurately, in terms of bright sunlight and patches of intense shadow.

Gift of the Joseph and Helen Regenstein Foundation.

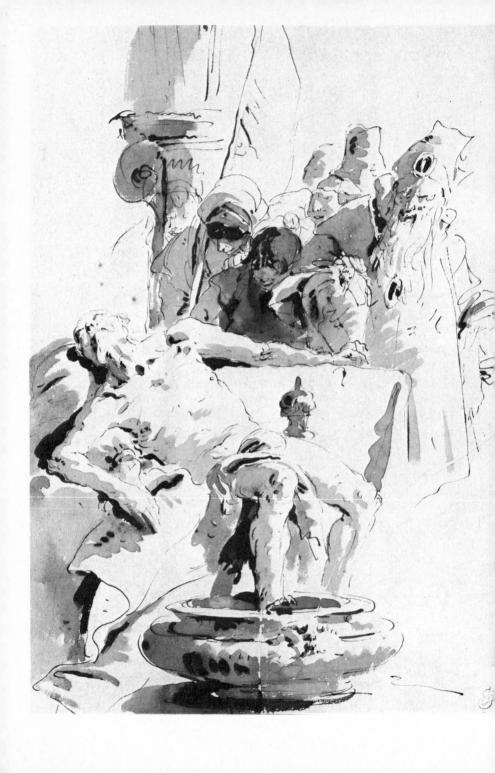

GIOVANNI BATTISTA TIEPOLO (1696–1770) The Death of Seneca Pen, brush, and sepia wash, $13\frac{1}{2} \times 9\frac{1}{2}$ in (34.4×24.2) Acc. no. 1959.36

This brilliant drawing of the pathetic episode of the death of Nero's master, Seneca, translates the horror of the incident into an abstracted pattern of light and dark with the effect of the brightest light contrasted with patches of darkest shadow. Tiepolo's antiquity is his own, with strong quotations from the Venice he knew as well as from the Italian comedy. There is almost no archaeological quotation as had become familiar contemporaneously in Rome. Tiepolo has presented a fragment of an episode insofar as its location is con-

cerned, for, in fact, the action is set nowhere.

The importance of the drawing lies in the brilliance of its line work, its light and patterns of shade, and in its ultimately humanistic emphasis. The very horror of the subject is only suggested by the implied expression on Seneca's face, but there is no attempt to be explicit. Rather, Tiepolo makes his viewer contemplate the forms of the participants and, thus, by extension, the implications of the action. Indeed, the whole scene is so impersonal that it might just as well represent the end of some Christian martyr. Tiepolo managed to suggest color in his rendering of light and dark. There is, of course, no color, but his use of his limited tonalities, with the suggestion of brilliant light and equally dazzling shade, carries with it an implication of color. The structure of the elements of the drawing embody the very end of the Baroque style as it survived in Rococo Venice.

The drawing is part of the Joseph and Helen Regenstein Foundation.

Antonio Canal called Canaletto (1697–1768)

Italian

Ruins of a Courtyard

Pen, brown ink, and grey wash over graphite, $11\frac{1}{2} \times 8\frac{1}{8}$ in $(29.2 \times 20.6 \text{ cm})$ Acc. no. 1943.514

By the time of Canaletto's maturity there was an immense market not only for his pictures and prints but also for his drawings. This market included a continuing demand for *capriccio* subjects, that is, landscapes which were variations upon real places with imaginary scenes, such as this one, but which, because they are constructed with apparently logical means, are entirely convincing even though the subjects have never existed as they are rendered. In this case, Canaletto has presented the ruins of a noble courtyard with which various tenements have been devised, and life seems to continue within these tenements. At the far distance in the rear may be seen a Venetian Gothic arch, the bottom

of which is silted up, and in the farthest distance is a walled city (similar to Castelfranco) with familiar Venetian towers and domes beyond the battlements.

Canaletto (like his nephew and namesake, Bellotto) was among the first of Venetian artists to make imaginative use of the *camera oscura*; from this technical device he perfected his workings of perspective, although frequently his perspective seems to have been empirically achieved. In this instance, one feels that the perspective is based upon Canaletto's vast knowledge of natural appearances. What is especially appealing in this drawing is his use of bits of foliage which appear, even as in Italy, on unexpected bits of the stonework. If the logic of these ruins is tenuous in fact, Canaletto's logic about their recorded use is convincing if only because of the reality of the action within the scene.

The drawing was bought from the income of the Samuel Putnam Avery Fund.

GIOVANNI DOMENICO TIEPOLO (1727–1804)

Christ in the House of Jairus

Pen and ink with grey and brown wash, $18\frac{7}{8} \times 15$ in (48.0 × 38.2 cm)

Acc. no. 1960.547

The younger Tiepolo is sometimes exceedingly close in style to his father, but as his career continued after his father's death he became more and more Neoclassical. His technique continued very much as it always was, but the forms and the spatial structures reflected the new aesthetic.

This drawing of Christ in the House of Jairus is typical of the younger Tiepolo's later style, when he was drawing away from his father's structural methods. The scene of the action is a large and essentially traditional Venetian room whose walls are covered with a familiar Venetian sixteenth-century pattern of meandering pomegranates. Set against the wall is a decked-out table which has obviously been used for a meal. There is a tiled floor with a

wooden stool set upon it in the mid-foreground. All of this is distinctly and traditionally Venetian and precedents could be found in the sixteenth century. There are two things in the drawing which could only belong to the eighteenth century. One of these is the hanging lamp which is strongly Neo-classical in its form. The other is the disposition of the figures, which are set as a frieze across the diagonal to the left rear of the scene with the figure of Christ set parallel to the frieze in front of it. The gestures are quoted from antique sculpture as well as, rather surprisingly, from certain earlier pictures. Quotation from antiquity was an old custom in Venice: Tintoretto did it at the very start of his career. But the young Tiepolo has done it in terms of the new wave of antique interest which was sweeping Italy. What is surprising is that the concept works and that the result is Neo-classical in spite of Tiepolo's old-fashioned technique.

The drawing is part of the Tiffany and Margaret Blake Collection.

Francisco Goya y Lucientes (1746–1828) Spanish Beware of that Step!, c. 1805 Brush in grey and black wash on white paper, $10\frac{3}{8} \times 7\frac{3}{16}$ in (26.4×18.2 cm) Acc. no. 1958.542

As a draftsman in both his prints and his drawings, Goya is uncannily appealing for his technical bravura and for his incredible understanding of the possibilities of his media. (This understanding did not always extend to his use of oil, which could occasionally be wilful in terms of what he was attempting.) When Goya set about to do a proverb or a cautionary episode in terms of drawing, he was unsurpassable. Furthermore, the drawing in his paintings was sometimes, to say the very least, peculiar in the light of his subjects. When he was working in black and white, the very discipline of the lack of color seems to have made him completely assured and capable of rendering the subtlest of movements and actions to account for both his subject and his purpose.

Here one can see a figure in the act of a slightly ridiculous dance step, about which the artist himself has added the words of caution, Cuydado con ese paso, which can have an application broader than the immediate context. What is breath-taking about the drawing is the clear way in which Goya has described not only the figure (she is a very heavy girl) but also the slightly heavy grace of her action, a corsetted Isadora a century before her time. Goya has rendered the stuff of the overblouse in simple, puddled washes with only a scribble of black on top of it to indicate the form of the lace trimming. The touch is an incredibly light one, yet the artist has conveyed the whole fact of his heavy dancing girl and her efforts on her feet.

The drawing is part of the Joseph and Helen Regenstein Foundation.

Crydado un ese porto

Honoré Daumier (1808-1879)

The Three Judges

Pen and ink over pencil and watercolor, $11\frac{3}{4} \times 18\frac{3}{8}$ in $(29.8 \times 46.8 \text{ cm})$

Acc. no. 1968.160

Daumier was the greatest of all political cartoonists and ranks with Goya as the supreme master of social comment in the visual arts. Daumier's style is a personal one which reflects eighteenth-century precedent and on occasion even evokes Fragonard's touch. What Daumier did in his cartoons was to emphasize the intellectual concept and the political point he was making. His method was the very old one of caricature, which is to exaggerate the particular and to minimize the merely typical. The result is always a clear image of what Daumier meant his public to see.

In this watercolor Daumier has presented his three judges with a rather diminished emphasis on satirical effect, with the result that the finished work is the more devastating in its impact. The contrast between the ceremonial robes of office and what they imply, and the very human men who are wearing them, is most gently stated. Daumier has neatly underscored, through simple linear emphasis, the effect and appearance of the three faces. It is quite true that faces as such tell rather little in fact, but the material evidence of how a man has lived can in itself be a devastating commentary on the man's view of life. In his rendering of the three carefully differentiated faces, Daumier has told his viewer a set of sardonic facts.

The watercolor was bought from a gift of the Joseph and Helen Regenstein Foundation.

HONORÉ DAUMIER (1808–1879) Fatherly Discipline Pen and ink wash over pencil, $10 \times 7\frac{7}{8}$ in $(25.5 \times 20.0 \text{ cm})$ Acc. no. 1955.1108

French

Daumier's many years as a working cartoonist-journalist always stood him well when he turned his attention to representing domestic episodes. Here he takes a homely scene and handles it in a fashion worthy of Rembrandt, albeit with a far lighter touch than the Dutch master would have had. What he records without flinching is a scruffy-looking couple awakened by a screaming infant, and the father's attempt to quiet the child. The figure of the mother aroused from sleep is barely indicated, particularly in the rough pencil drawing which lies beneath the finished surface of the ink drawing. The father is characterized through his gesture and his scrawny physique. The anger of the kicking and howling child is clearly and devastatingly presented. The effect of the candle upon the chest is to illuminate the scene, although in actual fact the illumination would have been in a much heavier chiaroscuro.

Daumier has indicated his action as well as the furniture with the simplest lines. Upon this lightly indicated framework for his action, he then laid in his washes with enough variation of surfaces to give richness and the feeling of space. Upon these two surfaces he then drew lightly and scratchingly with his pen to achieve the full effect of the narrative he was illustrating. The thing which keeps this drawing from being merely humorous illustration or cheap, socially realistic commentary is the brilliance of the composition as well as of the two and three-dimensional pattern. In addition, Daumier has rendered his tale in a completely personal way; one which is instantly recognizable as his. He has transformed a local truth into a universal one.

The drawing was bought from the income of the Arthur Heun Fund.

J. A. D. INGRES (1780–1867) Charles Gounod, 1841 Pencil on paper, $11\frac{13}{16} \times 9\frac{1}{16}$ in (30.0 \times 23.0 cm) Acc. no. 1964.77 French

Ingres, that most intractable, humorless, and greatest of academic artists, was one of the greatest of all portraitists. And of his portraits, those in pencil on paper rank as his finest. He earned a living in Italy doing these portraits, and his repertory of English visitors as well as of French swells on a belated grand tour is impressive. But Ingres was at his best and most persuasive, when he was rendering a friend.

The young Gounod, as a pensionnaire of the French Academy in Rome, is seen seated at an old-fashioned grand piano – it still has a knee pedal – in the act of playing something from Mozart's Don Giovanni; while playing he turns to look at Ingres and, so, at the spectator. Ingres's pencil has softened from its earlier usage, and there is a melting softness over the whole drawing. Rightly, he has emphasized the face (as he also does in the face of Mme Gounod which he drew as pendant some years later). But he has written the title of the score too large on the open page of the music book, as though to emphasize a common passion of his and his sitter's. (One is reminded in this of the occasion when the child Mendelssohn told the aged Goethe that he would play for him the most beautiful music ever written and then played the Minuet from Don Giovanni; and it is known that Mozart enjoyed a great reputation among the Romantics.)

Ingres has here made a memorable image of Gounod. His reaction to the potential distinction of the young musician was the one current at the time; Princess Mathilde and her friends reacted in the same way, and never seemed to notice that Gounod failed to live up to his early promise.

The drawing and its companion were given by Charles Deering McCormick, Brooks McCormick, and Roger McCormick.

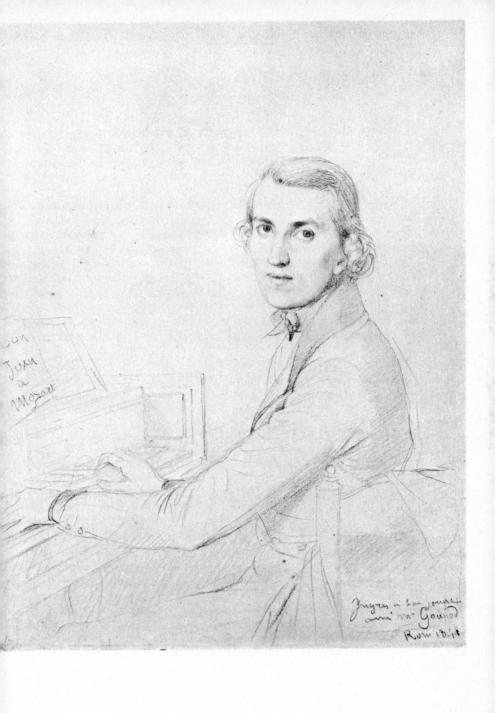

ÉDOUARD MANET (1832–1883)

Portrait of Berthe Morisot, 1874

Watercolor on paper, $8 \times 6\frac{1}{2}$ in (20.3 × 16.5 cm)

Acc. no. 1963.812

French

By the time Manet painted this watercolor study of his talented painter-sister-in-law, he had reached not only an absolute mastery of the medium of oil painting but had also mastered the far more difficult medium of watercolor. Watercolor is intractable because, while it is easy enough to achieve a cheap and flashy effect to this medium, it is not easy to use it for a simple and direct statement of form in space, which is neither unacceptably summary nor yet ill-achieved in its end result.

Manet here has managed a complete control of the application of colored washes, whether – as with the undertones in pink – they are liquid and puddled, or – as with the blacks – they are essentially in dry-brush layings-in. And here, in this medium, Manet's extremely personal style of draftmanship which is occasionally both mannered and arbitrary in black and white, works perfectly simply because it is expressed in terms of color. The very thing which makes this piece Manet's and nineteenth century in idiom and formal concept, as opposed to Fragonard and eighteenth century, is just this use of color in the drawing itself.

The watercolor was acquired through a gift of the Joseph and Helen Regenstein Foundation.

PIERRE AUGUSTE RENOIR (1841–1919) Nude (study for The Great Bathers), 1884–85 Pastel and wash, 39×25 in $(99.2 \times 63.6$ cm) Acc. no. 1949.514

French

By his middle forties Renoir was successful enough to be able to afford to work on projects for his own delectation in addition to his commissioned portraits. One of the greatest of these was *The Great Bathers* (*Les grandes baigneuses*) now in the Tyson Collection of the Philadelphia Museum of Art. It was a work into

which the painter concentrated his entire knowledge and feelings and in which he seemed to be trying to re-create not only Boucher but also Titian.

The difficulty with Renoir as a painter is that, though his paint surfaces are of incredible loveliness even in his worst works – he had not been a china painter at Limoges for nothing – his drawing, not to mention his taste, frequently leaves much to be desired. In this drawing his draftsmanship is not only adequate, tough, it is brilliant, and his taste is unexceptionable. The image Renoir is evoking, that of a young woman in a pool in the act of splashing a friend, is trivial, both in the final finished work and in the reworking of the theme he did many years later. That it seems so is only because Renoir was not the man to turn his washerwomen into Demeters and his bathing girls into images from Olympus; they stubbornly remain *Limogeoises*. In this great drawing – great both in size and in execution – the image is one of a girl's body which will remain forever as Renoir saw it: young, hardy, and infinitely graceful.

Bequest of Kate L. Brewster.

GEORGES SEURAT (1859–1891) Trees on the Bank of The Seine, c. 1884/85 Conté crayon, $24\frac{3}{8} \times 18\frac{1}{2}$ in (62.0 × 47.1 cm) Acc. no. 1955.184

French

This large drawing is a study for Seurat's masterpiece, Sunday afternoon on the island of La Grande-Jatte, also in the Art Institute (see p. 92). The picture was most carefully constructed by Seurat after many small studies for the final version and such black and white studies as this for the various parts. Here one may see that he has studied the tree forms he needed, but he has stopped these forms where the figures were to impinge in the finished picture.

This drawing is austere in its simplicity, and Seurat's concept of form is simple to the point of bareness. What he is concerned with in this study as in all his studies is the representation of forms as they are seen emergent from darkness, forms barely outlined but, rather, felt, as areas in light and ultimately in colors. In this case he is not interested in landscape as such, but rather in landscape as an adjunct to a much greater whole. Seurat's aim was to understand each piece of landscape and each figure so well that when he finally put them together they together created not only a harmonious whole but a great work of art.

Seurat has taken his rather difficult medium of conté crayon and made it describe beautiful variations of tonality and the implications of form in space. The drawing affords the viewer a close-up glimpse into the interior of Seurat's greatest work.

The drawing was acquired for the Joseph and Helen Regenstein Collection.

VINCENT VAN GOGH (1853–1890) Grove of Cypresses, 1889 Ink and reed pen over pencil, $25\frac{5}{8} \times 18\frac{1}{4}$ in (65.2×46.5) Acc. no. 1927.543

Dutch

This drawing counts as a very late work in van Gogh's pathetically short career. Technically it is of great interest, for one's first impression is that it was dashed off at breakneck speed. A consideration of how it was done suggests that van Gogh was deliberate and self-conscious in his method. He first sketched the whole scene in pencil, very lightly indeed. Then upon this lightly achieved lay-in, he proceeded to execute the drawing with a reed pen and ink. The evidence is that, though the drawing was probably done relatively quickly, it was by no means an automatic production done without any consideration. His measured strokes of the pen may have had some intuitive motivation, but they were not accomplished either mechanically or without awareness. Rather, they may be seen to be completely self-conscious and aware. He was transforming the growth pattern of the cypresses for himself and, so, for his viewer. Nor

is it for nothing that Vincent had looked at Japanese prints, been deeply moved by them, and learned from their example. The disposition of the background landscape, the house, and the cloud patterns of the sky show just how much Vincent had responded to the Japanese printmakers.

Gift of Robert Allerton.

PAUL CÉZANNE (1839–1906)

Montagne-Sainte-Victoire

Watercolor on paper, $13\frac{5}{8} \times 20\frac{7}{8}$ in $(34.7 \times 53.1 \text{ cm})$ Acc. no. 1964.199

French

The great mountain in Provence was one of Cézanne's favorite subjects, and one can trace the development and changes in his style by studying his successive views of the place. In fact, the Montagne-Sainte-Victoire is a rather dull, lumpish, gravelly piece of mountainside, but somehow Cézanne always manages – even in his earliest, most tentative views – to lend the scene grandeur and nobility. In this watercolor he not only makes the scenery noble – his recreation of Poussin out of nature, in his own phrase – he also demonstrates the precise nature of his style in his maturity: spots and touches of color laid down to suggest the reality of light and air which envelops solid forms. He is as concerned by the space around the objects he is rendering as he is with the objects themselves; in his passion to communicate the solidity of the objects – be they apples, rocks, or people – he equally had to communicate the emptiness of space itself. It is the confrontation between the solid and the void, expressed in terms of luminous color, that creates the magic of Cézanne's world.

Bequest of the fourth Marshall Field.

WINSLOW HOMER (1836–1910) Gulfstream Watercolor, $11\frac{3}{8} \times 20\frac{1}{16}$ in (28.9 × 51.0 cm) Acc. no. 1933.1241

American

Winslow Homer was one of the most influential of late nineteenth-century American painters. Initially he earned his living as an illustrator – he covered the Civil War for *Harper's Weekly* – but after 1875 devoted himself exclusively to painting. Many of his pictures have a strong narrative quality which might be a result of his journalist days. After a visit to England in 1881–82 he returned to violent realistic paintings connected with the sea. Later he developed an impressionistic watercolor technique.

There is a version of this work in oils (now in the Metropolitan Museum). In the watercolor shown here the theme – a doomed man clinging to the deck of a wrecked sailing vessel and menaced by sharks – is simple and compressed. The image is reduced to its simplest and most abstract elements, so that one is first aware of the two-dimensional pattern and only secondarily of the three-dimensional shape of the listing boat and the beautifully rendered form of the man, reclining on the deck rather like an antique river god; finally one becomes aware of the menacing form of the shark and thus of the narrative implications of the picture.

Homer, more than any other American painter, made watercolor his medium, and it is as a watercolorist that he is at this best. He managed to avoid the merely pretty and trivial – a danger of this medium – and did not fall into the trap of adapting the techniques of oil painting to watercolor.

Mr and Mrs Martin A. Ryerson Collection.

PABLO PICASSO (1881–1973)

Fernande Olivier, 1906

Charcoal, 24×18 in (61.0×45.8 cm)

Acc. no. 1951.210

Picasso in his rose period (so called from his prevailing use of warm beiges and soft rose) achieved a gentle mode of expression which transformed the sentiment, not to say sentimentality, of his blue period into a kind of expression which used simple studio episodes of nudes and figures put together with but the simplest of narrative gestures. He also in this time did a number of impressive portraits, many of his mistress, Fernande Olivier. These rose period portraits are Picasso's first gesture towards a monumental style, and this portrait is a remarkable example of this impulse towards monumentality. Fernande, who was, if her photographs are an accurate guide, a rather plump, affable-seeming, hulkish woman, is here transformed into an almost hieratic image with something of the qualities of a piece of painted wood sculpture. Picasso has already begun to alter the facial structure for poetic license, and as a likeness it bears more resemblance to his other pictures of Fernande than it apparently did to Fernande herself.

Gift of Hermann Waldeck.

UMBERTO BOCCIONI (1882–1916) *Ines*, 1909 Pencil, $15 \times 15\frac{1}{2}$ in (38.2 \times 39.5 cm) Acc. no. 1967.244

Italian

Umberto Boccioni, whom Marcel Duchamp called the 'Prince of Futurism', was one of the leading exponents and the chief theoretician of Futuristic painting. The theory was that art should depict the dynamism and speed of modern life and that this should be done by showing simultaneously several states which actually occur consecutively in life.

Boccioni did not develop his theories until 1910 when, together with Balla, Carrà, Russolo, and Severini, he compiled his 'Manifesto of Futuristic Painting'. The present drawing, done in 1909, is still in the traditional style. Except for

some details – the repeated lines of the shading upon the jaw and the side of the nose – this drawing could have been done in the nineteenth century. This is particularly true of the handling of the eyes and the hair. It is an attractive and probably true-to-life portrait, but it hardly suggests the kind of painting which Boccioni was later to create.

Gift of Margaret Blake.

Pablo Picasso (1881–1973)

Spanish

Figure

Gouache on cardboard, $24\frac{3}{4} \times 19$ in $(63.0 \times 48.3 \text{ cm})$

Acc. no. 1953.192

This figure is typical of Picasso's work of the years 1907–08. He had by then discovered the forms of African tribal art, and these had an overwhelming effect upon him. In the years immediately before this, he had been haunted by the shapes of old Iberian sculpture and had invented, through their example, a kind of archaistic formal expression which remains both beautiful and calm. Then the effect of his Fauvist contemporaries, as well as the example of the African tribesmen, transformed his expression.

What Picasso has done is to see forms in terms quite comparable to those of the African carver. But it must be remembered that the process of seeing was

quite different for the Spanish master: he perceived the forms of his models in terms of a traditional, anonymous, tribal expression, whereas the African sculptor was seeing the forms of his concept in terms of three-dimensional ideograms. Picasso was seeing the anatomy of sitters in terms of the sculptor's

realized ideograms, which is by no means the same thing.

The influence of this traditional and tribal art upon Picasso's style was crucial, not to say explosive. Up to the moment of its impact he had been an enormously talented minor figure, haunted by Toulouse-Lautrec, by the Pre-Raphaelites, by his own divagations upon Puvis de Chavannes, and by his reactions to Spanish village life. His reactions to African art, as shown in this drawing (and best seen in his *Demoiselles d'Avignon*), set off a visual explosion which was the first of his transformations of Western art.

The drawing was given by Mrs Wolfgang Schoenborn and Samuel A.

Marx.

PIET MONDRIAN (1872–1944) Composition, 1913–14 Black chalk, $24\frac{3}{4} \times 19$ in (63.0 × 48.3 cm) Acc. no. 1968.15

Dutch

Mondrian began as an old-fashioned painter of scenery, but his style shows a consistent development in the direction of increased abstraction. His removal to Paris in 1910 brought him into contact with Cubism; and with van Doesburg he was a founder of the Dutch group known as de Stijl.

This drawing was done after he had been in Paris for three years and was already under the strong influence of Cubism. But whereas his earlier works had been highly geometric in their structure, especially when he was painting trees, and whereas the Cubists always kept a reference to some real scene or subject, Mondrian has here abandoned any reference to the external world. He has, rather, given the spectator a structure of lines of varying weights and lengths which might refer back to some visual experience but are, in fact, lines adjusted to each other for their own sake. What Mondrian has achieved, just a few years after Kandinsky had done something similar in intention, is to create a picture which is a visual structure of and for itself without any reference to an episode of human experience. The drawing is not just abstract, it is non-objective.

In this drawing Mondrian has broken down his picture surface into a personal realm, and was well on the way to his abstractions of the twenties and

thirties.

The drawing was bought from the Grant J. Pick Memorial Fund.

This is a capital drawing very early in Picasso's Neo-classical phase. His stay in Italy during the First World War seems to have impressed him, and his encounter with Etruscan mirror-backs provided him with a revised attitude towards line drawing. The only problem is that everything has always come to Picasso with almost disastrous ease. It is the very ease with which he works that seems occasionally to have given Picasso a pre-conscious motivation to try something difficult, or, in this case, to make something colossally easy into something hard. Accordingly, he has altered the anatomical structure of Dejanira into a complete impossibility and yet quite imaginable. Further, he has made Nessus seemingly out of movable marble. There is also in this drawing a very early example of what was to recur many times in Picasso's work: a strong element of the comic.

Spanish

In his use of an ancient, even archaic, medium, Picasso has also returned to an archaic style. This action is parcel to his rediscovery of a lost antiquity or, more accurately, his invention of a highly personalized kind of antiquity which never actually existed at all.

The drawing was bought for the Clarence Buckingham Collection.

ARSHILE GORKY (1904–1948) The Artist's Mother, 1936 Charcoal, $24\frac{3}{4} \times 19\frac{1}{8}$ in (63.0 × 48.5 cm) Acc. no. 1965.510

American

Gorky was pathetically late in finding himself as an artist. He was of Armenian birth and came to the United States when still young. Throughout his career, his work was an amalgam of many influences, and much of the time these influences seemed undigested. Yet, no matter how obvious the influences have seemed, there is a personal note in Gorky's work which is always compelling. It is often a note of elegiac tenderness, but can also be one of demonic fury.

This drawing, which is a study of Gorky's mother, was done for his finest early painting, c. 1935–36, which represents himself as a boy standing by his mother. The picture, which exists in two versions, was done from a snapshot. What Gorky did with his camera source was to transform it and to render it in terms which are at once heroic and commonplace. The mother is clad in simple Armenian country clothes. In Gorky's hands these become reminiscent of the primordial raiment of an earth goddess, and also, not surprisingly, of something left over from Byzantine times.

The drawing was acquired for the Worcester Sketch Collection.

PHOTOGRAPHY

WILLIAM HENRY FOX TALBOT (1800–1877) Lacock Abbey Cloisters, c. 1842 Calotype, $6\frac{1}{2} \times 8\frac{1}{8}$ in (16.5 × 20.6 cm) Acc. no. 1967.155 English

Fox Talbot was one of the earliest photographers, and this calotype illustrates the brilliance with which he used the mysterious new medium. Unlike some early photographers, he was not trying to reproduce the appearance and style of a painting. What he was trying to do was to get representations through photography which were valid and true. As he was both a man of taste as well as sensibility, his results are of great beauty, because they record the truth of the world of the Victorian gentry as it affected their eye. The viewer today can still, thanks to Fox Talbot and his camera, know how the world looked to the eye of a Victorian gentleman in the middle of the nineteenth century.

This print was brought from a gift of the Blum-Kovler Foundation.

ORIENTAL ART

LATE SHANG OF EARLY CHOU DYNASTIES (12th–10th century BC) Food vessel, called a *Kuei* Chinese Bronze with patination, H. 9_4^1 in (23.5 cm) Acc. no. 1963.15

This vessel, which seems to be transitional in date from the Shang to the Chou period, has exceptionally handsome handles with zoomorphic heads which suggest, in highly stylized form, the faces of bats. The vessel supposedly held food, although it is by no means clear what kind, nor precisely for what purpose it was intended. However, the uncertainty does not detract from the beauty of the piece, nor, incidentally, does its present patination. But no matter how much the modern connoisseur admires the patination and discoloration of the bronze, this is not how it was conceived nor intended to appear.

The vessel came with the collection of Dr Edith B. Farnsworth.

SHANG DYNASTY (before 1028 BC) Wine vessel, called a *Lei* Bronze with patination, H. $17\frac{3}{4}$ in (45.2 cm) Acc. no. 1938.17

Chinese

Lei are large bronze bowls or vases which, according to the ritual texts, were used for wine or water. Pottery versions have been found and there is a particularly famous lei made of the characteristic kaolinic white stoneware of Anyang in the Freer Gallery of Art, Washington.

The lei shown here is said to have been excavated at the site of the Shang capital of Anyang. (It was here that the first Shang bronzes were excavated in 1928 to 1934.) The handles at the neck and the loop nearer the base were probably to facilitate pouring. On the inside of the lid there is a cicada cast in high relief and the knob on the top has traces of an inlay within the interstices of the ornament. Through chemical action from exposure to the soil the metal has turned a cool silver-grey with a few touches of deposits of malachite and azurite.

The piece is part of the Lucy Maud Buckingham Collection.

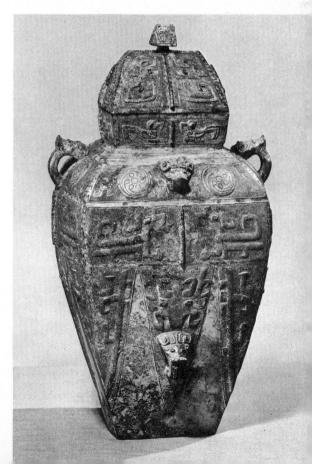

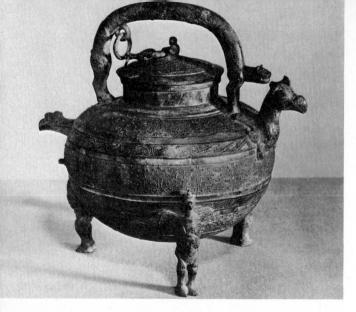

SECOND HALF OF EASTERN CHOU DYNASTY (480–222 BC) Chinese Covered wine vessel called a Ho Bronze with patination, H. $10\frac{1}{8}$ in (25.7 cm) Acc. no. 1930.366

Ho are vessels in the shape of kettles or teapots and were probably used for preparing wine or other liquids. Standing on three legs, this particular ho appears to have been designed for heating the liquids, since it could be stood over a fire; the hinged lid on the spout would prevent evaporation.

There are various humanoid figures as decoration, as well as a monkey for the lid knob, an elongated cat form to make the handle of the vessel, and a bird's head forming the spout. The body is further ornamented with copper inlays which would have made a contrast of pink metal against the silvery body of the bronze itself.

The vessel is part of the Lucy Maud Buckingham Collection.

HAN DYNASTY (206 BC-AD 221) Jar for wine storage, called a HuBronze, H. 17 $\frac{3}{4}$ in (45.2 cm) Acc. no. 1927.315 Chinese

Hu are among the largest Chinese bronze vessels. Their basic features are a low-slung belly, sloping shoulders, a tall neck and a slightly flared and rather narrow mouth. They usually have ring handles. They were wine vessels but

were sometimes used for storing food. There are also pottery versions of this form.

The piece shown here is gilded, with silver-colored parts said to have been created by coloring the parts to be silver with mercury. (The technique used is not known for certain, nor is that used for the gilding, though it may have been the mercury gilding process which was standard practice throughout the world until the end of the nineteenth century.) The predominance of dragon motifs suggests that the piece was made for imperial usage. It seems once to have had a lid.

The companion to this great vessel is in the Grenville L. Winthrop Collection of the William Hayes Fogg Museum, Harvard University.

This piece came as part of the Lucy Maud Buckingham Collection.

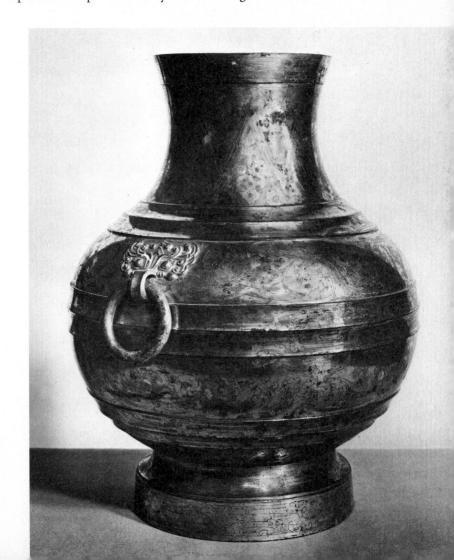

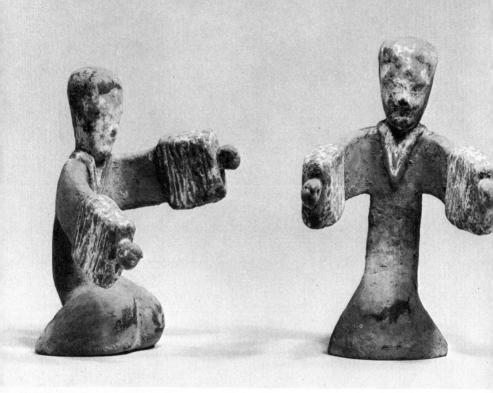

LATE HAN DYNASTY (AD 9–221) Statuettes of Dancers Painted pottery, H. $6\frac{1}{4}$, $6\frac{7}{8}$ in (15.8, 17.5 cm) Acc. no. 1954.478

Chinese

In early China it was usual for a man's wives, concubines, servants, horses, and other animals to be buried with him when he died, since it was believed that, in his new life after death, he would need all the people and things essential to him in this life. Later, however, living sacrifices were replaced by clay models which were cheap and readily available. Of course, these models, plus the household goods which were often also buried with the deceased, constitute an excellent historical record of the time.

These little figures with their traces of paint are reduced to almost completely conventionalized and abstract shapes. It may be that they represent musicians without their instruments rather than dancers, perhaps taking part in a funeral ceremony. In spite of the stylization one can get some idea of the dress and appearance of people at the time.

These were given by Russell Tyson.

Among the most beautiful and sophisticated of all Chinese productions in jade are the ring discs called *pi*. They developed very early in Chinese culture and by the time of the Late Chou period the quality of the surface carving as well as the forms employed were of the most elegant. But the significance of the pieces is not known. *Pi* refers simply to all perforated stone discs, other than rings, bracelets or spindle whorls; it might have been a ritual object in connection with the worship of the sun and moon; on the other hand, it might have been a mortuary object, in which case its prototype was a tool, perhaps a disc-shaped shaft-hole axe.

This pi is ornamented with a band of interlocked forms composed of articulated reeds with alternating feline and bird heads. The inner zone is composed of scale-like shapes. The character of the shapes is certainly partly determined by the exigencies of cutting the jade, one of the most intractable stones. This particular piece has the cloudy patterning and coloration which was and is especially esteemed by Chinese connoisseurs.

The piece came as part of the Edward and Louise B. Sonnenschein Collection.

LATE EASTERN CHOU DYNASTY (c. 660–222 BC)

Kneeling Prisoner

Steatite (?), H. 7³/₄ in (19.7 cm)

Acc. no. 1950.671

Chinese

In the Far East, jade has always been regarded as a precious stone and the fact of its preciousness has sometimes taken precedence over the forms into which it has been rendered. In this carving, however, the forms themselves are more important than the material out of which they are cut, although the dark color of this piece is in itself of great beauty.

This piece is rendered with great simplicity and the relationships of the various parts to each other and to the whole are perfectly harmonious. The representation of the bound and submissive male figure is austere but touching in spite of its impersonality, perhaps even by reason of it. Whether this was the sentiment the artist intended to evoke and whether his contemporaries saw the prisoner as an object for scorn rather than pity, we do not of course know.

The piece came as part of the Edward and Louise B. Sonnenschein Collection.

T'ANG DYNASTY (AD 618–906)

Tomb figure of a Horse
Glazed pottery, H. 30½ in (77.5 cm)

Acc. no. 1943,1136

Of all ceramic grave goods produced in ancient China, the most popular single type among collectors has been, for three quarters of a century, large-scale animals, particularly horses. This is a unique and particularly splendid example. It combines the techniques of glazed and fired coloring with that of hand painting upon white slip. The glaze colors embody the typical T'ang combination of brown, green, blue and yellow. Parts of the figure, especially the ornaments of the trappings, appear to have been mold-cast and then applied.

The real charm of such figures is the extraordinary intensity and truth of the potter's observation of natural reality. This horse with its finely trimmed mane and cropped tail is observed in the process of bending down to its hoof. It is remarkable for the accuracy of the anatomical detail; one sees the musculature and bone structure observed as carefully as in a drawing by Leonardo.

This piece was given by Russell Tyson.

T'ANG DYNASTY (AD 618–906)

Standing Warrior

Painted pottery with traces of gilt, H. 38 in (96.5 cm)

Acc. no. 1943.1139

In contrast to the crude pieces shown on p. 178, this truly grand figure must be considered as a piece of sculpture and was probably made for the tomb of an important person. In its present state, with much of its paint and gilding gone, it is rather hard to see just how noble the final surface forms must have been. Perhaps only in the face, which still retains substantial traces of its painted decoration, can one see just how luxurious a production this was.

The concept of the warrior or guardian figure is ancient in both East and West, and in the T'ang period the image becomes a noble rather than a horrendous one.

This piece was the gift of Russell Tyson.

UNKNOWN PAINTER, SUNG DYNASTY (AD 960–1279) Chinese Palace Musicians

Handscroll, ink and colors on silk, $16\frac{1}{2} \times 72\frac{1}{2}$ in $(42.0 \times 184.2 \text{ cm})$ Acc. no. 1950.1370

This scroll reveals the qualities of the typical Sung handscroll which illustrates scenes of domestic life. The attitude towards the representation of space and the forms seen within space is typically Chinese. It is important to remember that throughout the political and cultural upheavals of Chinese history, a cultural continuity did survive, so that, for the great part, changes in artistic style are at most evolutionary, and only rarely cases of revolutionary innovation. The natural habit of Chinese thought since the time of Confucius himself has been essentially conservative and dedicated to the preservation of traditional values. Thus, behind the traditions which this scroll embodies, lies the convention of painting and representation in the T'ang period, and behind that epoch were traditions which certainly went back to the Han dynasty. This does not mean that styles did not change, for, of course, they did; but traditions changed very slowly.

The women represented on this scroll are seen with their attributes of musical instruments. The method of perspective projection, pragmatically Chinese in invention, is close enough to the Western method known as isometric. That is, as forms recede into space they do not diminish in size but are merely moved upward on the picture surface and at a constant angle. There is no attempt to model in tone. Rather, the forms are presented flatly, defined linearly, and rendered with flat tones of color.

The scroll was acquired for the Kate S. Buckingham Collection.

Ch'en Ju-Yen (active 1340–1380) A Hermitage

Chinese

Hanging scroll, ink on paper, $34\frac{3}{4} \times 19$ in $(88.3 \times 48.3 \text{ cm})$ Acc. no. 1961.222

From about AD 1000 on, landscape as a category became a leading form of pictorial expression in China.

The technique in this scroll is simple and consists merely of brushed in passages of various tones of grey ink. But the virtuosity of the brushwork, which is expressed not only in linear touches but also in broad patches, is masterly.

What the artist has done is to set up, through the typically Chinese version of isometric perspective, the scheme of an entire section of a mountainous land-scape. The viewer can examine not only the rock formations with the foliated bits but also the growth and even the species of various sorts of trees. More impressive, because more simply done, is the feeling of a mountain pass in the

far distance. Only after careful scrutiny does one discover that the hermit on his way to the hermitage is to be seen in profile perdu at the bottom center of the picture. He is a tiny part of the picture, and, paradoxically, its entire reason for being. The whole heart of the Chinese attitude towards the awesome aspect of nature and man's relative significance may be noted in this small detail.

The scroll was bought for the Kate S. Buckingham Collection.

T'ANG YIN (1470-1523) Drinking at Night Handscroll, ink on paper, 13×35 in $(33.0 \times 88.9 \text{ cm})$ Acc. no. 1955.761

Chinese

T'ang Yin was one of the most eminent painters of the Ming period. He painted a variety of subjects, some of which, like the genre pictures of the pleasure quarters of Suchou, were probably executed with the prospective buyer in mind. His works were repeated in the earliest woodblock prints.

In this landscape, the artist has handled his medium with great skill and subtlety. One can see the inviting pavilion standing in its grove on a hillside, below which there is a small waterfall. The cloud layer with the moon just shining through, and the paler streak of sky running right across the picture. suggest a calm, damp evening. The whole picture is most evocative. Reading the scroll as a handscroll should be read, section by section, is like wandering through the landscape itself.

Severely limited though he was by the use of black ink on paper, the artist has, by implication, managed to suggest the feeling of color as well as atmosphere. This is a phenomenon which is rather rare in the West - one thinks of Rembrandt's prints, or the black and white drawings of Manet or Tiepolo, for something roughly comparable - but it was a normal occurrence in Chinese painting.

The quality and importance of the painting is noted by the presence of the various collectors' seals on the surface of the scroll.

This scroll was acquired through a gift of the Joseph and Helen Regenstein Foundation.

Ch'En Chi-Ju (1558–1637) Calligraphy Ink on gilt-spattered paper $7\frac{1}{4}\times20\frac{1}{4}$ in (18.5 \times 51.5 cm) Acc. no. 1941.1034

Chinese collectors have always valued elegant calligraphy not only for what it says but for the elegance of the brushwork. The discipline and the freedom with which fine calligraphy is done have always aroused intense admiration among educated Chinese people, and certainly by the Ming dynasty it had become a recognized craft expression in itself (not that the literary content was ever

Chinese

ignored).

To Western eyes calligraphy beautifully done is one of the most appealing and, at the same time, awe inspiring forms of Chinese pictorial expression. It is the 'pure' character of the calligraphy which appeals to sophisticated Western taste, and familiarity with calligraphy such as is found on this fan helps to explain the popularity of certain American painters of the 1950s. However, it must be remembered that no matter how extravagant the form of Chinese calligraphy may have been, it always remained calligraphy, whose primary function was the communication of ideas by way of simple writing. In other words it was always expression for a specific purpose and never for itself alone. The fact that it is an alien written tongue has given it an immunity from having to mean anything extrinsically to a Westerner; to an educated Chinese the written content, in fact, may be so compelling that the very beauty of the calligraphy itself becomes irrelevant.

This fan was acquired for the S.M. Nickerson Collection in 1941.

Lan Ying (1578–1660)

Landscape

Album leaf, ink and color on paper, 12 \times 16 in (30.5 \times 40.8 cm)

Acc. no. 1958.395

This little picture is one of a set of eight album leaves done deliberately in the styles of other artists. They represent Lan's reaction to much earlier modes of expression, in this instance the aestheticism of the Late Sung dynasty manner; but the various leaves, particularly this one, have independent importance as works of art.

Chinese

This is one of the purest examples of the scope of the traditional Chinese method of painting in simple washes of ink with a few broad brushstrokes to indicate, through the gentlest implication, the details of the landscape. It is a mode which is actually extremely difficult, for there is a real temptation to fall into mere mannerism, into calligraphic brushwork for its own sake, or simple preciosity. But Lan has avoided each of these pitfalls, and even though this was a kind of academic exercise, even, perhaps, a pastiche, it is a lovely evocation not only of a past manner and master but also of the beautiful Chinese countryside. The sense of speedily moving cloud and fog banks is lightly suggested, as is the presence of the house beyond the copse.

This leaf and the other seven in the series were bought for the S. M. Nickerson

Collection.

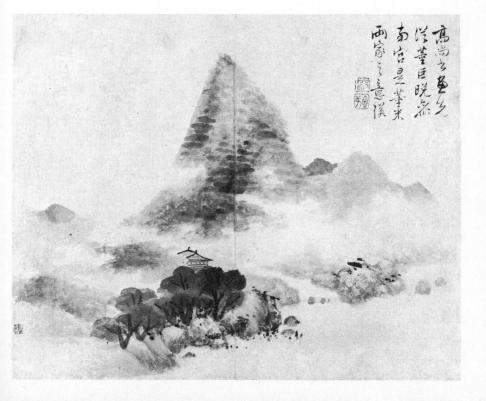

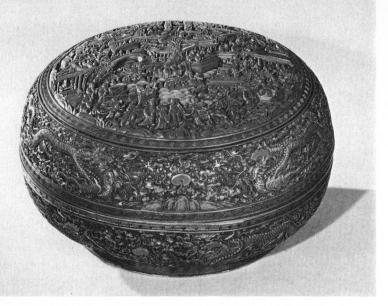

UNKNOWN ARTIST, CH'ING DYNASTY (1644–1912) Carved Lacquer Box Lacquer, D. 14 in (35.7 cm) Acc. no. 1961.65

Chinese

Chinese lacquer is the natural juice of the lac tree, a native originally of China, today found also in Annam, Korea, and Japan. After preparation, its qualities are an almost unbelievable resistance to water, as well as to heat and acidity. It therefore excels as a protective envelope and as a vehicle for surface decoration. The use of lacquer goes back at least as far as the Late Chou period, and because of its preserving qualities, lacquer goods are usually in remarkably good condition, even after having been buried in the earth for centuries.

When hard, lacquer can be cut, carved, or engraved with as much precision as ivory. This type of work reached its climax during the eighteenth century, especially in the time of the Emperor Ch'ien Lung, although some of the loveliest furniture ever made is that crafted in white lacquer during the Ming

dynasty in the first half of the seventeenth century.

This box represents just how luxurious an object can be fabricated from lacquer. The color, cinnabar red, is of the most elegant, and the carving and chiseling of the surface, into a breathtakingly complex surface which represents a pattern of landscape, are of the most competent technical authority. This box represents the kind of prototype of thousands of mass-produced cigarette boxes of the last century.

Given by Mr and Mrs Philip Pinsof.

Chair

Bamboo with painted details, H. 37 in (94.0 cm)

Acc. no. 1967.346

Westerners, especially British and American, have seen so many pieces of furniture of vaguely Chinese inspiration that a real piece of Chinese furniture is always faintly surprising to them. It is so because one forgets how improbably fragile-seeming it can be in spite of its real toughness of construction. It may also surprise because Chinese furniture – particularly of the seventeenth and eighteenth centuries – is frequently very beautiful. This chair, one of a pair, is no exception. (The Chinese were apparently the only Far Eastern people who sat on stools or chairs rather than on the floor.) For all its apparent fragility, it is, in fact, not only strongly built but designed to take the hardest of usage. It is also built to be comfortable even in the context of formal living. It seems to have all the qualities the Chinese considered essential in the making of furniture: functionalism, simplicity, strength and symmetry.

The piece is not only designed in terms of the structural possibilities of bamboo as a medium, but also in terms of variations in size of the pieces of

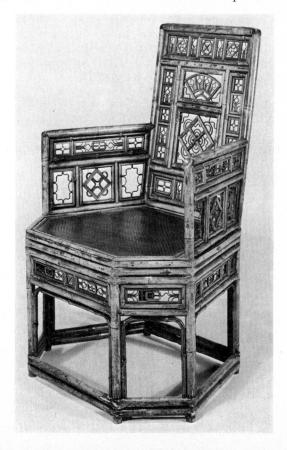

bamboo. The relation of small and tiny-scaled ornament to the larger areas of the chair is skillfully accomplished, as is the organization of the various

parts of the chair.

When Chinese furniture was done with a light touch, that touch was of gossamer elegance, and this piece is a fine example of the mode. It may lack the formal grandeur of a great white lacquer table of the Ming dynasty, but it has a grace and elegance more than enough to compensate for its lack of bulk.

Given by Josephine P. Albright in memory of her mother, Alice H.

Patterson.

KORYO DYNASTY (13th century)

Vase
Pottery, H. 10¹/₄ in (26.0 cm)

Acc. no. 1964.957

Korean

The Koryo dynasty (918–1392) was founded half a century before the Chinese Sung dynasty and lasted just over a century after it collapsed. Chinese influence was strong, and Korean celadons owe their inspiration to the Yüeh wares of the Chekiang province. In fact Korean potters may well have been taught by the Chinese. Towards the end of the tenth century the celadons produced were crude, but within a century the Koreans had mastered the technique. In the twelfth century they invented the technique of inlaying different colored clays to produce black and white decorations on their celadon wares. This type of ware is unique to Korea, and here we have a fine example. Note that the artist has used standard Chinese motifs – dragons, birds, stylized plants – but the presentation is unmistakably not Chinese. The cool grey-green of the celadon is handsomely set off by the finely inlaid lines of dark grey and off-white.

The piece came as the bequest of Russell Tyson.

KORYO DYNASTY (13th century)

Ewer

Pottery, H. 10 in (25.5 cm)

Acc. no. 1964.950

Korean

This piece repeats the shape and surface of a bamboo ewer in the fictile material—not off-hand a promising imitation. In fact, the piece is extremely elegant in form and lovely in the color of its glaze. Perhaps its most attractive feature is the design of the bamboo shoots carved upon it almost at random. This design restates the facts of the bamboo tree and its uses in terms of real charm.

This piece was bequeathed by Russell Tyson.

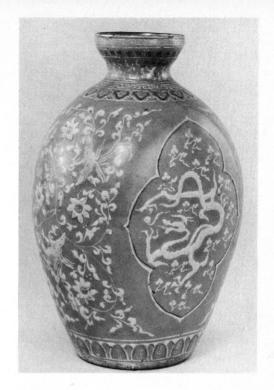

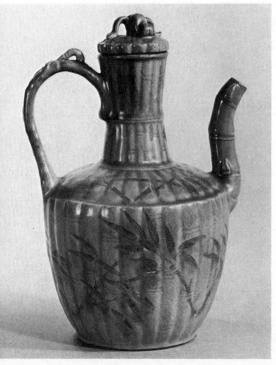

UNKNOWN ARTIST, NARA PERIOD (AD 710–784) Seated Bosatsu Figure Lacquered wood, 24×17 in $(61.0 \times 43.3$ cm) Acc. no. 1962.356

During the era of the great T'ang dynasty, Chinese influence spread throughout the Far East. In Japan cities were built in Chinese style, and Chinese manners and modes became the standards of civilized behavior.

Bosatsu is the Japanese word for Bodhisattva – a being whose merit, acquired through countless lives, is so great that he becomes a deity of bounteous compassion, and whose wisdom is such that he is the essence of perfect knowledge. In this Bosatsu the Chinese inspiration is evident, yet the idol has an uncomplicated sincerity which is typical of Japanese religious sculpture. In its present state, with its gilded and painted surface cracked and coated with encrustations of dirt and dried incense smoke, it is not easy to imagine it as it

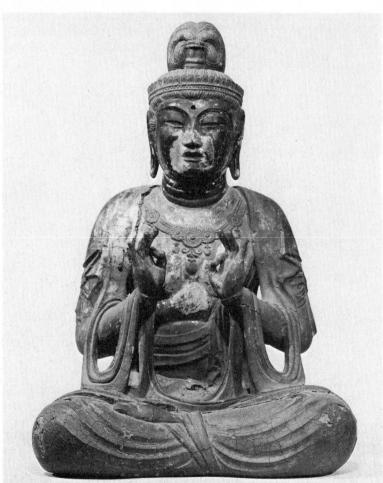

originally was - the absolute elegance of the surface combined with the utmost suavity and sophistication of form. Yet the statue still transmits a sense of restrained power and compassion.

The piece was bought for the Kate S. Buckingham Collection.

UNKNOWN ARTIST, LATE HEIAN PERIOD (9th century)

Tapanese

Seated Hachiman

Wood, H. 21 in (53.5 cm)

Acc. no. 1960.755

The Late Heian period, also known as the Fujiwara period from the name of the powerful family, lasted from 898 to 1185. From 894 all regular embassies to China had stopped and Japanese cultural life developed along independent

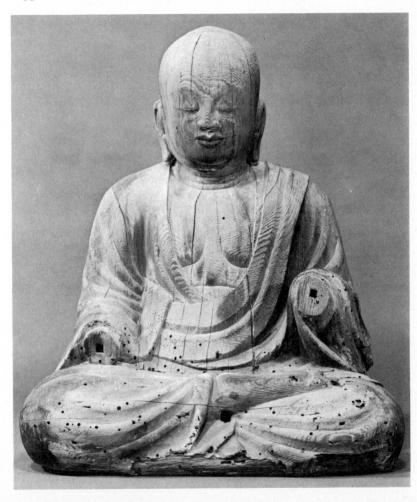

lines. Buddhism, however, remained the main religion, although it was

to undergo considerable change and to become much less severe.

It is interesting to compare this figure of Hachiman, Shinto God of War, depicted as Bosatsu, with the preceding figure which still has some of its paint. This figure, in its stripped state, presents a more purely sculptural aspect for the Westerner. But the beauty obtained from the pattern of the wood in relation to the forms is accidental and not part of the artist's image, which was considered in terms of color and gilding upon the surface of the lacquer coating. By visualizing the figure with its paint and gilding, it will be seen that it really resembles the preceding figure to an astonishing degree. The similarity is partly iconographic, but is also partly due to the conservatism in style over a century.

The wrapped robe represents the garment traditionally worn by Siddartha (the early name of the Buddha) after his enlightenment. It is here rendered with

broad and flat folds.

This piece was bought through a gift of the Joseph and Helen Regenstein Foundation.

UNKNOWN ARTIST, KAMAKURA PERIOD (1185–1392) Guardian Figure Painted wood with paste inlays, H. $36\frac{1}{2}$ in (92.8 cm) Acc. no. 1958.120

Japanese

This figure of a supernatural warrior-guardian represents the activist motif in Japanese sculpture. The preceding figures, which represent contemplative images, are rendered to suggest serenity and inwardness. But the Japanese sculptor was also quite capable of portraying a figure of violence or power. The emphasis here is upon musculature heavily developed, with the implication of power that such development implies. There is the sense of bulk and mass as well, with a careful definition of aspects of anatomy. (Especially notable are the bulging arteries of the upraised right arm.)

If the feeling of weight and hulking form is defined by the proportions of the figure, the feeling of motion is implied only in the billowing ends of the sash and the wavy locks of the hat. Motion is also suggested by the gesture of the figure which implies that moment of inaction which precedes a violent action.

The painted surface was designed not only to increase the ornamental sense of the statue but also to enhance its evocative aspects. The piece in its present state, still covered with dirt and the coagulated and dried incense smoke, makes it hard to realize that the figure was designed to be ferocious in all its implications.

The piece was bought for the Kate S. Buckingham Collection in 1958.

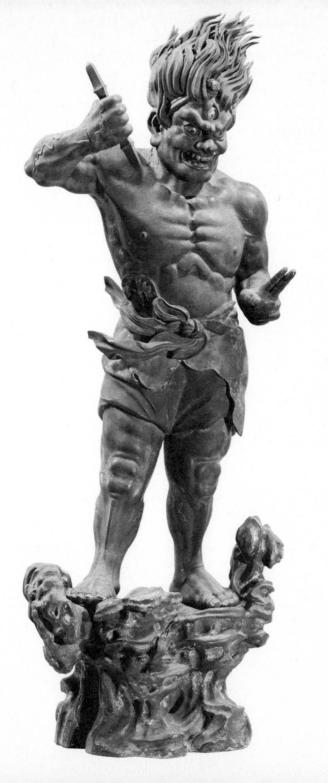

UNKNOWN ARTIST (14th century)
Shika Mandara

Japanese

Hanging scroll, watercolor, ink and gilt on silk, $49\frac{3}{8}\times$ 20 in (125.5 \times 50.9 cm) Acc. no. 1960.314

A mandara is a diagrammatic representation of Buddhist theology – mysteries which words cannot express are revealed in visual form. The mandaras were essential in the ritual of certain Buddhist sects.

It is possible to see Chinese prototypes in this scroll, but the character of the lines and forms is peculiarly Japanese. The ornamental quality and the refinement of the image are typically Japanese; notice the pipe-stem thinness of the legs of the deer and the linearity of its antlers. The size of the animal in relation to the landscape details is also of interest – it is quite clear that this is an ideal, conceptual image and not a piece of naturalistic observation.

The scroll was bought for the Kate S. Buckingham Collection.

UNKNOWN ARTIST (14th century) The Priest Kōbō Daishi as a Child Japanese

Hanging scroll, watercolors, ink and gilt on silk, $34\frac{1}{8}\times$ $19\frac{1}{4}$ in $(86.6\times49.0$ cm) Acc. no. 1959.552

Kōbō Daishi (774–835) was the founder and exponent of the Shingon or True Word sect of Buddhism. In this picture he is shown as a child of five or six when he dreamed that he knelt upon a lotus and desired to converse with all the Buddhas. The child's face has some of the characteristics of a portrait, even though the image must be thought of as an ideal evocation rather than simple, observed portraiture.

The concept of the image with its placement within a circle and its divorce from ordinary reality is particularly Japanese, as is its relationship to the calligraphy which is placed within a field far above the image itself. Especially Japanese, too, is the breaking up of any sense of three-dimensional reality into

a flattened and highly decorative scheme. This flattened and two-dimensional world does not imply a rejection of solid forms in space, but, rather, a statement about them in terms of image and concept instead of merely observed fact.

The use of color for decorative impact is appealing, even though the hues and touches are obviously no longer as bright as they were when the scroll was new. It is basically a luxurious and rich image which is evoked, and this luxurious elegance is, again, typically Japanese.

The scroll was bought through a gift of the Joseph and Helen Regenstein

Foundation.

SESSON SHUKEI (1504–1589) Landscape of the Four Seasons

Japanese

Six-fold screen, ink and color on paper, $61\frac{3}{8} \times 133$ in $(155.9 \times 337.9$ cm) Acc. no. 1958.167

Sesson, an individualistic, self-taught artist is associated with places in the provinces of Hitachi and Iwashiro in the northern part of Japan.

This screen (like its companion) portrays a monumental vista of mountains framing a harbor with its shipping and village life. Like the great Chinese landscape painters before him, the artist has observed not only the reality of the landscape but also the attendant phenomena of weather – the movement of cloud banks and patches of fog, as well as the forms of the mountain structure and those of the trees, are all delineated. Photographs of Japanese scenery will show how accurate and completely observed this scene is.

The screen was a particularly grand object of decoration, especially within the context of the rather austere Japanese house where its luxury could be appreciated to the full. The fact that screens were viewed only occasionally added to their impact. Their scale provides the closest analogy to large-scale easel painting as it is known in the West. Actually, the screens are formed from repeated scrolls which are laid out so that decoration on a monumental scale

becomes possible.

The screen and its mate were bought from a gift of the Joseph and Helen Regenstein Foundation.

Sнојо Sнокадо (1584–1639)

Japanese

Plum and Bamboo

Hanging scrolls, ink with touches of color on paper, 46×12 in $(116.9 \times 30.5 \text{ cm})$

Acc. no. 1964.283 a and b

This elegant pair of hanging scrolls represents a particularly Japanese fragmentation of reality – the concentration on a small fragment of experience, while taking into consideration both material fact and episode.

In this case the material fact consists of a branch of prunus blossoms and the shafts of bamboo plants with a little foliage just visible. The episode is that of a small bird flying below the bamboo foliage. It is this savoring of a tiny episode which is a characteristic of Japanese feelings about all experience.

The technical mastery of the difficult medium is of the highest; the handling of the ink to produce both the subtle gradations of tone and the softness of effect is exemplary, as are the restraint and authority in the pair.

The scrolls were bought through a gift of the David T. Siegel Foundation.

Hoitsu (1761–1828)

Japanese

Mandarin Ducks in the Snow

Two-fold screen, color and gilt on paper, $67\frac{3}{8} \times 64\frac{3}{4}$ in (171.1 \times 164.5 cm)

Acc. no. 1957.244

By the period in which Hoitsu painted this two-fold screen, the earlier styles, which were still essentially naturalistic in the intensity of observation, had yielded to a more consciously stylized method which, though naturalistic in its intent,

had become flatly decorative. The sense of a late spring which has suddenly covered the early blooming is still preserved, but it is stated without the continuing sense of wonder at natural phenomena which before had been a characteristic of Japanese pictorial expression. The snow, the flowers seen through it, the carefully noted ornithological details of the ducks are still present, but one no longer feels that this presentation is a primary aim of the painter. Rather, he has subordinated these details to make them a part of a greater whole which is frankly decorative and elegant in its concept and in its motivation.

The decorative quality is emphasized through the use of the gold-flecked background which, as with Sienese medieval panels, suddenly kills any illusionistic quality of the whole scene in favor of a static reality for itself alone. For sheer luxury of effect it is hard to surpass a screen such as this one.

Gift of Robert Allerton.

KIYONOBU I (1664–1729) The Actor Takii Hannosuke as a Wakashu, c. 1710 Colored woodblock print, $22 \times 11\frac{1}{2}$ in (55.9 × 29.2 cm) Acc. no. 1925.1736

Kiyonobu I was a member of the Torii family, who traditionally designed the billboards of the Kabuki theater (Kabuki being the more realistic and exciting

Tapanese

popular form of theater as opposed to the aristocratic Noh).

This print, which is plausibly attributed to Kiyonobu on stylistic grounds, was executed about 1710 and represents an actor, Takii Hannosuke, as a wakashu wearing a sword and carrying a large straw hat. The brilliance of the concept, is matched by the completely realized sense of what the tools of the wood-engraver can accomplish. The forms are rendered in purely flat (though textured) areas, but these areas are adjusted perceptively not only to recall the flowing ink of the brushed lines on the woodblock but to suggest with the most powerful conviction the movement of a highly trained actor at work in a profession devoted to completely stylized movement and expression.

Though the art of the Japanese printmaker was a popular one, it did preserve much of the luxury and elegance of the painter. The tightening and simplification which the printmaker employed merely forced him to make his work clearer in its intention and more economic in its expression than would have been the case had he executed it as a painting. But no matter what the degree of simplification and stylization, the aim of the artist was always a clear

and direct evocation of local reality as he saw it.

Clarence Buckingham Collection.

Japanese

The woodblock print technique can be traced back to the T'ang dynasty in China when it was used for printing black and white iconographical pictures. In Japan during the Fujiwara period woodblocks were used for decorative papers which formed backgrounds for Buddhist texts. By the seventeenth and eighteenth centuries the Japanese had developed the art to perfection.

This print clearly illustrates the economic way in which the Japanese printmaker achieved his goal. Behind each print there lay, of course, a brush drawing, or in any case, the memory of one, and it is easy to see that the sharp and smoothly flowing lines are derived from the equally smooth and flowing flourishes of the brush which would have been placed on the woodblock itself.

But it is not merely the technical excellence and accommodation of the pictorial concept to the medium which makes the print so impressive. For beyond the structure and pictorial substance is the humanistic content and simple narrative observation which compels even an alien audience of a far different time from that of the artist. The languidly sensual attitude of the man and the woman is admirably conveyed as is the luxury of their surrounding which is indicated only by a superb screen. Probably the most beguiling touch is the clear and convincing portrayal of a calico cat with a somewhat scrawny but playful calico kitten.

The print was bought for the Clarence Buckingham Collection in 1967.

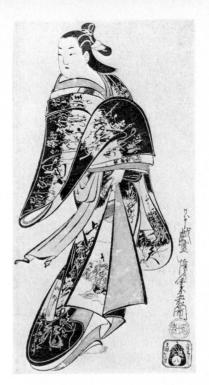

Anchi Kwaigetsudō (active 1710–1720)

Standing Beauty

Colored woodblock print, $21\frac{3}{4} \times 11\frac{1}{2}$ in $(55.4 \times 29.2 \text{ cm})$

Acc. no. 1925.1741

This print is even smoother and more limpid in its character than the Kiyonobu. It also evokes a physical presence, but it is a physical presence which is apprehended within the terms of an enveloping, luxurious, and stiff costume.

One of the slightly unexpected details is the male figure in a garden which is embroidered upon the lining of the kimono on the subject's lower right side. He may well be a poet, in which case the cursive script all over the dress represents fragments of poetry. Pictures within pictures occur, of course, in medieval and Renaissance European art and, occasionally, in such later works as Monet's *The Kimono* which repeats in that artist's terms exactly the same thing as seen in this print.

The effect of luxury is only part of the charm in this print. Another and equal part is the sense of a particular moment in time and space which is evoked with real intensity. And yet these prints were essentially articles produced

in volume rather than precious, individual objects.

Clarence Buckingham Collection.

Japanese

Torii Kiyonaga became the head of the fourth generation of the Torii family (see p. 202) and as such he had to carry on the job of designing signboards and playbills. However, his greatest achievements were his prints of famous beauties.

Japanese

This diptych was done around the year 1783 and represents an informal social gathering. As with most other examples of the craft of the Japanese printmaker, the viewer has a seemingly casual arrangement of the external world which is, in fact, most carefully composed as a work of art. The spotting of the dark areas is done to achieve an optical balance of the flat areas as well as to reinforce the effect of the patches of color and the blacks of the patches of hair.

Again, as in other Japanese prints, the real importance, beyond mere matters of artistic quality, lies in the faithful sense of observed reality. These prints were intended to be completely realistic evocations of the observed, factual world, with the meanings of that world to be understood in terms of eighteenth-century Japan. In earlier European art, a rough parallel may be recalled in Botticelli's *Epiphany* in Florence, which is also closely observed from the point of view of natural fact, but done in terms of the most subtle organization. It is this reordering of natural experience into purely visual terms, and in terms adapted to the printmaker's craft, which gives Japanese prints their authority. Clarence Buckingham Collection.

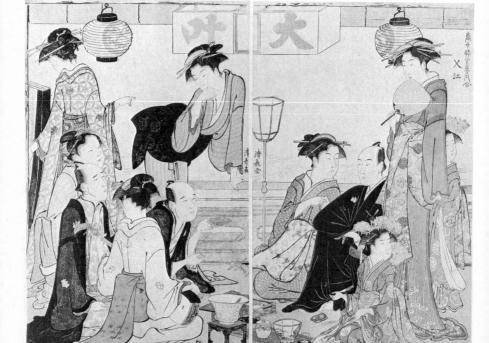

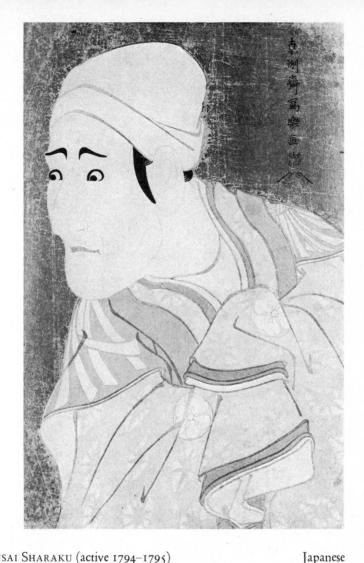

TOSHUSAI SHARAKU (active 1794–1795)

The Actor Morita Kanya VIII

Colored woodblock print, $12\frac{1}{2} \times 9\frac{3}{4}$ in $(31.8 \times 24.8 \text{ cm})$ Acc. no. 1934.232

Toshusai Sharaku is believed to have been a Noh actor at the court of Edo (Tokyo). He made about 140 actor portraits – all within the span of ten months (from May 1794 to February 1795). His portraits are remarkable for their intensity – compare the contortion of the face in this portrait with the composed

expression of the face in Kiyonobu's picture on page 203. He presented these figures with the most searching scrutiny, obviously clearly and accurately observed. But even in the apparent accuracy of his observation, Sharaku always treated the faces as part of an impressive, even startling piece of two-dimensional design. The paradox is that in his emphasis on the particular reality of the visage, the artist emphasized the unreality of the image, its artist emphasized the unreality of the image, its artist emphasized the unreality of the image.

This particular print is an admirable specimen of the artist's style and shows his talent for characterization. The gesture of the man is implied through the folds of his kimono, and the jut of his jaw serves to emphasize the force of the obviously clutched hands. The whitened face evokes the masked images of the theater and accentuates the expression of the eyes and eyebrows; the skull-cap reemphasizes the effect. The final impact of the print is achieved through the use of the close-up technique, that is, the figure is related to no environment (Sharaku never gave his portraits backgrounds), merely to himself and his craft and, so, to the spectator.

Clarence Buckingham Collection.

KITAGAWA UTAMARO (1753–1806) Geisha and her Maid Colored woodblock print, 15×10 in (38.2×25.4 cm) Acc. no. 1968.158

Japanese

In this print it is possible to see not only Utamaro's remarkable technical refinement and accomplishment but also his compelling sense of design structure. One is presented with a fragment of reality which is not merely a fragment of forms set into a kind of indefinite space, but also a fragment in time itself; for there is a clear emphasis on the chance event of the shower of rain through which the women must move and are indeed moving.

Utamaro's special paradox in this print is his own intensely felt amalgam of the two and three dimensional aspects which are cut, as it were, from context and fused into his own individual kind of reality. But this emphasis upon a tiny fragment of simple experience is not just part of Utamaro's repertory, it is part of the whole Japanese outlook upon life itself and savoring of experience. The sense of magic lies in his accomplishing of this fusion not only through simple and direct representation, but also through rigorously schematized and stylized devices. That is, rain does not normally appear as lines of direction, but intellectually the spectator recognizes the reference so that they epitomize the very wetness of a summer shower.

The print was given by Gaylord Donnelley.

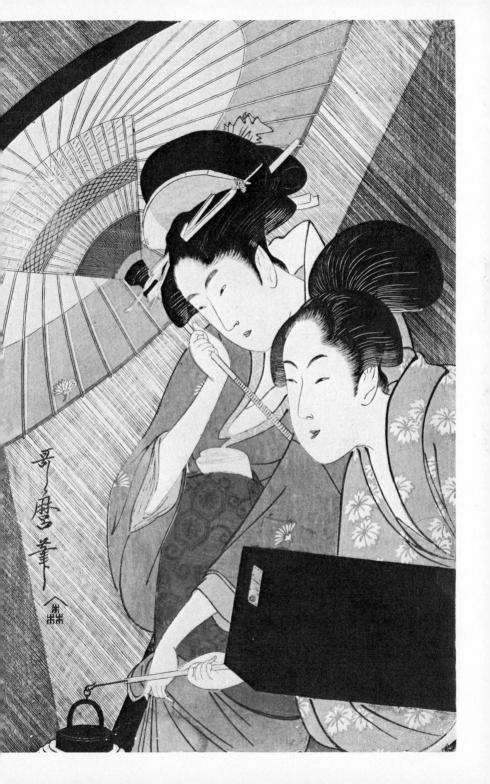

Tapanese

KITAGAWA UTAMARO (1753–1806)

The Hour of the Wild Boar, 10 p.m. to 11 p.m.

Colored woodblock print, 15×10 in (38.2×25.5 cm)

Acc. no. 1925,3061

Utamaro ranks not only as one of the most famous of all Japanese printmakers but also as one of the most distinguished. This print illustrates his virtues and his technical facility. What he managed to do was to refine the technique of the craftsman to a state it had not previously reached in the printmaker's art. But the point about Utamaro's refinements is that they are not visible in themselves but only as a means to the enhancement of the artist's aim.

The subtle adjustment of the weight of the line, as well of its character, is a device which the artist has used in this print to express the niceties of detail in the costume and the headdress. It is the extraordinary care with which these technical adjustments are made that makes the viewer respond to the sense of the women actually at work as well as to the details of their physical presence.

Clarence Buckingham Collection.

TORII KIYONAGA (1752–1815)

Women landing from a Pleasure Boat

Colored woodblock print, $15\frac{1}{2} \times 10\frac{1}{4}$ in (39.5× 26.0 cm)

Acc. no. 1925.2611

This print is a triptych. The device was used to accommodate the scale of the blocks of wood available to the craftsmen on ordinary occasions and, presumably, to make production easier. In this instance, it makes for a particularly spacious design with a remarkably intense sense of open space more or less in normal terms, as Western eyes are used to interpreting the visible, real world. The standard techniques of Oriental rendering seem to be at the minimum here, and the result is one which emphasizes direct observation of the real world as it was experienced at the end of the eighteenth century in Japan.

Clarence Buckingham Collection.

YOSHITOSHI (1838–1892) Japanese Girl in Western Dress, 1888 Colored woodblock print, $14_4^1 \times 9_8^5$ in $(36.3 \times 24.5 \text{ cm})$ Acc. no. 1968.149

Japanese

This stylish print illustrates the impact of the West upon the traditional world of Japan and gives a foretaste of what was to happen in Japan in the decades after the Second World War when Japan was to become rapidly Westernized and in the process jettison much of its traditional appearance. This print is dated 1888. What is to be seen is a Japanese lady wearing a European costume and hat of a style in vogue approximately ten years before the date of the print. Note that – contrary to Western etiquette – she is not wearing gloves.

The print embodies all the traditional Japanese methods of incising, coloring, and, even, seeing: the cut-off image with the blooming irises, the woman's pose, and the inscriptive panels are all in the Japanese pictorial tradition. The only thing which is not native is the costume itself; but while it is carefully even lovingly, observed, the artist has managed to present it and its wearer in such Japanese terms that one must look twice to notice that it is not a kimono and standard Japanese coiffure which is rendered here. This print demonstrates how difficult it is to translate aesthetic experiences, not only from tongue to tongue, but from world to world.

This print came from the Japanese Print Purchase Account.

CHOLA PERIOD (907–1053) Standing Figure of Brahma Pink granite, H. 54 in (137.2 cm) Acc. no. 1965.452

Of all Oriental art perhaps the most difficult for the Western mind and taste to assimilate is that of Brahmin India. In the first place the theology it illustrates, with its specialized and precise iconography, is a largely mysterious quantity for the Westerner. In the second place its forms, conceived as they are strictly to illustrate iconographic meanings, are often arbitrary and austere to the Western eye. Finally, there is always about Hindu artifacts the sense of the particular Hindu ethic and attitude towards life. After all, a culture which has produced the concept of suttee as the noblest of conjugal gestures will necessarily seem alien to minds reared in post-Classical or post-Christian traditions.

This figure, which represents the chief member of the Hindu Trinity (Brahma, Vishnu, and Shiva), is large in size and sure in its technical mastery of stonecutting. It is imbued with a spirit which seems particularly Indian and contemplative. It is now bereft of its color which might have reinforced the sense of an antinatural, supernatural, divine image.

The piece was bought for the Kate S. Buckingham Collection.

UNKNOWN ARTIST (11th century)
Figure of Shiva Nataraja
Bronze with patina, H. 28 in (71.2 cm)
Acc. no. 1965.1130

The bronzes from south India are the most accessible form of Indian sculpture to Western eyes. Of these bronzes the most appealing are those which represent a dancing Shiva. The divinity is portrayed as wearing a diaphanous loincloth with embroidered streamers, a feathered and jeweled headdress. He stands on a recumbent dwarf, symbolizing ignorance, who is placed upon a lotus bed. Around the dancing god is a jeweled ring from which flames have sprouted. The image is one of fantastic grace and elegance, and the concept of motion is intensely suggested, even though merely anatomical and physiological reality is by no means naturalistically observed. It is the conceptual rather than apparent truth which the sculptor has evoked.

Technically, this piece is executed with consummate craftsmanship. The casting is of the best, and the piece, like all such bronzes, is solid and not hollow. The holes in the base were made for inserting carrying poles, for the piece was

designed to be carried in procession.

The impression which the observer keeps with him is that of motion and the concept of motion. The difference between motion visualized as a concept rather than as an actual happening in time can best be realized if one recalls the drawings Rodin did of Isadora Duncan in action. The fact is that a static image cannot truly portray the appearance of movement, but can suggest the concept of the movement.

The figure was bought for the Kate S. Buckingham Collection.

Mughal Indian Procession in a palace, leaf from a royal manuscript of the Shah-Jehan Nameh, c. 1650

Ink, color, and gold on paper, $14\frac{3}{4} \times 8\frac{11}{16}$ in $(37.5 \times 22.0 \text{ cm})$

Acc. no. 1975.555

The manuscript paintings of India, Rajput or Mughal, are among the most splendid of any civilization. The style is based on a synthesis of careful naturalistic observations combined with a decorative splendor which seems to have been a constant tradition of the sub-continent. This manuscript comes from the apogee of the Mughal style, the mid-seventeenth century. While the work is done for Mughal royal usage there is, all the same, the strong flavor of indigenous art.

The miniature is part of the Kate S. Buckingham Collection.

CLASSICAL AND DECORATIVE ARTS

THE CHICAGO PAINTER (mid-5th century BC)
The Chicago Vase, c. 460–440 BC
Terracotta, H. 14³/₄ in (37.5 cm)
Acc. no. 1889.22

Greek

Greek pottery contains the principal surviving evidence of Greek painting. However, the exigencies of the medium, which required, basically, a purely flat and linear style, do not necessarily give much real evidence of how contemporaneous Greek painting actually appeared.

While Greek pottery varied greatly in quality and in style from place to place, the finest of it was work made to order for luxurious custom. The piece illustrated here is such an example. It is a fine example of the potter's craft, with the elegant subtlety of shape which always characterized Greek pottery, even

in the crudest pieces.

While collectors have long admired Greek pottery for its shapes, the primary interest here is in the decoration on the pot. Many of the vase painters are known by name, and the entire craft has been studied enough during the last seventy-five years for other individual personalities to have been identified, even though their names are unknown. The painter of this vase is one of such, and it is from this vase that he has been identified as the Chicago painter. His work is the epitome of the High Classical style, expressed with virile strength and consummate grace.

Gift of Philip D. Armour and Charles L. Hutchinson.

UNKNOWN SCULPTOR (end of the 4th century BC)
Figure of a Youth from a Gravestone
Marble, H. 32 in. (81.3 cm)
Acc. no. 1960.70

Greek, Attic

This handsome, three-quarter-length figure of a young man is part of an Attic Greek tombstone made at the end of the fourth century BC. It embodies the virtues of classic sculpture at the end of the classic era and at the beginning of the Hellenistic period, although it is still basically Classical in flavor. It is, obviously, only a fragment, albeit a beautiful one, and there must have been at least one other figure seen in connection with this one, as well as an architectural setting; the whole thing was, originally, painted. As the color is gone and the figure is somewhat weathered it is hard to imagine the impact it had for the patron who commissioned it.

The Greek view of death appears to have been a relaxed one, and the grave monuments are sensible and matter-of-fact in their presentation of the facts

about the dead; there is no lack of feeling, but that feeling is never in the least sentimental. The touching thing about this fragment is the image it gives of a young man still in his teens and in the prime of physical condition.

The piece was bought from a gift of the Silvain and Arma Wyler Foundation.

Rome Italian

Gallienus, c. AD 260

Marble, H. $13\frac{2}{3}$ in (34 cm)

Acc. no. 1975.328

Roman imperial portraits developed a glamor which is quite different from the austerely uncompromising – frequently unflattering – character of late republican and even early imperial portraits. The former must frequently have been worked from life-masks, and the resulting heads have an immediacy of effect which was no doubt even more striking when the painted surfaces were intact. What late imperial portraits lose in pictorial candor they gain in splendor, richness, and stylization. This, of course, is the logical consequence of the habit of deifying dead emperors, which by Gallienus's time turned them into figures of a mystery religion.

This elegant head was bought from the income of the Katherine Keith

Adler Memorial Fund.

NORTHERN FRANCE Virgin and Child Enthroned, c. 1240 Ivory, once partly gilt, $8\frac{7}{8} \times 3\frac{3}{4}$ in $(22.6 \times 9.5 \text{ cm})$ Acc. no. 1971.786

French

This grand object seems much larger than it is, and after seeing it one recalls it as at least a foot high. It is in fine state: only the Virgin's right forearm, the tips of her Crown, and a few other minor bits are gone. The pattern of the fine decorated crocheted arabesques remain on the side of the throne and were presumably done in burnished gilt. There would have been other touches of color, in the pupils of the eyes, the lips, and on the clothing. The costumes are naturalistic, but the forms are heavy and monumental in relationship to one another. Presumably it was made as a devotional object for the use of a very rich client.

It was bought from the Kate S. Buckingham Fund Income.

School of the Ile de France Head of a Prophet or an Apostle, c. 1200 Limestone, H. 17 in (43.3 cm) Acc. no. 1944.413

This battered but still noble, monumental head is of the highest interest as it is said to have come from one of the great monuments of French medieval art, the cathedral of Paris, Notre Dame.

The piece was removed apparently in the nineteenth century in the time of the French architect Viollet-le-Duc, who was a great figure no matter how modern taste regards his ideas of restoration and preservation. It happens that

some of his restoration removals actually saved objects which would by now have totally disintegrated in the polluted atmosphere of modern Paris.

It is well to remember that this piece would have been painted and gilded, so that the total image was intended to give a divine impression of majestic splendor. The color and texture of the natural cut stone would have been invisible. Most sculpture up to the time of Michelangelo was meant to be seen painted and not in its raw state. What the modern viewer so values by way of cutting and adjusting to the material was obviously taken for granted by the medieval craftsman, to whom the modern notion of the beauty of the natural material would have been incomprehensible. After all, the church itself was meant to have limewash and color upon it, a notion which makes the total Gothic concept of form more understandable even if the attitude towards material now seems alien.

The piece was acquired for the Lucy Maud Buckingham Collection.

LOWER SAXONY Monstrance of St Christina, c. 1473 Silver, $8\frac{3}{4} \times 5\frac{1}{2}$ in $(22.2 \times 14.0 \text{ cm})$ Acc. no. 1962.90

German

This monstrance (ostensorium) for a finger relic of St Christina dates from the second half of the fifteenth century, was made in Lower Saxony, and was part of the Guelph Treasure. It is rather a 'standard' piece of late medieval silversmithery, and the engraved image of St Christina parallels the earliest engraved prints. The object is not only elegant but beautiful, and it, as well as other objects in the Art Institute from the Welfenschatz, give some notion of what was lost in England at the time of the Reformation and during the Commonwealth, and also in Rome itself during the sack of 1527.

The piece was given by Mrs Chauncey McCormick.

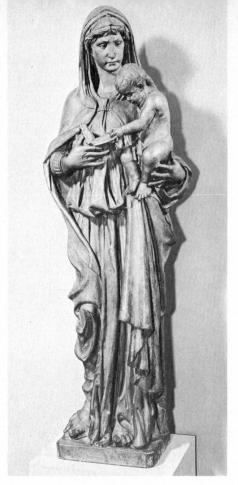

GIOVANNI MINELLI DEI BARDI (1460–1527) Virgin and Child, c. 1520 Terracotta with traces of paint, H. 57³/₄ in (146.8 cm) Acc. no. 1933.1303

Italian

This piece is by a sculptor whose career is essentially in the High Renaissance. The forms are heroic, and the traces of antique models are clearly visible in the head of the Virgin and the sternness of her gaze, which definitely evoke Roman republican busts. A logical influence on Minelli would have been that of Donatello, whose work for the high altar of the Santo in Padua he presumably knew. The great work was in bronze, and there is something of the character of that medium in this terracotta work, as though this piece might have been translated into bronze; this would have been an easy task, for the few patches of

ornament, such as the Virgin's embroidered cuff, seem visualized for rendering into chased metal.

The piece was executed at a time when sculptors still painted their work — and they continued to do so for more than a century. There are still substantial traces of the original paint, which was probably added by a specialist and not by Giovanni himself. But the piece could quite easily also have been rendered into marble. The main point is that it is conceived in terms which are purely sculptural, that is, forms set against each other in space so as to exclose and define more bits of space.

The statue came with the bequest of Martin A. Ryerson.

ALESSANDRO VITTORIA (1525–1613) St Luke, c. 1570 Terracotta, H. 23\frac{1}{8} in (58.7 cm) Acc. no. 1953.330

Alessandro Vittoria was the most important of Late Renaissance or Mannerist sculptors in Venice. A pupil of Sansovino, he was famous for his portrait busts and small bronzes as well as for his monumental works.

This figure and its three companions are detailed models for a set of the four Evangelists presumably to be executed on a monumental scale. The actual statues made from these models have still not been identified.

The bull seen at the Evangelist's feet is the beast traditionally associated with St Luke. The face of St Luke recalls Roman portrait heads, while the pose of the figure evokes Michelangelo. The surface is lively, the more so since the paint of the Victorian era has been removed. In this piece and its pendants, one has an immediacy of effect and an insight into the sculptor's methods which is most striking.

The piece was bought for the Lucy Maud Buckingham Collection.

Italian

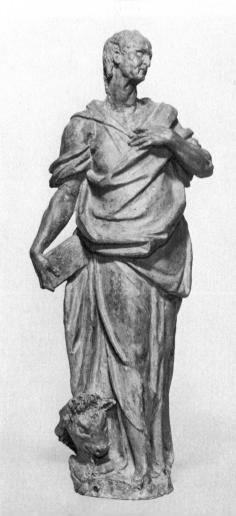

UNKNOWN ARTIST

Bohemian

Beaker: Allegory of the Ages of Man, c. 1600

Green glass with enameled decoration, H. $12\frac{3}{16}$ in (31.0 cm)

Acc. no. 1927.1012

This vessel or beaker was presumably designed to hold beer or, perhaps, wine. It is a characteristic production of the latest phase of the Renaissance in Bohemia or the earliest phase of the Baroque. The rather heraldic character of the decoration is derived in part from the nature of the enameling medium and its

exigencies and, in part, from the example of wood engravings.

The moral overtones of the concept of the Ages of Man, from ages ten to one hundred, have a cautionary value and represent a kind of traditional view in the heart of the Counter-Reformation. However, while the iconography is of great interest to the historian, it is the decorative quality which makes the piece so greatly appealing to the collector. The material, of course, makes the survival of such objects rather rare, although, as they were never cheap and were thus treated with great care, more of them have survived than might at first be expected. The charm of the beaker lies in the color of the glass – a lovely glowing green – and in the color and brisk and sprightly character of the ornament. That the ornament has humanistic interest adds to its value and intensifies its impact.

This beaker is a fine example of an object which can be called folk art but which was so expensive that, though it may not actually have been made to

order, it was nevertheless comparable to bespoke merchandise.
Julius and Augusta N. Rosenwald Collection.

Cornelius Vanderburgh Caudle Cup, c. 1683 Silver, H. $5\frac{1}{2}$ in (14.0 cm) Acc. no. 1955.651

American

This cup was made in New York in the last quarter of the seventeenth century. The basic body is spun and hammered, while the handles are cast. The form is Late Baroque, and it illustrates how colonial art usually displays a time-lag between its own date and that of its prototypes in the home country. In this case the prototype was Dutch (or, perhaps, English) silver of a generation or even half a century earlier.

Part of the charm of the piece lies in its simplicity and the very slight crudity of the handles, where the coarseness of detail lends vigor, and the bearded motifs reflect the enameled or jeweled forms of Augsburg silver of almost a century earlier. Like most colonial art this piece is also truly provincial; that is, it is made away from the determinant source but it has absorbed the source to the extent that it has become a common idiom. The quality of the engraved arms is high indeed, especially in the draftsmanship of the mantling.

This cup demonstrates how slowly basic concepts of form tend to change in silver or other metalwork. This may be attributed, in part, to the taste of a conservative public, but also, perhaps, to the craftsman's discovering a good thing and seeing no need for change, particularly if he belongs to a traditionally oriented society.

Gift from Dr and Mrs C. Phillip Miller.

PAUL DE LAMERIE (1688–1751) English The Tredegar Cup, 1739–1740 Silver, $14 \times 13\frac{1}{8}$ in, $6\frac{7}{16}$ in diameter at lip (35.5 \times 33.2 cm, 16.5 cm) Acc. no. 1974.530 a and b

This loving cup in the highly ornamental style, called the Tredegar Cup, is one of the superlatively fine works typical of this French silversmith, a long-time refugee in England. Lamerie, indeed, was the finest smith in London during the second quarter of the eighteenth century. He was as responsible as anyone for the adaptation of the *Régence* style for English use. While the form and concept are French, by the time this piece was made a subtle feeling of Englishness had come into Lamerie's work.

The piece was bought from a gift of Eloise W. Martin and a gift from the Harold T. Martin Charitable Trust.

CAPO-DI-MONTE WARE Ewer, c. 1745

Italian

Soft-paste porcelain with coloring and gilt, H. 12 in. (30.5 cm) Acc. no. 1957.490a

Capo-di-Monte ware is so called because it comes from the factory at Capo-di-Monte, near Naples, which was in operation from 1743 to 1759 under the patronage of Charles, King of Naples. This kind of porcelain is typically a glassy soft-paste, extravagantly decorated with reliefs.

This ewer, with its matching basin, is the epitome of the Neapolitan Rococo style. The shell theme is typical of the Rococo and here, not only are there various realistic shell shapes and coral as decoration, but the whole jug evokes the form of a shell. There are no angles, no straight lines, and the whole piece has a kind of smoothness as though all jagged edges had been worn away by the sea tides. Surprisingly the piece, which could so easily have been vulgar and ridiculous, is graceful and elegant. This may be due to the fact that the potter seems to have kept the actual function of the ewer in mind – it pours without dripping and the handle is comfortable to the grip and secure – and this imposed a certain discipline which prevented his imagination running amok.

Given by the family of Professor Alfred Chatain in his memory.

RICHARD GURNEY and THOMAS COOK Covered Cup, c. 1757–58 Gold, H. 8 in (20.3 cm) Acc. no. 1957.455

English

This elegant covered cup illustrates how, even in the case of a luxury product, there can be a time-lag concerning taste. By the time the piece was made in London, the first wave of Neo-classicism had swept over French taste, and was already being felt in England. The horn-blowing triton holding up the whole piece is a reflection of Bernini's style; but where an Italian goldsmith would have emphasized the form of the triton figure by increasing its scale, the conservative British craftsman reduced it to the normal scale of a connective knob. The result is that the little figure seems crushed by the volume above it, and this makes the whole piece seem much larger by contrast.

The shellwork ornament and gadrooning has been applied to a basically simple vasiform shape, and the great handles go back almost a century in their form and scale. Their size was dictated by their practical function, but they, like the tiny triton figure, serve to increase the illusion of great size.

The cup was bought for the Buckingham Collection.

JEAN-HENRI RIESENER (1734–1806)

Commode, probably 1791-92

Mahogany, gilt bronze, and marble, $37\frac{3}{4} \times 65\frac{1}{4} \times 22\frac{1}{4}$ in $(95.9 \times 155.7 \times 56.5$ cm)

French

Acc. no. 1972.412

This commode is a superb piece of furniture which epitomizes the Louis XVI style in its combination of ornamentation in inlaid wooden arabesques and the luxurious gilded mounts. Contrary to law and custom at the time, Riesener frequently made his own, and these seem no exception. The dating may presumably be established by the absence of a royal monogram and, instead, the use of a garland. One may posit that Riesener had the piece in hand when the decree forbidding royal cyphers was promulgated and so finished it off as it now is. In a very short time the style would have changed. There is evidence to believe the piece was owned by William Beckford at Fonthill Abbey.

It was bought from the income of the Wirt D. Walker Fund and the Major

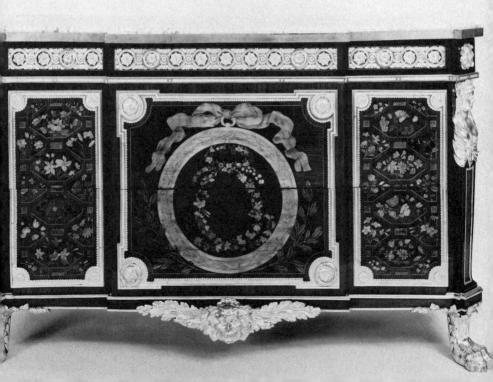

Acc. no. 1966.114a and b

Biennais is reputed to have been Napoleon's favourite goldsmith. According to tradition he owed this enviable position to the fact that he supplied the Emperor with a nécessaire de voyage prior to his departure for the Egyptian campaign and trusted him to pay for it on his return.

French

This splendid pair of sauce-boats belongs to a large set of tableware made for Napoleon's sister, Pauline Borghese, presumably from specifications by Percier and Fontaine, the imperial architects who supplied many of Biennais's best designs. They bear the Borghese arms. They were probably made between the end of the eighteenth century and the first decade of the nineteenth and reflect the interest in Classical art and archaeology typical of the Empire style. The mythological creatures are reminiscent of Egyptian forms and the lions on the base and the lion's feet add to the grandness and nobility of the pieces. Biennais, like most court jewelers, was not only a superb craftsman with the best of staff under him, he was also particularly attuned to the demands of exalted taste.

The pieces, which had belonged to Edith Rockefeller McCormick, were given by Mrs Charles V. Hickox.

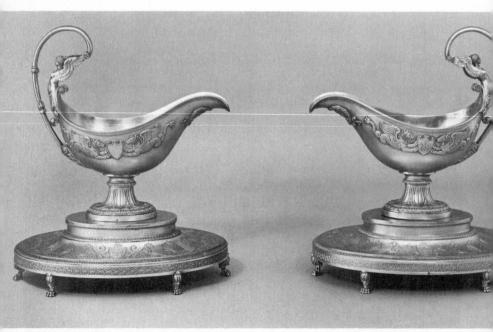

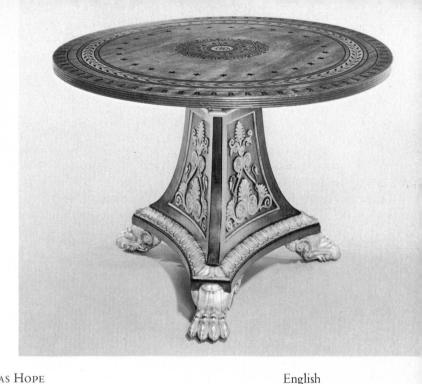

after Thomas Hope E Circular Table, c. 1810 Unstained mahogany inlaid, with gilt ornaments, H. 28½ in (72.5 cm) Acc. no. 1964.346

Thomas Hope of Deepdene was one of the principal arbiters of English Regency taste. His publication of designs for furniture determined to some degree the course of English Neo-classical furniture. He was himself a great collector of Classical antiquities; with impeccable taste and a remarkable flair for presentation, he established for clarity and serenity of expression in interior decoration what both Soane and Nash did for architecture.

This table is reproduced from a design published by Hope, and it is a work of real luxury by a master-craftsman who was capable of carving, chiseling, and using rich inlays of both wood and mother-of-pearl. It is not only an elegant table, but also a work of sculpture. The fact that it is conceived in sculptural terms, as well as in terms of a beautifully inlaid surface enhanced with gilded ornament, may seem surprising, especially as the contrast of the handsome unstained wood and the goldwork is so striking. But sculptural form the table certainly has, and of the simplest sort: a disc set upon a truncated concave pyramid.

The table was given through the generosity of Mrs Henry C. Woods.

TEXTILES

UNKNOWN ARTIST (late 13th-early 14th centuries) German, lower Saxony Embroidered Square: The Last Supper

Linen and silk, $14\frac{1}{4} \times 15$ in $(36.3 \times 38.2 \text{ cm})$

Acc. no. 1907.765

This panel may have formed part of an altar frontal or a dossal, or been part of the embroidered edging or orphrey of an altar cloth. It is certainly only part of a larger piece showing further scenes from the life of Christ. What has survived demonstrates the style of Early Gothic embroidery techniques and the nice adaptations of designs to the exigencies of the embroiderer's craft, so that, for example, there is no attempt – hardly feasible at the scale of the piece – to show the folds of the garments or the tablecloth. Rather, there is a clear rendering of the patterns of the fabrics which combine to make a pleasant overall pattern and emphasize the decorative function of the design.

But for all the stylization employed, the designer has managed in a typically Gothic way to emphasize the reality of the scene through the use of carefully observed details. An example of this is the gesture of the figure at the spectator's right, or the gesture of Christ in handing the communion host to the

apostle at the near side of the table.

The piece is a veritable repertory of the stitches used by embroiderers at this time, all of them chosen for their suitability for the fabric – thin linen – and its ornamentation.

The embroidery was acquired through exchange.

UNKNOWN ARTIST Spanish, presumably made in Burgo de Osma Dossal and Antependium: Scenes from the Life of Christ, c. 1468 Silver and gold, silk on linen, Dossal: $62\frac{3}{4} \times 77\frac{1}{2}$ in (159.5 × 196.9 cm), Ante-

pendium: $30\frac{1}{2} \times 79\frac{1}{4}$ in $(77.5 \times 201.3 \text{ cm})$

Acc. no. 1927.1779

This set of embroidered panels is one of the rare complete ones to survive from the Spanish Middle Ages. It was made for Don Pedro de Montoya, Bishop of Osma, and may have been a portable set intended for his episcopal visits; on the other hand it may have been a particularly luxurious set for use on special feast days.

The set consists of a dossal – the piece designed to hang behind the altar – and an antependium – which hung in front of the altar. The padded parts of the embroidery of the dossal imitate the kind of wooden framing and small pinnacles of painted wooden altarpieces, and the same kind of architectural motif is repeated on the antependium, presumably to imitate the carving or sculpture of the altar itself. The Latin inscriptions on this piece may have been restored and a translation of them is: 'Remember, O man, that Jesus suffered these pains for you' and 'The Lord indeed is risen and appeared to Simon'. The embroiderers used sequins and seed pearls as well as gold thread and stuffing and a great variety of stitches. It is clear that there is a strong Flemish influence, but the embroiderers' names are not known (they were presumably men, as embroidery was always done by men at this period).

Although these pieces are very valuable owing to their rarity and luxury, they are based on Spanish provincial designs of the end of the Middle Ages.

These panels were bought by Charles Deering at the end of the First World War and were given to the Museum by his daughters, Mrs Richard E. Danielson and Mrs Chauncey McCormick, in 1927.

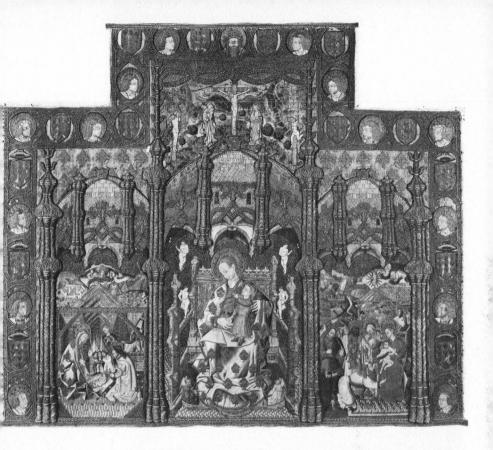

UNKNOWN ARTIST (early 16th century)

The Annunciation

Tapestry of silk, wool, gold, and linen, 46×72 in $(116.9 \times 182.9 \text{ cm})$

Italian

Acc. no. 1937.1099

Tapestry is one of the oldest of weaving techniques. This piece was woven for Francesco Gonzaga Fourth, Marquess of Mantua, who was a great patron of the arts. The actual weaving was done by a northern craftsman – Flemish or French – whose name is now lost. But the weavers usually worked from cartoons and it seems probably that the artist who provided it in this case was the greatest painter of Mantua, Andrea Mantegna. Since Mantegna died in 1506, the tapestry must have been designed before this date; it was presumably woven before 1519, the date of the marquess's death, perhaps also before 1506. The design has also been attributed to Mantegna's brother in law, Gentile Bellini, the senior and somewhat less gifted brother of Giovanni Bellini.

This tapestry came to the collection on the death of Mrs Martin Ryerson in 1937.

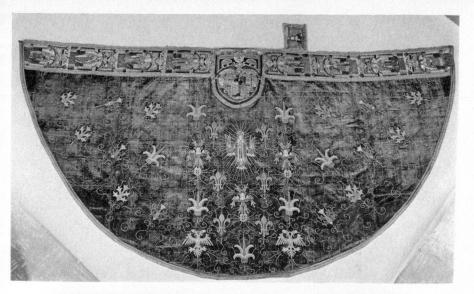

Opus Anglicanum

Cope, late 15th, early 16th century

Cope: $56\frac{5}{16} \times 115$ in $(143.0 \times 292.0 \text{ cm})$

Linen strip: $21\frac{15}{16} \times 97\frac{15}{16}$ in $(55.8 \times 248.8 \text{ cm})$. $8\frac{3}{4} \times 8$ in $(22.3 \times 20.3 \text{ cm})$

Acc. no. 1971.312 a and b

This cope, of brown silk voided velvet, embroidered in multicolored silks, metal threads, and sequins, is in unfaded condition (as the surface beneath the hood shows) and may have what is its original lining of blue holland. English medieval embroidery, called opus anglicanum, consistently the most splendid of the Middle Ages, was produced in well-run shops by male embroiderers. This magnificent processional vestment is in admirable state and shows only too clearly what was lost in the Reformation. When this vestment was cleaned it was found that the orphrey band was stuffed with a fragment of painted and stencilled linen wall-hanging from around the turn of the fourteenth century.

The garment was bought from the Grace R. Smith Textile Fund.

English

PRIMITIVE ART

TEOTIHUACAN CULTURE (AD 400–700) Mexico Painted Wall Decoration Adobe with lime and Indian red pigment, $36\frac{5}{8} \times 25\frac{1}{8}$ in (93.0×63.9 cm) Acc. no. 1962.702

Wall-painting was a highly developed art, much practised among the ancient American civilizations. One of the great surviving sites for such wall-painting is the area of Teotihuacan, just outside Mexico City. The history of Teotihuacan painting shows a gradual increase in the depiction of scenes with aqueous symbolism, presumably executed as the climate became increasingly drought ridden. The irony is that the very process of making the wall-paintings, which covered all the surfaces of the buildings, required the burning of enormous quantities of limestone, and the wood fires needed for the purpose gradually depleted the forests, only to hasten the desiccation and further to disturb the natural balance of the climate. Ultimately, in the eighth century, the lack of water seems to have brought about the final collapse of the culture.

This decoration portrays an elaborately dressed man scattering water and seeds over a field of maguey (American aloes). He is rendered in beige and black touches on a field of intense earth red.

Primitive Art Purchase Fund.

MAYA CULTURE (late 8th, early 9th century AD) Wall Panel

Mexico or Guatemala

Stone, L. 17 in (43.3 cm) Acc. no. 1965.407

Mayan stone reliefs usually occur as stelae which seem to have been set up periodically to commemorate specific time lapses; they show elaborately dressed figures accompanied by glyphs translatable into precise dates. A rarer sort shows complex ceremonial scenes; these were used as architectural ornaments set into the walls of buildings. The one illustrated here belongs to the latter category. Two men are shown wearing rich costumes with ornaments of feather, jade, animal, and bird-forms as well as richly woven skirts and tasseled belts. They also wear knee-pads and wrist-guards, and the recumbent figure has a thick yoke about his waist. These details seem to indicate that they were participants in a ceremonial ball-game. The stepped form on the left represents a part of the ball-court structure, and directly above it is the ball itself, presumably enlarged to many times its normal size. The panel at the top right where the glyphs once were is now abraded, and decipherment is not possible.

By stylistic analogy with pieces of known provenance, it seems clear that this piece came from the upper Usumacinta River area and was done during the dynamic phase of the Late Classic period, AD 751-811. It is now known that this relief belongs to a set of eight, of which three are devoted to glyphs, and

the remaining four show single figures in similar ball-game costume. The entire set could have ornamented a ball-court area, though the fine preservation suggests an original site within a building. The piece represents the greatest period of Mayan art.

The carving was bought from the Ada Turnbull Hertle Fund.

MAYA CULTURE, LATE CLASSIC PERIOD (c. AD 700–900) Cylindrical Vessel Mexico or Guatemala Painted, fired clay, H. $8\frac{3}{8}$ in (21.4 cm) Acc. no. 1966.161

The scenes shown on Mayan painted ceramics are tantalizing, for they are of ceremonies and events whose meaning can only be guessed. This superb specimen presents two almost identical scenes, each surrounded by a frame of decorative glyphs. One scene (shown in the photograph) presents a cross-legged central figure leaning towards a tripodal bowl containing an offering, perhaps of food. The glyph appearing between his lips and the offering indicates speech, just like the 'balloon' of the modern comic strip. Facing this figure is another seated figure in profile pointing to the offering. The other panel (not shown here) is similar: the central figure is shown offering a small object to his companion; between them there is a small, cylindrical covered vessel.

A plausible interpretation of the scenes depicted is that they show the meeting and exchange of gifts between important Mayan personages. Elaborately painted vessels such as this were made to accompany burials, and perhaps the two scenes relate to important episodes in the life of the dead man, represented by the central figure. The large oval form behind each figure is considered to represent a ceremonial jaguar skin.

This vessel, in superb condition, was made between the eighth and the tenth centuries and came from an important site, still unidentified, in Guatemala or southern Mexico. It is important not only for its representation of an ancient ritual or ceremony, but also, artistically, for the imbalance in the poses of the human figures; this was a specifically Mayan contribution to pre-Hispanic American art.

The piece was bought from the income of the Ada Turnbull Hertle Fund.

AZTEC CULTURE (after AD 900)

Standing Male Figure, the god Xipe

Terracetta with traces of pigment 1

Mexico, Veracruz

Terracotta with traces of pigment, H. 23¹/₄ in (59.1 cm)

Acc. no. 1960.905

The god Xipe belonged to the pantheons of the Teotihuacan, Zapotec, and Mixtec cultures. He is frequently shown in Aztec times. Xipe was the patron of the guild of Mixtec goldsmiths. But he is mainly known as the god responsible

for the annual renewal of vegetation and for the growth of flowers, a kind of male, Aztec Persephone. The piece shown here is typical, and its symbolization of nature's regeneration is more gruesomely graphic than any notion of Persephone.

Xipe is always depicted with two layers of skin. The outer layer is the flayed and partly sewn integument from a victim sacrificed by cutting out his heart. The renewal of nature is symbolized by the removal (in a ceremony) of

the outer skin to reveal the new beneath it.

Xipe was much represented in stone, and there are many smaller figures of him in clay. This one is among the very largest surviving to be made of terracotta. The piece was made in Veracruz. At Remojadas, in that state, there was a long-lasting tradition of figurative sculpture in ceramic which originated in the Classic period, and it is possible that this fine work was made there.

The sculpture was given by Florene May Schoenborn and Samuel A. Marx.

MOCHICA CULTURE (AD 500–700)

Portrait Vessel with a Stirrup Spout

Terracotta, H. 14 in (35.7 cm)

Acc. no. 1955.2338

Peru

True portraiture is uncommon in pre-Hispanic America. Most of its figurative art represents supernatural deities or typical, important figures from the priestly establishment. Although some of these likenesses can be taken as highly idealized portraits, any sense of a specific individual is almost always missing. But the potters of the Mochica culture, who worked on the northern coast of Peru between 200 BC and AD 700 did create notable exceptions, and their productions always give the impression of depicting an individual personality.

The illustrated piece dates from the sixth through the eighth centuries – the late period – and depicts an important personage wearing an elaborate textile headband. The smallest details have been rendered with the greatest care, and the strong Indian character of the head has various features still visible

among the Indians of the highlands of Peru.

Sculptures such as this one were made from two-piece moulds, the spout and bottom being added when the body was taken from the mould. Painted and modelled details were then added and the whole subsequently fired in an open kiln. The vessel was apparently made to be buried with the man represented.

This piece came from the collection of Eduard Gaffron, and was bought from the Buckingham Fund in 1955.

BAKOTA PEOPLE, GABON (late 19th century)

Reliquary Figure

Wood, copper, brass, bone, twine, and hide, 24×12 in $(61.0 \times 30.5 \text{ cm})$

Acc. no. 1975.125

These figures marked the funerary baskets in which the exhumed bones of a distinguished personage were kept. The figure apparently symbolizes the concept of ancestorhood rather than depicting the person over whose bones it is placed. The convexity and concavity of the head suggest the quality of the individual spirit. Such pieces were of enormous importance to disparate artists like Picasso, Brancusi, and Modigliani, and represent the first wave of exoticism in the twentieth century.

This one was bought from the Samuel A. Marx Fund.

MADE BY THE BAMBARA TRIBE

Pair of Antelope Headpieces

Wood, metal, shell, H. 31¹/₄, 38³/₄ in (79.3, 98.5 cm)

Acc. no. 1965.06,07

Africa, Mali

Africa

By reason of their elegant, graceful forms, antelope carvings from the Bambara tribe rank among the most popular and admired expressions of West African sculpture. Designed as headpieces to be set upon cloth or basketwork caps, they were worn during ceremonial dances which were held in honor of a mythical anthropomorphic antelope called Tji Wara. The Bambarans believed Tji Wara had taught them the science of cultivation, and danced in his honor on such occasions as the clearing of a new field or the beginning of the rainy season. The dances were executed by pairs of performers, one of whom wore the ensign of a male antelope, the other that of a female (here identified by the baby on her back). The dancers also wore long costumes of vegetable fibre. Their actions imitated motions of playing animals, and to this end the dancers used two canes for support and elevation.

Intact pairs of headdresses are rare. The forms and also the surface detailings and the precise use of brass tacks, metal strips, and cowrie-shell necklaces are

evidence that these headdresses form a pair. This open-work type of headdress is customarily thought to have been made in the Segou area of the Bambara country.

These were bought from the income of the Ada Turnbull Hertle Fund.

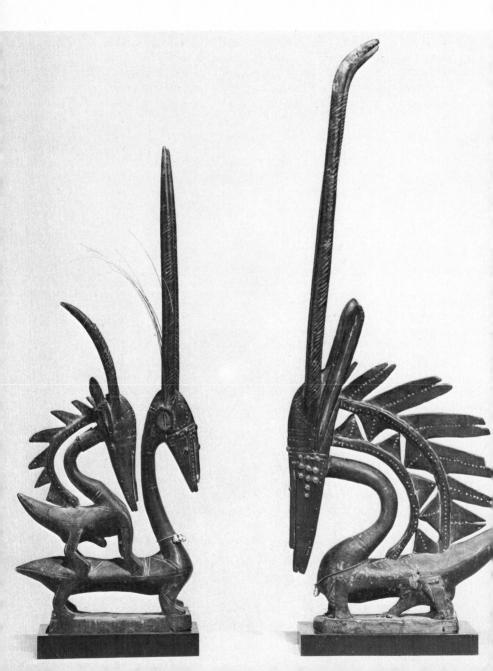

APPENDIX

This section of the book illustrates in black and white more works from the holdings of painting and sculpture. It is hoped that from these the reader will get a still clearer idea of the scope of the Collections.

Veneto-Riminese Virgin and Child with Scenes from the Life of Christ c. 1325-30

Flemish School Lamentation c. 1490

Lucas Cranach the Elder The Crucifixion 1533 (38?)

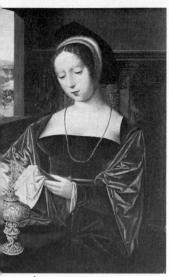

er of the Female Half-Figures Mary Magdalen c. 1525

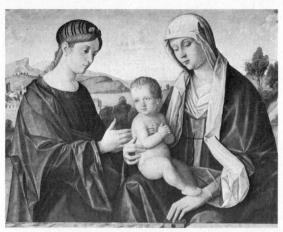

Catena Virgin and Child with Saint c. 1500

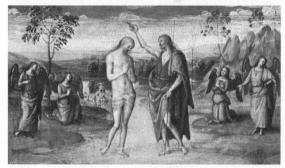

Perugino Baptism of Christ c. 1510

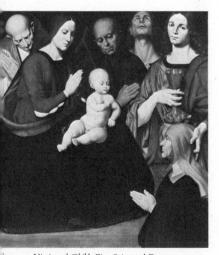

impatta Virgin and Child, Five Saints and Donor c. 1500

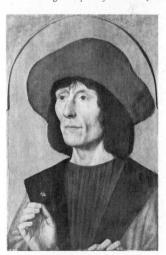

Massys Man with a Pink 1510-20

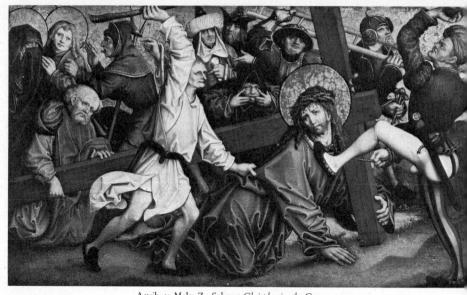

Attrib. to Maler Zu Schwaz Christ bearing the Cross c. 1515

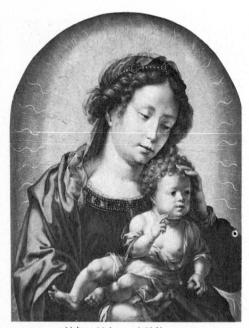

Mabuse Madonna and Child c. 1520

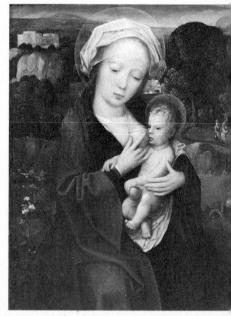

Isenbrandt Madonna and Child c. 1510-40

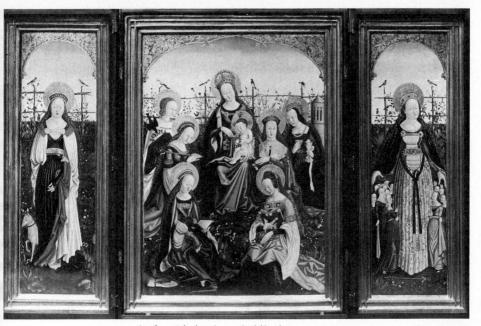

Attrib. to Scheel Madonna and Child with Saints c. 1525

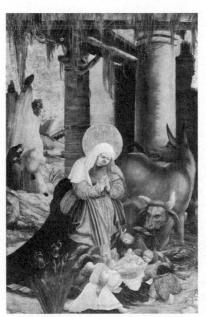

Master of the Historia Nativity c. 1510-20

Lo Spagna St Catherine of Siena c. 1516

Gerung The Judgment of Paris 1536

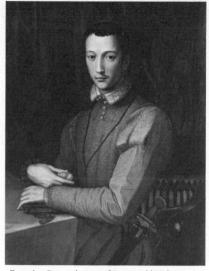

Bronzino Presumed portrait of Francesco de' Medici c. 1560

Moretto Mary Magdalene 16th C.

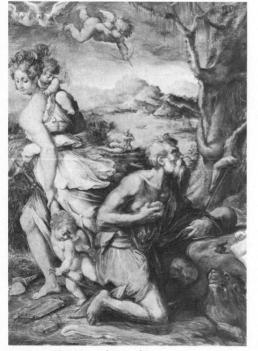

Vasari Mystical Vision of S. Jerome c. 1550

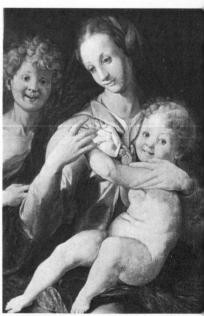

Pontormo (follower) Virgin, Child, and Infant St John 16th C.

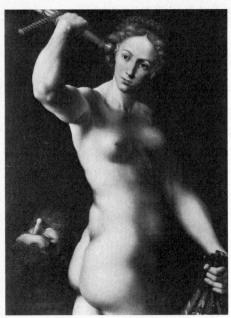

Van Hemessen Judith c. 1560

Moroni Lodovico Madruzzo c. 1560

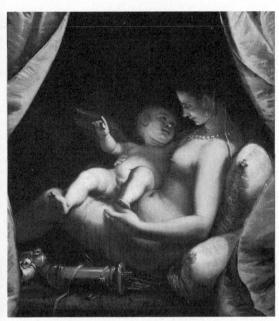

Luca Cambiaso Venus and Cupid 1570-75

Attrib. to Jacopo da Empoli Widow of the Medici Family 16–17th C.

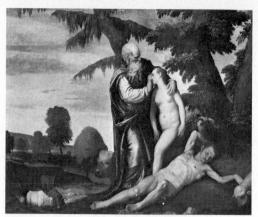

Veronese Creation of Eve c. 1570

Juan Sánchez Cotán Still-Life c. 1602

Cecco del Caravaggio The Resurrection c. 1600

Velazquez St John in the Wilderness

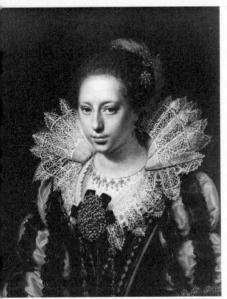

Moreelse Portrait of a Lady c. 1620

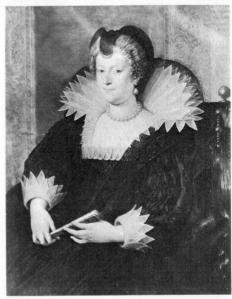

Pourbus the Younger Marie de' Medici 1616

Velazquez The Servant 1618-22

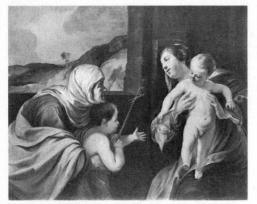

Blanchard Virgin, Child with SS John and Anne 1630-31

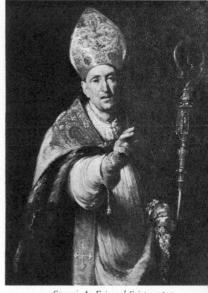

Strozzi An Episcopal Saint c. 1630

Follower of Zurbarán Still-Life: Flowers and Fruit c. 1633–44

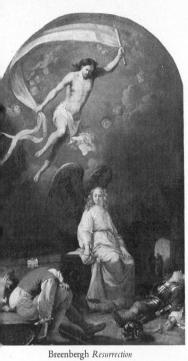

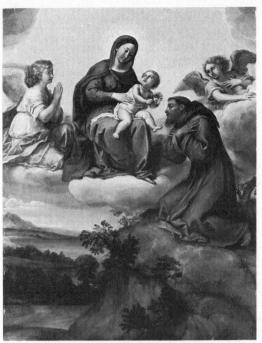

Albani Virgin and Child adored by St Francis

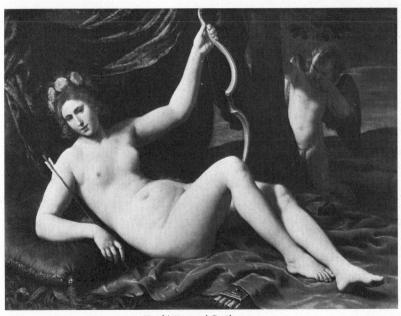

Turchi Venus and Cupid c. 1630

Ruisdael Ruins of Egmond 1650-60

Van Soest Portrait of Dr John Bulwer 17th C.

Terborch The Music Lesson 1660

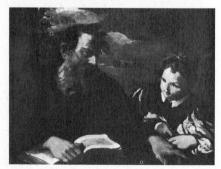

Mola Homer Dictating c. 1650

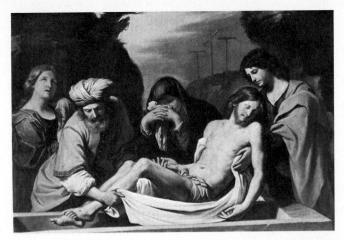

Guercino The Entombment 1656

Hobbema The Watermill with the Great Red Roof c. 1670

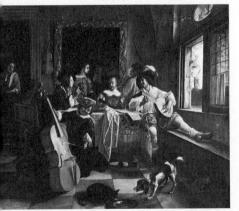

Steen The Family Concert 1666

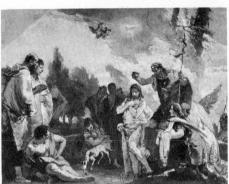

Tiepolo The Baptism of Christ

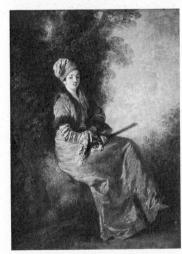

Watteau The Dreamer 18th C.

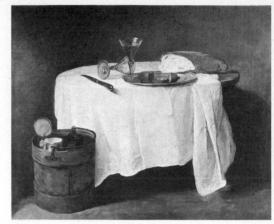

Chardin The White Tablecloth c. 1737

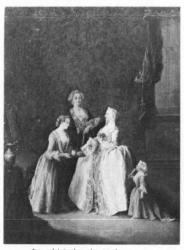

Longhi Lady at her Toilet c. 1740

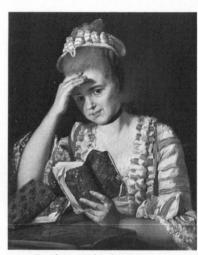

David Portrait of Madame Buron 1769

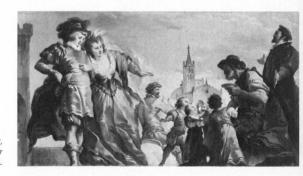

Giuseppe Cades Meeting of Gautier, Count of Antwerp, and his Daughter Violante 18th C.

Goya The Hanged Monk c. 1810

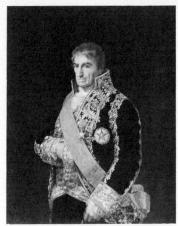

Goya General José Manuel Romero c. 1810

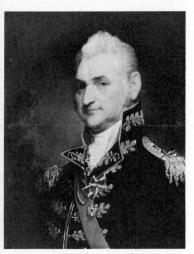

Stuart Major General Henry Dearborn 1811-12

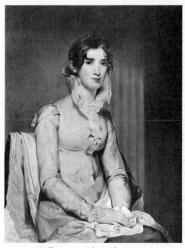

Sully Anna Milnor Klapp 1814

Géricault After Death 1818-19

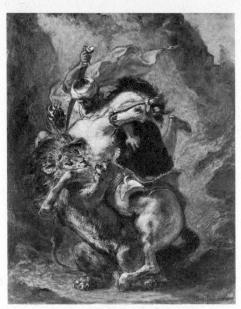

Delacroix Arab Rider Attacked by Lion 1849

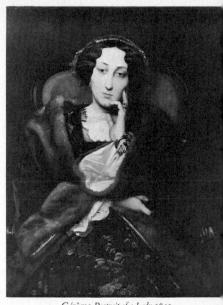

Gérôme Portrait of a Lady 1851

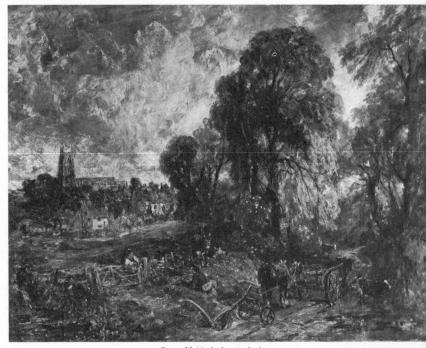

Constable Stoke-by-Nayland 1836

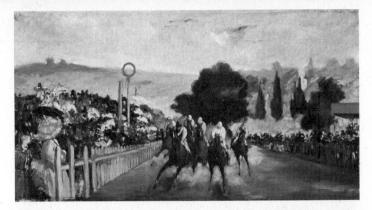

net Race track near Paris 1864

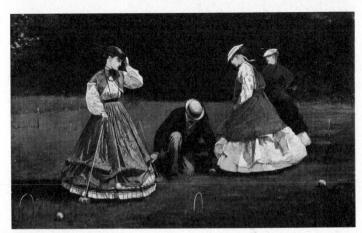

Homer Croquet Scene 1866

Manet Boy with Pitcher c. 1862

Fantin-Latour Portrait of Édouard Manet 1867

Corot Wounded Eurydice 1868–70

Fantin-Latour Still-Life: Corner of a Table 1873

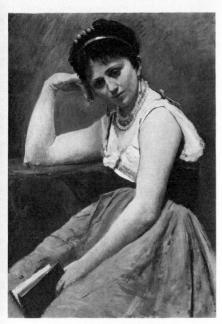

Corot Interrupted Reading c. 1870

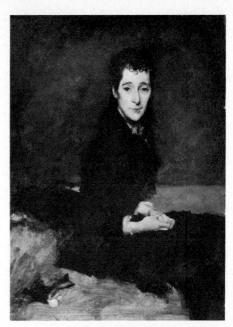

Sargent Mrs Charles Gifford Dyer 1880

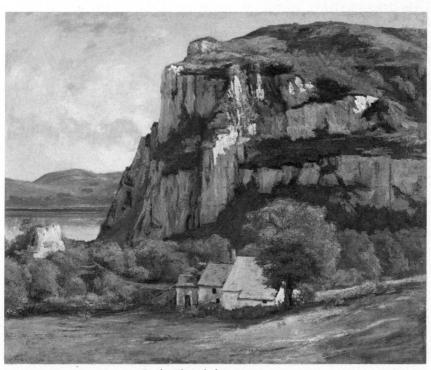

Courbet The Rock of Hautepierre c. 1869

Degas Woman in a Rose Hat 1879

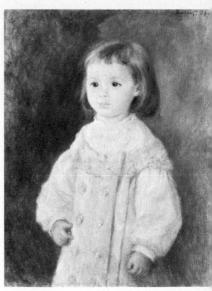

Renoir Child in White 1883

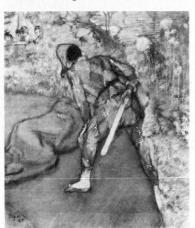

Degas Harlequin 1885

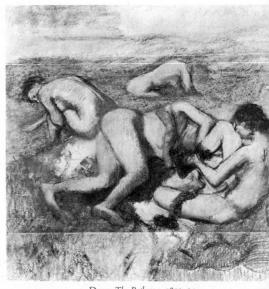

Degas The Bathers c. 1890-95

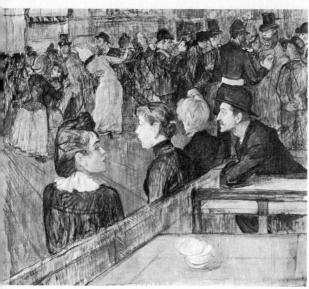

Toulouse-Lautrec Moulin de la Galette 1889

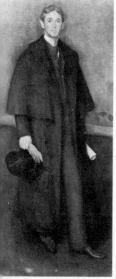

Whistler Arthur Jerome Eddy 1894

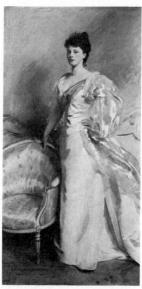

Sargent Mrs George Swinton 1896

Mancini Resting

Pissarro Girl Sewing 1895

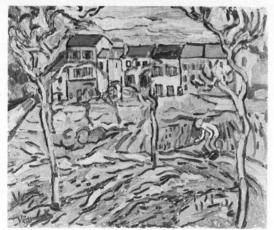

Vlaminck Houses at Chatou 1903

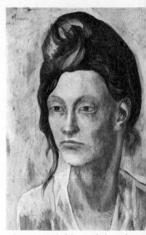

Picasso Head of the Acrobat's Wife 190.

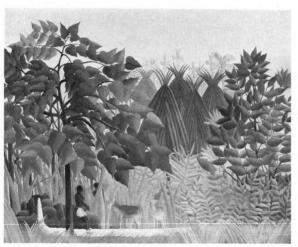

Rousseau The Waterfall 1910

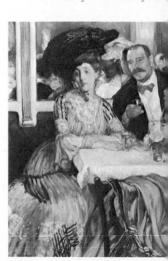

Glackens Chez Mouquin 1905

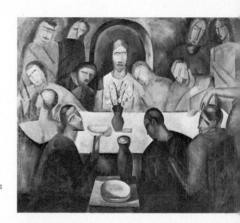

Derain The Last Supper 1911

Miró Portrait of a Woman (Juanita Obrador) 1918

Marc Bewitched Mill 1913

Chagall The Praying Jew 1914

Chirico The Philosopher's Conquest 1914

Feininger Village Street 1929

Bonnard La Seine à Vernon

Albright That Which I Should Have Done I Did Not Do 1931-41

O'Keeffe Cow's Skull with Calico Roses 1931

Beckmann Self-Portrait 1937

Magritte Time Transfixed 1939

Dali Inventions of the Monsters 1937

Balthus Patience 1943

Delvaux The Village of the Mermaids 1942

Hopper Nighthawks 1942

Blume The Rock 1948

Gorky The Plough and the Song No. 2 1946

Picasso Nude Under a Pine Tree 1959

De Kooning Excavation 1950

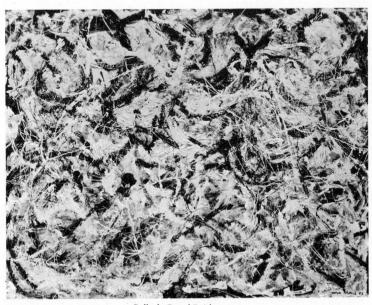

Pollock Grayed Rainbow 1953

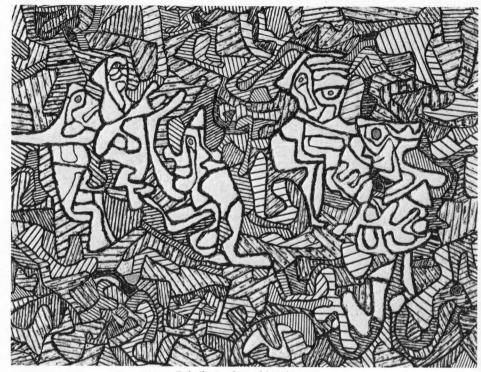

Dubuffet Genuflexion of the Bishop 1963

INDEX OF ILLUSTRATIONS

The Art Institute of Chicago 6 Albani, Francesco, 1578–1660: Virgin and Child adored by Saint Francis. Oil on copper. $12\frac{3}{4} \times 9\frac{3}{4}$ in $(32.3 \times 24.8$ cm). Cyrus McCormick Fund 259

ALBRIGHT, IVAN LE LORRAINE, b. 1897: That Which I Should Have Done I Did Not Do, 1931-41. Oil on canvas. 97×36 in (246.5×91.5 cm) 272

Anchi Kwaigetsudō, active 1710–1720: Standing Beauty. Colored woodblock print. $21\frac{3}{4} \times 11\frac{1}{2}$ in $(55.4 \times 29.2 \text{ cm})$

AZTEC CULTURE (after AD 900): Standing Male Figure, the god Xipe. Terracotta with traces of pigment. H. 23½ in (59.1 cm)

BAKOTA PEOPLE: Reliquary, late 19th century. Wood, copper and brass sheeting, bone, twine, and hide. H. 24 in, W. 12 in $(61.0 \times 30.5 \text{ cm})$ 246

Balthus, Balthasar Klossowsky, b. 1910: Patience, 1943. Oil on canvas. $63\frac{1}{8}\times64\frac{1}{2}$ in (161.0×163.9 cm). The Joseph Winterbotham Fund 273

BAMBARA TRIBE: Pair of Antelope Headpieces. Wood, metal, shell. H. 314, 384 in (79.3, 98.5 cm)

Bartolommeo, Fra, 1475–1517: Landscape: Hermitage upon a Hill. Pen and ink on paper. It $\frac{7}{16} \times 8\frac{1}{2}$ in $(29.0 \times 21.7 \text{ cm})$ 143

BASSANO (JACOPO DA PONTE) c. 1510–1592: Madonna and Child and infant St John the Baptist, c. 1565–68. Oil on canvas. 29×33¼ in (73.7× 84.5 cm)

BATONI, POMPEO GIROLAMO (1708–1787): José Muñoz, Duque de Florida Blanca, 1777. Oil on canvas. $39\frac{1}{4} \times 29\frac{5}{8}$ in $(99.5 \times 75.3$ cm) 64

BAZILLE, FRÉDÉRIC, 1841–1870: Self-Portrait, 1865. Oil on canvas. $42\frac{3}{4} \times 28\frac{3}{8}$ in (108.6 \times 72.0 cm)

BECKMANN, MAX, 1884–1950: Self-Portrait, 1937. Oil on canvas. $75\frac{3}{4} \times 35$ in (192.5 \times 88.9 cm). Gift of Mr and Mrs Philip Ringer

BIENNAIS, MARTIN GUILLAUME, 1764–1843:
Pair of Sauciers en Plateau. Silver gilt. H. 11½ in (29.2 cm)

BLANCHARD, JACQUES, 1600-1638: Virgin, Child with SS. John and Anne, 1630-31. Oil on canvas. 37×48 in $(94\times122$ cm). Gift of Sam Salz 258

BLUME, PETER, b. 1906: *The Rock*, 1948. Oil on canvas. 58 × 74 in (147.4 × 188.0 cm) 275

BOCCIONI, UMBERTO, 1882–1916: *Ines*, 1909. Pencil. 15×15½ in (38.2×39.5 cm) 166

BOHEMIAN, UNKNOWN ARTIST: Beaker: Allegory of the Ages of Man, c. 1600. Green glass with enameled decoration. H. $12\frac{3}{16}$ in (31.0 cm) 228

BONNARD, PIERRE, 1867–1947: La Seine à Vernon, 1930. Oil on canvas. $42\frac{1}{2} \times 42\frac{1}{2}$ in (108.0 \times 108.0 cm). Clyde M. Carr Fund

BOTTICELLI, SANDRO, 1444–1510: Madonna and Child with Angels, c. 1490. Tempera on panel. D. $13\frac{1}{8}$ in (33.4 cm)

BOUCHER, FRANÇOIS (1703–1770): Pense-t-il aux Raisins?, 1747. Oil on canvas. $31\frac{5}{8} \times 27$ in (80.0 \times 68.5 cm)

BOUDIN, EUGÈNE, 1824–1898: Approaching Storm, 1864. Oil on panel. $14\frac{3}{8} \times 22\frac{3}{4}$ in $(36.6 \times 57.9 \text{ cm})$

Breenbergh, Bartholomeus, 1599–1655/59: Resurrection. Oil on panel. $14 \times 8\frac{3}{8}$ in $(35.7 \times 21.4$ cm). Frank H. and Louise B. Woods Fund 259 Breton, Jules, 1827–1906: The Song of the Lark, 1884. Oil on canvas. $43\frac{1}{2} \times 33\frac{3}{4}$ in $(110.6 \times 85.8$ cm)

Bronzino (Angelo Allori), 1502/3–1572. Presumed Portrait of Francesco de' Medici, c. 1560. Oil on panel. $38\frac{3}{4}\times30$ in (98.5 \times 76.3 cm). Gift of Edgar Kaufmann, Jr 254

Brueghel the Elder, Pieter, c. 1525–1569: The Hare Hunters, 1566. Etching. $8\frac{5}{8} \times 11\frac{1}{2}$ in (22.0×29.2 cm)

BURGKMAIR, HANS, 1473–1531: Maximilian I on Horseback, 1508. Woodcut printed in black ink and gold upon vellum. $12\frac{1}{2} \times 9$ in $(31.8 \times 22.8 \text{ cm})129$

BUTINONE, BERNARDINO (before 1436–after 1507): Flight into Egypt, c. 1480. Egg tempera on panel. $10\frac{3}{16} \times 8\frac{11}{16}$ in $(25.9 \times 22.1 \text{ cm})$ 30

Cades, Giuseppe, 1750–1799: Meeting of Gautier, Count of Antwerp, and his Daughter Violante. Oil on canvas. $14\frac{5}{8} \times 27\frac{1}{2}$ in (37.2 \times 70 cm). Worcester Sketch Fund

CAILLEBOTTE, GUSTAVE, 1848–1894: The Place de l'Europe on a Rainy Day, 1877. Oil on canvas. $83\frac{1}{2} \times 108\frac{3}{4} \, (212.2 \times 276.2 \text{ cm})$ 95

Cambiaso, Luca, 1527–1585: Venus and Cupid, 1570–75. Oil on canvas. $42\frac{3}{8} \times 37\frac{3}{4}$ in (107.7× 95.9 cm). A. A. Munger Collection

CANALETTO (ANTONIO CANAL), 1697–1768: Ruins of a Courtyard. Pen, brown ink, and grey wash over graphite. $11\frac{1}{2} \times 8\frac{1}{6}$ in $(29.2 \times 20.6 \text{ cm})$

CAPO DI MONTE WARE: Ewer, c. 1745. Soft paste porcelain with coloring and gilt. H. 12 in (30.5 cm)

CARAVAGGIO, CECCO DEL, active 1st quarter 17th century: *The Resurrection*, c. 1600. Oil on canvas. 133½×78½ in (339.1×199.5 cm). Charles H. and Mary F.S. Worcester Collection

CARPACCIO, VITTORE, c. 1450–c. 1522: A Young Nobleman. Brushed grey ink heightened with white. $10 \times 7\frac{5}{8}$ in $(25.5 \times 19.4 \text{ cm})$

CASSATT, MARY, 1844–1926: The Bath, c. 1891–92. Oil on canvas. $39\frac{1}{2} \times 26$ in $(100.3 \times 66.1 \text{ cm})$

CATENA, VINCENZO DI BIAGIO, ϵ . 1470–1531: Virgin and Child with Saint. Oil on panel. $25\frac{3}{4}\times 33\frac{1}{8}$ in (65.4×84.1 cm). Gift of Chester D. Tripp

CÉZANNE, PAUL, 1839–1906: The Basket of Apples, 1890–94. Oil on canvas. $25\frac{3}{4} \times 32$ in $(65.4 \times 81.3 \text{ cm})$ 99 Bathers, c. 1900. Oil on canvas. $20\frac{3}{16} \times 24\frac{1}{4}$ in $(51.3 \times 61.7 \text{ cm})$ 103 Mme Cézanne in a Yellow Chair, 1890–94. Oil on canvas. $31\frac{7}{8} \times 25\frac{1}{2}$ in $(81.0 \times 64.8 \text{ cm})$ 102 Montagne-Sainte-Victoire. Watercolor on paper. $13\frac{5}{8} \times 20\frac{7}{8}$ in $(34.7 \times 53.1 \text{ cm})$ 163 The Vase of Tulips, 1890–94. Oil on canvas. $23\frac{1}{2} \times 16\frac{5}{8}$ in $(59.6 \times 42.3 \text{ cm})$ 101

CHAGALL, MARC, b. 1887: The Praying Jew (The Rabbi of Vitebsk), 1914. Oil on canvas. 46×35 in (116.9×88.9 cm). The Joseph Winterbotham Collection

CHARDIN, JEAN-BAPTISTE SIMÉON, 1699–1779: The White Tablecloth, c. 1737. Oil on canvas. $37\frac{7}{8} \times 48\frac{3}{4}$ in $(95.9 \times 123.8$ cm). Gift of Annie Swan Coburn to the Mr and Mrs Lewis Larned Coburn Memorial Collection

CH'EN CHI/JU, 1558–1637: Calligraphy. Ink on gilt-spattered paper. $7\frac{1}{4} \times 20\frac{1}{4}$ in (18.5 \times 51.5 cm)

CH'EN JU-YEN, active 1340–1380: A Hermitage. Hanging scroll, ink on paper. $34\frac{3}{4}\times19$ in (88.3×48.3 cm)

CHICAGO PAINTER, mid-5th century BC: The Chicago Vase, c. 460–440 BC. Terracotta. H. 14³/₄ in (37.5 cm)

CH'ING DYNASTY, 1644–1912: Chair. Bamboo with painted details. H. 37 in (94.0 cm) 189 Carved Lacquer Box. Lacquer. D. 14 in (35.7 cm)

CHIRICO, GIORGIO DE, b. 1888: The Philosopher's Conquest, 1914. Oil on canvas. $49\frac{1}{2} \times 39\frac{1}{4}$ in (125.8 \times 100.3 cm). The Joseph Winterbotham Collection 271

CHOLA PERIOD, 907–1053: Standing Figure of Brahma. Pink granite. H. 54 in (137.2 cm) 213

CONSTABLE, JOHN, 1776–1837: Stoke-by-Nayland, 1836. Oil on canvas. $49\frac{1}{2}\times66\frac{3}{8}$ in (125.8×168.8 cm). Mr and Mrs. W. W. Kimball Collection

Copley, John Singleton, 1738–1815: Mary Greene Hubbard, 1764. Oil on canvas. $50\frac{1}{4} \times 39\frac{7}{8}$ in (127.7×101.3 cm)

CORINTH, LOVIS, 1858–1925: Self-Portrait, 1917. Oil on canvas. $18\frac{1}{8} \times 14\frac{5}{8}$ in $(46.2 \times 37.1 \text{ cm})$ 118

COROT, JEAN-BAPTISTE CAMILLE, 1796–1875: Interrupted Reading, c. 1870. Oil on canvas. $36\frac{1}{2} \times 25\frac{3}{4}$ in (92.8×65.5 cm) 267 View of Genoa, 1834. Oil on paper. $11\frac{5}{8} \times 16\frac{3}{8}$ in (29.5×41.7 cm) 70 Wounded Eurydice, 1868–70. Oil on canvas. $22 \times 16\frac{1}{4}$ in (56.0×41.5 cm). Henry Field Memorial Collection 266

Correggio (Antonio Allegri) ϵ . 1494–1524: Virgin and Child with St John the Baptist, probably 1515. Oil on panel. $25\frac{1}{4} \times 19\frac{3}{4}$ in $(64.2 \times 50.4 \text{ cm})$

Cotán, Juan Sánchez, 1561–1627: Still-Life, c. 1602. Oil on canvas. $26_8^3 \times 34_4^3$ in $(67.7 \times 88.3$ cm). Gift of Mr and Mrs Leigh B. Block 256

COURBET, GUSTAVE, 1819-1877: Mère Grégoire, 1855. Oil on canvas. $50\frac{3}{4} \times 38\frac{1}{4}$ in $(128.9 \times 97.2 \text{ cm})$ 74

The Rock of Hautepierre, c. 1869. Oil on canvas. $31\frac{1}{2} \times 39\frac{1}{2}$ in $(80.2 \times 100.3 \text{ cm})$ 267

Cranach the Elder, Lucas, 1472-1553: The Crucifixion, 1533 (382). Oil on panel. $47\frac{11}{16} \times 32\frac{1}{2}$ in (121.1×82.6 cm). Charles H. and Mary F.S. Worcester Collection 250 Eve tempted by the Serpent, c. 1530. Oil on panel. $42\frac{3}{8} \times 14\frac{3}{8}$ in (107.7×36.6 cm) 38

Dali, Salvador, b. 1904: Inventions of the Monsters, 1937. Oil on canvas. $20\frac{1}{8} \times 30\frac{7}{8}$ in $(51.1 \times 78.4$ cm)

DAUMIER, HONORÉ, 1808–1878: Fatherly Discipline. Pen and ink wash over pencil. $10 \times 7_8^7$ in $(25.5 \times 20.0 \text{ cm})$ The Three Judges. Pen and ink over pencil and watercolor. $11_4^3 \times 18_8^3$ in $(29.8 \times 46.8 \text{ cm})$ 154

DAVID, GÉRARD, c. 1455–1523: Lamentation at the foot of the Cross, c. 1511. Oil on panel. $21\frac{1}{2} \times 24\frac{1}{2}$ in $(54.7 \times 62.4$ cm)

David, Jacques-Louis, 1748–1825: Mme Pastoret and her Son, c. 1791–92. Oil on canvas. $52\frac{3}{8} \times 39\frac{3}{8}$ in (133.1×100.0 cm) 65 Portrait of Madame Buron, 1769. Oil on canvas. $25\frac{5}{8} \times 21\frac{1}{2}$ in (65.2×54.7 cm). Gift of Mrs Albert

J. Beveridge in memory of her mother Abby Louise Spencer (Mrs Augustus Eddy) 262

DEGAS, EDGAR, 1834–1917: The Bathers, c. 1890–95. Pastel on paper. $44\frac{5}{8} \times 45\frac{1}{2}$ in (113.4×115.7 cm). Gift of Nathan Cummings 268 Dancers preparing for the Ballet, c. 1880. Oil on canvas. $29\frac{3}{16} \times 23\frac{3}{4}$ in (74.1×60.5 cm) 88 Harlequin, 1885. Pastel on paper. $22\frac{1}{2} \times 25\frac{1}{2}$ in (57.3×64.8 cm). Bequest of Loula D. Lasker 268 The Millimery Shop, c. 1882. Oil on canvas. $39\frac{1}{8} \times 43\frac{3}{8}$ in (99.5×110.3 cm) 89 Woman in a Rose Hat, 1879. Pastel, tempera and oil on canvas $33\frac{3}{4} \times 29\frac{5}{8}$ in (85.8×75.3 cm). The Joseph Winterbotham Collection 268

DE KOONING, WILLEM, b. 1904: Excavation, 1950. Oil on canvas. $80\frac{1}{8} \times 100\frac{1}{8}$ in (203.5×254.5 cm). Mr and Mrs Frank G. Logan Purchase Prize, Gift of Mr Edgar Kaufmann, Jr and Mr and Mrs Noah Goldowsky

DELACROIX, EUGÈNE, 1798–1863: Arab Rider Attacked by Lion, 1849. Oil on panel. $18\times14_4^3$ in (45.8 \times 37.5 cm). Potter Palmer Collection 264 The Lion Hunt, 1861. Oil on canvas. $30\frac{1}{16}\times38\frac{3}{4}$ in (76.5 \times 98.5 cm)

DELAUNAY, ROBERT, 1882–1941: Champ de Mars, the Red Tower, 1911. Oil on canvas. $64\times 51\frac{1}{2}$ (162.6 \times 130.9 cm)

DELVAUX, PAUL, b. 1897: The Village of the Mermaids, 1942. Oil on panel. 41×49 in (104.2×124.5 cm). Gift of Mr and Mrs Maurice E. Culberg

Derain, André, 1880–1954: The Last Supper, 1911. Oil on canvas. $89\frac{1}{4} \times 113\frac{1}{2}$ in (226.7 \times 288.4 cm). Gift of Mrs Frank R. Lillie 270

DUBUFFET, JEAN, b. 1901: Genuflexion of the Bishop, 1963. Oil on canvas. $86\frac{3}{4} \times 118$ in (220.4×299.7 cm). The Joseph Winterbotham Fund 278

EAKINS, THOMAS, 1844–1916: Addie, Woman in Black, 1899. Oil on canvas. 24×20 in $(61.0\times50.9 \text{ cm})$

EASTERN CHOU DYNASTY, SECOND HALF, 480-222 BC: Covered wine vessel called a Ho. Bronze with patination. H. 10½ in (25.7 cm) 176

EASTERN CHOU DYNASTY, LATE, c. 660-222 BC: Kneeling Prisoner. Steatite (?), H. 7³/₄ in (19.7 cm)

Ring disc called a Pi. Jade. D. 8 in (20.3 cm) 179

EMPOLI, JACOPO DA (JACOPO CHIMENTI), Attrib. to, c. 1554–1640: Widow of the Medici Family. Oil on canvas. $87 \times 48\frac{1}{4}$ in (221×122.6 cm). Frank H. and Louise B. Woods Purchase Fund

FANTIN-LATOUR, HENRI, 1836–1904: Portrait of Édouard Manet, 1867. Oil on canvas. $46 \times 35\frac{1}{2}$ in (116.9 \times 90.2 cm). Stickney Fund 266 Still Life: Corner of a Table, 1873. Oil on canvas. $38\frac{1}{4} \times 49\frac{1}{4}$ in (97.2 \times 125.1 cm). Ada Turnbull Hertle Fund 266

FEININGER, LYONEL, 1871–1956: Village Street, 1929. Oil on canvas. $31\frac{3}{4} \times 39\frac{3}{4}$ in (80.8 \times 101.0 cm). Gift of Mr and Mrs Sigmund Kunstadter 271

FLEMISH SCHOOL, 15th century: Lamentation, c. 1490. Oil on panel. $16\frac{3}{4} \times 11\frac{1}{4}$ in (42.6 \times 28.6 cm). Max and Leola Epstein Collection 250

FOX TALBOT, WILLIAM HENRY, 1800–1877: Lacock Abbey Cloisters, c. 1842. Calotype. $6\frac{1}{2} \times 8\frac{1}{8}$ in (16.5×20.6 cm)

Gauguin, Paul, 1848–1903: The Day of the God, 1894. Oil on canvas, $27\frac{3}{8} \times 35\frac{5}{8}$ in $(69.6 \times 90.5$ cm) 97 Women at the River (Auti te Pape), 1893–95. Colored woodcut, 8×14 in $(20.3 \times 35.7$ cm) 135

GÉRICAULT, THÉODORE, 1791–1824: After Death, 1818–19. Oil on canvas. $17\frac{3}{4} \times 22$ in $(45.1 \times 55.9$ cm). A. A. Munger Collection 263.

GERMAN, ANONYMOUS ENGRAVER, 15th century: Man of Sorrows, c. 1465–70. Hand-colored woodcut. $15\frac{3}{4} \times 10\frac{1}{2}$ in $(40.1 \times 26.7 \text{ cm})$ 127

GERMAN, LOW, ANONYMOUS PRINTMAKER, 15th century: Man of Sorrows with Four Angels, c. 1470. Dotted metal cut print, $13 \times 9_8^7$ in $(33.0 \times 25.1 \text{ cm})$

GERMAN, LOWER SAXONY, late 13th-early 14th centuries: Embroidered Square: The Last Supper. Linen and silk. $14\frac{1}{4} \times 15$ in $(36.3 \times 38.2 \text{ cm})$ 235 Monstrance of St Christina, c. 1475. Silver. $8\frac{3}{4} \times 5\frac{1}{2}$ in $(22.2 \times 14.0 \text{ cm})$ 223

GÉRÔME, JEAN/LÉON, 1824–1904: Portrait of a Lady, 1851. Oil on canvas. 36½×29 in (92.8×73.7 cm). Silvain and Arma Wyler Foundation, Restricted Gift

GERUNG, MATTHIAS, c. 1500-c. 1568/70: The Judgment of Paris, 1536. Oil on panel. $18\frac{3}{4} \times 12\frac{1}{2}$ in

(47.7×31.8 cm). Charles H. and Mary F.S. Worcester Collection

GLACKENS, WILLIAM J., 1870–1938; Chez Mouquin, 1905. Oil on canvas. $48\frac{3}{16} \times 36\frac{1}{4}$ in (122.3 \times 92.1 cm). Friends of American Art Collection

GORKY, ARSHILE, 1904–1948: The Artist's Mother, 1936. Charcoal. $24\frac{3}{4} \times 19\frac{1}{8}$ in $(63.0 \times 48.5$ cm) 171 The Plough and the Song No. 2, 1946. Oil on canvas. $51\frac{7}{8} \times 61\frac{3}{8}$ in $(131.8 \times 155.9$ cm). Mr and Mrs Lewis Larned Coburn Fund

GOYA Y LUCIENTES, FRANCISCO, 1746–1828: Beware of that Step!, c. 1805. Brush in grey and black wash on white paper. $10\frac{3}{8} \times 7\frac{3}{16}$ in $(26.4 \times 18.2 \text{ cm})$ Capture of Maragato by Fray Pedro, c. 1807. Oil on panel. $11\frac{1}{2} \times 15\frac{1}{8}$ in $(29.2 \times 38.5 \text{ cm})$ 67
The Hanged Monk, c. 1810. Oil on panel. $12\frac{3}{16} \times 15\frac{5}{16}$ in $(31 \times 39.2 \text{ cm})$. Robert A. Waller Fund

Portrait of General José Manuel Romero, c. 1810. Oil on canvas. $41\frac{1}{2} \times 37\frac{7}{8}$ in $(105.5 \times 83.5$ cm)

EL GRECO (DOMENICO THEOTOCOPULI), 1541–1614: *The Assumption of the Virgin*, 1577. Oil on canvas. 158×90 in (401.4×228.7 cm)

GREEK, ATTIC, UNKNOWN SCULPTOR, end of 4th century BC: Figure of a Youth from a Gravestone. Marble. H. 32 in (81.3 cm)

GRIS, JUAN, 1887–1927: Portrait of Picasso, 1912. Oil on canvas. $29\frac{1}{4} \times 36\frac{7}{8}$ in $(74.3 \times 93.7$ cm) 115

GUERCINO (G.F. BARBIERI), 1591–1666: The Entombment, 1656. Oil on canvas. $56 \times 85\frac{1}{4}$ in (142.2 \times 216.6 cm). Wilson L. Mead Fund

Gurney, Richard and Thomas Cook: Covered Cup, c. 1757–58. Gold. H. 8 in (20.3 cm)

HAN DYNASTY, 206 BC-AD 221: Jar for wine storage called a Hu. Bronze. H. $17\frac{3}{4}$ in (45.2 cm) 177

HAN DYNASTY, LATE, AD 9–221: Statuettes of Dancers. Painted pottery. H. $6\frac{1}{4}$, $6\frac{7}{8}$ in (15.8, 17.5 cm)

HARNETT, WILLIAM MICHAEL, 1848–1892: Just Dessert, 1891. Oil on canvas. $22\frac{1}{4} \times 26\frac{3}{4}$ in $(56.6 \times 68.0 \text{ cm})$

HEIAN PERIOD, LATE, UNKNOWN ARTIST, 9th century: Seated Hachiman. Wood. H. 21 in (53.5 cm)

Hobbema, Meindert, 1638–1709: The Watermill with the Great Red Roof, c. 1670. Oil on canvas. $32\times43\frac{1}{8}$ in $(81.3\times109.6$ cm). Gift of Mr and Mrs Frank G. Logan

HOITSU, 1761–1828: Mandarin Ducks in the Snow. Two-fold screen, color and gilt on paper. $67\frac{3}{8} \times 64\frac{3}{4}$ in $(171.1 \times 164.5 \text{ cm})$

Homer, Winslow, 1836–1910: Croquet Scene, 1866. Oil on canvas. $15\frac{7}{8} \times 26\frac{1}{16}$ in (40.3×66.2 cm). Friends of American Art Collection 265 Gulfstream. Watercolor. $11\frac{3}{8} \times 20\frac{1}{16}$ in (28.9×51.0 cm) 164 The Herring Net, 1885. Oil on canvas. $29\frac{1}{2} \times 47\frac{1}{2}$ in (75.0×120.6 cm) 106

HOPE, THOMAS (after): Circular Table, c. 1810. Unstained mahogany inlaid, with gilt ornaments. H. 28½ in (72.5 cm)

HOPPER, EDWARD, 1882–1976: Nighthawks, 1942. Oil on canvas. $33\frac{3}{16} \times 60\frac{1}{8}$ in $(84.3 \times 152.7 \text{ cm})$

INDIAN, UNKNOWN ARTIST, 11th century: Figure of Shiva Nataraja. Bronze with patina. H. 28 in (71.2 cm)

INGRES, J. A. D., 1780–1867: Charles Gounod, 1841. Pencil on paper. 11 $\frac{3}{16} \times 9\frac{1}{16}$ in (30.0 × 23.0 cm)

157

Amédée-David, Marquis de Pastoret, 1826. Oil on canvas. $39\frac{3}{8} \times 32\frac{1}{4}$ in (99.5 × 82.0 cm)

69

ISENBRANDT, ADRIAEN, active 1510, d. 1551: Madonna and Child, c. 1510–40. Oil on panel. $15\frac{1}{4} \times 12$ in $(38.8 \times 30.5$ cm). Mr and Mrs Martin A. Ryerson Collection

ITALIAN, UNKNOWN ARTIST, 14th century: Crucifixion, probably 1390–1415. Tempera on panel. $20\times9_4^1$ in $(50.9\times23.5$ cm)

UNKNOWN ARTIST, early 16th century: The Annunciation. Tapestry of silk, wool, gold, and linen. 46×72 in $(116.9\times182.9$ cm)

ANONYMOUS NORTH ITALIAN ARTIST, 15th century (?): Profile Portrait of a Man, c. 1450 (?). Silverpoint on prepared surface. $9\frac{3}{4} \times 6\frac{7}{8}$ in $(24.8 \times 17.5 \text{ cm})$

JAPANESE, UNKNOWN ARTIST, 14th century: The Priest Kobo Daishi as a Child. Hanging scroll, water-colors, ink and gilt on silk. $34\frac{1}{8} \times 19\frac{1}{4}$ in $(86.6 \times 49.0 \text{ cm})$

UNKNOWN ARTIST, 14th century: Shika Mandara. Hanging scroll, watercolor, ink and gilt on silk. $49\frac{3}{8} \times 20 \text{ in} (125.5 \times 50.9 \text{ cm})$ 196

KAMAKURA PERIOD, UNKNOWN ARTIST, 1185– 1392: Guardian Figure. Painted wood with paste inlays. H. 36½ in (92.8 cm)

Kandinsky, Wassily, 1866–1944: Improvisation with Green Center (No. 176), 1913. Oil on canvas. $43\frac{1}{4} \times 47\frac{1}{2}$ in (109.9×120.6 cm)

KIRCHNER, ERNST LUDWIG, 1880–1938: The Blacksmith, 1917. Woodcut $19\frac{11}{16} \times 15\frac{3}{4}$ in $(50.0 \times 40.1 \text{ cm})$

KITAGAWA UTAMARO, 1753–1806: Geisha and her Maid. Colored woodblock print. 15×10 in (38.2×25.4 cm) 209

The Hour of the Wild Boar, 10 p.m. to 11 p.m. Colored woodblock print. 15×10 in (38.2×25.5 cm) 210

KIYONOBU I, 1664–1729: The Actor Takii Hannosuke as a Wakashu, c. 1710. Colored woodblock print. 22×11½ in (56.0×29.2 cm) 203

Koryo Dynasty, 13th century: Vase. Pottery. H. $10\frac{1}{4}$ in (26.0 cm) 191 Ewer. Pottery. H. 10 in (25.5 cm) 191

LAMERIE, PAUL DE (1688–1751): 'Tredegar Cup', 1739–40. Silver. H. 14, W. $13\frac{1}{8}$, Diameter at lip $6\frac{7}{16}$ in (35.6, 33.3, 16.36 cm) 228

Lan Ying, 1578–1660: Landscape. Album leaf, ink and color on paper. 12×16 in $(30.5 \times 40.8 \text{ cm})$

LAWRENCE, SIR THOMAS, 1769–1830: Mrs Jens Wolff, 1803, 1815. Oil on canvas. $50\frac{3}{8}\times40\frac{1}{4}$ in (128.0 \times 102.2 cm)

LONGHI, PIETRO, 1702–1785. Lady at her Toilet, c. 1740. Oil on canvas. $22\frac{3}{8} \times 17\frac{1}{4}$ in (56.9 \times 43.9 cm). Flora Erskine Miles Fund

Lo Spagna, Giovanni di Pietro, c. 1450–1528: St Catherine of Siena, c. 1516. Oil on panel. $41\frac{1}{4} \times 19$ in $(104.8 \times 48.3 \text{ cm})$. Mr and Mrs Martin A. Ryerson Collection

MABUSE (JAN COSSAERT), c. 1478–c. 1535: Madonna and Child, c. 1520. Oil on panel. $21 \times 15\frac{7}{8}$ in (53.5 \times 40.4 cm). Charles H. and Mary F.S. Worcester Collection

MAGRITTE, RENÉ, 1898–1967: *Time Transfixed*, 1939. Oil on canvas. $57\frac{1}{2} \times 38\frac{3}{8}$ in (146.1×97.5 cm)

MALER ZU SCHWAZ, HANS, Attrib. to, c. 1479/80–c. 1530: Christ bearing the Cross, c. 1515. Oil and tempera on panel. $13\frac{1}{4}\times22\frac{11}{16}$ in $(33.7\times57.6$ cm). Charles H. and Mary F.S. Worcester Collection

MANCINI, ANTONIO, 1852–1930: Resting. Oil on canvas, $22\frac{3}{4} \times 38\frac{1}{2}$ in $(57.9 \times 97.9$ cm). Gift of Charles Deering McCormick, Brooks McCormick, and Roger McCormick

MANET, ÉDOUARD, 1832–1883: Boy with Pitcher, c. 1862. Oil on canvas. $22\frac{1}{4} \times 20$ in $(56.6 \times 50.9 \text{ cm})$. Bequest of Katharine Dexter McCormick 265 The Mocking of Christ, 1865. Oil on canvas. $75\frac{1}{8} \times 58\frac{3}{8}$ in $(190.8 \times 148.3 \text{ cm})$ 76 Portrait of Berthe Morisot, 1874. Watercolor on paper. $8 \times 6\frac{1}{2}$ in $(20.3 \times 16.5 \text{ cm})$ 158 Race Track Near Paris, 1864. Oil on canvas. $17\frac{1}{4} \times 33\frac{1}{4}$ in $(43.9 \times 84.5 \text{ cm})$. Potter Palmer Collection

Still-Life with Carp, 1864. Oil on canvas. $28\frac{7}{8} \times 36\frac{1}{4}$ in $(73.4 \times 92.1 \text{ cm})$

Manfredi, Bartolommeo, 1587–1620: Cupid Chastised, c. 1605–10. Oil on canvas. $69 \times 51\frac{3}{8}$ in (175.3 \times 130.6 cm)

MARC, FRANZ, 1880–1916: Bewitched Mill, 1913. Oil on canvas. $51\frac{3}{8} \times 35\frac{3}{4}$ in $(130.6 \times 90.8 \text{ cm})$ 271

Martorell, Bernardo, active 1427–1452: St George killing the Dragon, c. 1438. Tempera on panel. 56×38 in $(142.3 \times 96.5$ cm)

Massys, Quentin, 1465/66–1520: Man with a Pink, 1510–20. Oil on panel. $17\frac{1}{4} \times 11\frac{1}{2}$ in (43.9 \times 29.2 cm). Gift of John J. Glessner 251

MASTER OF AMIENS, active after 1475: St Hugh of Lincoln, c. 1480. Oil on panel. $46\frac{1}{8} \times 20$ in (117.2 \times 50.8 cm)

Master of the Bigallo Crucifix: Crucifix, c. 1260. Tempera on panel. $75\frac{3}{8} \times 50\frac{1}{4}$ in (191.5 \times 127.7 cm)

Master of the Female Half-Figures (flem-ish), c. 1500–1530: Mary Magdalen, c. 1525. Panel. $20\frac{1}{2}\times14\frac{3}{4}$ in (52.4 \times 37.5 cm). Max and Leola Epstein Collection 251

Master of Moulins, active c. 1500: Annunciation. Oil on panel. 29×20 in $(73.7 \times 50.9 \text{ cm})$ 34

MASTER OF THE HISTORIA: *Nativity, c.* 1510–20. Oil and tempera on panel. $46\frac{3}{4} \times 29\frac{1}{4}$ in (118.8 × 74.3 cm). Wilson L. Mead Fund

Matisse, Henri, 1869–1954: Apples, 1916. Oil on canvas. 46×35 in (116.9 \times 88.9 cm) 116 Bathers by a River, 1916–17. Oil on canvas. 103×154 in (261.8 \times 391.2 cm) 117 Interior at Nice, 1921. Oil on canvas. 52×35 in (132.2 \times 88.9 cm) 121

MAYA CULTURE, late 8th, early 9th centuries AD: Wall Panel. Stone. L. 17 in (43.3 cm) 241 Late Classic Period, c. AD 700–900: Cylindrical Vessel. Painted, fired clay. H. $8\frac{3}{8}$ in (21.4 cm) 242

MEMLING, HANS, c. 1433–1497: Madonna and Child with Donor, c. 1485. Oil and tempera on panel. $13\frac{1}{2}\times10\frac{1}{2}$ in $(34.4\times26.7 \text{ cm})$; $13\frac{3}{4}\times10\frac{5}{8}$ in $(35\times27 \text{ cm})$ 28–9

Millet, Jean François (1814–1875): Horse, c. 1841. Oil on canvas, $65\frac{1}{2}\times77\frac{1}{2}$ in (166.4 \times 196.8 cm)

MINELLI DEI BARDI, GIOVANNI, 1460–1527: Virgin and Child, c. 1520. Terracotta with traces of paint. H. $57\frac{3}{4}$ in (146.8 cm)

MIRÓ, JOAN, b. 1893: Portrait of a Woman (Juanita Obrador), 1918. Oil on canvas. $27\frac{1}{2} \times 24\frac{1}{2}$ in (69.5 \times 62.0 cm). The Joseph Winterbotham Collection

Mochica Culture, AD 500-700: Portrait Vessel with a Stirrup Spout. Terracotta. H. 14 in (35.7 cm)

Mola, Pier Francesco, 1612–1666: Homer Dictating, c. 1650. Oil on canvas. 28×38 in (71.2×96.5 cm). Charles H. and Mary F.S. Worcester Collection

Mondrian, Piet, 1872–1944: Composition, 1913–14. Black chalk $24\frac{3}{8} \times 19$ in $(63.0 \times 48.3 \text{ cm})$ 169

MONET, CLAUDE, 1840–1926: The Beach at Sainte-Adresse, 1867. Oil on canvas. $29\frac{1}{2} \times 39\frac{3}{4}$ in $(75.0 \times 101.0 \text{ cm})$

Old Saint-Lazare Station, Paris, 1877. Oil o	n canvas.
$23\frac{1}{2} \times 31\frac{1}{2}$ in (59.6×80.2 cm)	82
The River, 1868. Oil on canvas. $31\frac{7}{8} \times 39\frac{1}{2}$	in (81.0
× 100.3 cm)	81

MOREELSE, PAULUS, 1571–1638: Portrait of a Lady, c. 1620. Oil on panel. $28\frac{1}{8} \times 22\frac{5}{8}$ in (71.5×57.6 cm). Max and Leola Epstein Collection 257

MORETTO DA BRESCIA, c. 1498–1554: Mary Magdalene, second quarter 16th century. Oil on canvas. $64\frac{1}{2}\times17\frac{3}{4}$ in (163.9×45.2 cm). Gift of William Owen Goodman

MORONI, GIOVANNI BATTISTA, c. 1525–1578: Lodovico Madruzzo, c. 1560. Oil on canvas. $79\frac{3}{4}\times$ 46 in (202.6 \times 116.9 cm). Charles H. and Mary F.S. Worcester Collection

Mughal: Procession in a palace, leaf from a royal ms. of the Shah-Jehan Nameh, c. 1650. Ink, color, and gold on paper. $14\frac{3}{4} \times 8\frac{11}{16}$ in $(37.5 \times 22.0 \text{ cm})$ 215

NARA PERIOD, UNKNOWN ARTIST, AD 710–784: Seated Bosatsu Figure. Lacquered wood. 24×17 in (61.0×43.3 cm)

NORTHERN FRANCE: Virgin and Child Enthroned, c. 1240. Ivory, once partly gilt. $8\frac{7}{8} \times 3\frac{3}{4}$ in (22.6×9.5 cm)

O'KEEFFE, GEORGIA, b. 1887: Cow's Skull with Calico Roses, 1931. Oil on canvas. $35\frac{5}{8} \times 24$ in $(91.1 \times 61.0$ cm)

OPUS ANGLICANUM: Cope, late 15th—early 16th century. Velvet, silk, metal thread, and sequins. $56\frac{5}{16} \times 115$ in (143.0 \times 292.1 cm) 238

PAOLO, GIOVANNI DI, c. 1403–1482/3: St John the Baptist in Prison, c. 1450–60. Tempera on panel. $27 \times 14\frac{1}{4}$ in $(68.7 \times 36.3 \text{ cm})$

PERUGINO, PIETRO, c. 1452–1523: Baptism of Christ, c. 1510. Oil on canvas. $10\frac{1}{2} \times 16\frac{3}{4}$ in (26.7×42.6 cm). Mr and Mrs Martin A. Ryerson Collection

PIAZZETTA, GIOVANNI BATTISTA, 1683–1754: Pastoral Scene, c. 1740. Oil on canvas. $75\frac{1}{2}\times56\frac{1}{4}$ in (191.8×143.0 cm)

PICASSO, PABLO, 1881–1973: Daniel Henry Kahnweiler, 1910. Oil on canvas. $39\frac{5}{8}\times28\frac{5}{8}$ in $(100.6\times72.8$ cm)

The Frugal Repast, 1904. Etching printed in blue. $18\frac{1}{8} \times 15$ in $(46.2 \times 38.2$ cm) Fernande Olivier, 1906. Charcoal, 24×18 in (61.0× 45.8 cm) Figure. Gouache on cardboard. $24\frac{3}{4} \times 19$ in $(63.0 \times$ 48.3 cm) Head of the Acrobat's Wife (Woman with Helmet of *Hair*), 1904. Gouache on paperboard, $16\frac{7}{8} \times 12\frac{1}{4}$ in (42.9×31.2 cm). Gift of Kate L. Brewster Man with a Pipe, 1915. Oil on canvas. $51\frac{1}{4} \times 35\frac{1}{4}$ in (130.3×89.5 cm) TT2 Mother and Child, 1921. Oil on canvas, 561×64 in (143.5×162.6 cm) 120 Mother and Child, fragment. Oil on canvas. $55\frac{1}{2}$ $16\frac{1}{2}$ in (141.0×42.0 cm) T20 Nessus and Dejanira, 1920. Silverpoint on prepared paper. $8\frac{1}{4} \times 10\frac{5}{9}$ in $(21.3 \times 27.0 \text{ cm})$ Nude Under a Pine Tree, 1959. Oil on canvas. 72×96 in (182.9×244.0 cm). Grant J. Pick Collection 276

The Old Guitarist, 1903. Oil on panel. $48\frac{1}{8} \times 32\frac{7}{16}$ in $(122.3 \times 82.4 \text{ cm})$ 109 Sylvette (Mlle D.), 1954. Oil on canvas. $51\frac{1}{2} \times 38\frac{1}{4}$ in $(130.9 \times 97.2 \text{ cm})$ 123

PISANELLO, 1395–1455/56: Studies of the Eastern Patriarch, 1438. Pen and brown ink on paper. $7\frac{1}{2} \times 10\frac{1}{4}$ in $(19.1 \times 26.0 \text{ cm})$

PISSARRO, CAMILLE, 1830–1903: Girl Sewing, 1895. Oil on canvas. $25\frac{5}{8} \times 21\frac{3}{8}$ in $(65.2 \times 53.8 \text{ cm})$. Gift of Mrs Leigh B. Block 269 Place du Havre, Paris, 1893. Oil on canvas. $23\frac{5}{8} \times 28\frac{13}{16}$ in $(60.1 \times 73.5 \text{ cm})$ 98

POLLOCK, JACKSON, 1912–1956: Grayed Rainbow, 1953. Oil on canvas. 72×96 in (182.9×244.0 cm). Gift of the Society for Contemporary American Art

Pontormo, Jacopo, 1494–1557 (Follower): Virgin, Child and Infant St John. Oil on panel. $32\frac{1}{4}\times22\frac{1}{2}$ in $(82.0\times57.3$ cm). Charles H. and Mary F.S. Worcester Fund

Pourbus the Younger, Frans, 1569–1622: Marie de' Medici, 1616. Oil on canvas. $39\frac{1}{4} \times 30\frac{1}{2}$ in $(99.8 \times 77.5$ cm). Gift of Kate S. Buckingham

257

POUSSIN, NICOLAS, 1594–1665: St John on Patmos, c. 1650. Oil on canvas. $40 \times 53\frac{1}{2}$ in (101.7×135.9 cm)

REMBRANDT VAN RIJN, 1606–1669: *Noah's Ark*. Reed pen and wash. $7\frac{7}{8} \times 9\frac{1}{2}$ in (20.0×24.2 cm)

The Presentation in the Temple, late 1650s (?). Etching and drypoint. $7\frac{1}{2} \times 6\frac{3}{8}$ in (19.1 × 16.2 cm) 131 Presumed Portrait of the Artist's Father, c. 1631. Oil on panel. $32\frac{7}{8} \times 29\frac{3}{4}$ in (83.5×75.6 cm) 52 Young Girl at an open Half-Door, 1645. Oil on canvas. $40\frac{1}{8} \times 33\frac{1}{8}$ in (102.0×84.2 cm) 53

RENI, GUIDO, 1575–1642: Salome with the Head of John the Baptist, probably 1638–39. Oil on canvas. $97\frac{3}{4} \times 68\frac{1}{2}$ in (248.5×173.0 cm)

RENOIR, PIERRE AUGUSTE, 1841-1919: Child in White, 1883. Oil on canvas. $24\frac{1}{4} \times 19\frac{3}{4}$ in $(61.7 \times$ 50.4 cm). Mr and Mrs Martin A. Ryerson Collection Lady at the Piano, 1875. Oil on canvas, $36\frac{3}{4} \times 29\frac{1}{4}$ in $(93.4 \times 74.3 \text{ cm})$ Nude (study for The Great Bathers), 1884-85. Pastel and wash. 39×25 in (99.2×63.6 cm) On the Terrace, 1881. Oil on canvas. $39\frac{1}{2} \times 31\frac{7}{9}$ in (100.3×81 cm) 87 The Rowers' Lunch, c. 1880. Oil on canvas. $21\frac{1}{2}\times$ $25\frac{3}{4}$ in $(54.7 \times 65.5$ cm) 86 Two little Circus Girls, 1879. Oil on canvas. 5112× $38\frac{3}{4}$ in (130.9×98.5 cm)

REYNOLDS, SIR JOSHUA, 1723–1792: Lady Sarah Bunbury Sacrificing to the Graces, 1765. Oil on canvas. 94×60 in (238.9×152.5 cm) 60

RIESENER, JEAN-HENRI (1734–1806): Commode, c. 1791. Mahogany, gilt bronze, and marble. H. 37\frac{3}{4}, W. 65\frac{1}{4}, D. 22\frac{1}{4}\text{ in (95.9, 165.7, 56.6 cm)} 231

RIMPATTA, ANTONIO, last quarter 15th-early 16th centuries: Virgin and Child, Five Saints, and Donor. Oil on panel. $49\frac{1}{4} \times 47$ in (125.1 \times 119.4 cm). Clyde M. Carr Fund

ROBERT, HUBERT, 1733–1808: Villa Medici, Rome, 1785. Oil on panel. $12\frac{3}{8} \times 10\frac{3}{8}$ in $(31.5 \times 26.4$ cm)

ROME: Gallienus, c. AD 260. Marble. H. $13\frac{2}{3}$ in (34 cm)

ROUSSEAU, HENRI, 1844–1910: The Waterfall, 1910. Oil. $45\frac{5}{8} \times 59$ in (116.3×150.0 cm) 270

RUBENS, PETER PAUL, 1577–1640: Holy Family with St Elizabeth and St John the Baptist, c. 1615. Oil on panel. 46×35½ in (116.9×90.2 cm) 44

The Triumph of the Eucharist, 1626–27. Oil on panel. $12\frac{1}{2} \times 12\frac{1}{2}$ in $(31.8 \times 31.8 \text{ cm})$ 45

RUISDAEL, JACOB VAN, 1628/9-1682: Ruins of Egmond, 1650-60. Oil on canvas. $38\frac{7}{8} \times 51\frac{1}{8}$ in $(98.9 \times 129.9$ cm). Potter Palmer Collection 260

SARGENT, JOHN SINGER, 1856-1925: Mrs Charles Gifford Dyer (May Anthony), 1880. Oil on canvas. $24\frac{5}{8} \times 17\frac{1}{4}$ in (62.7×43.9 cm). Friends of American Art Collection 267 Mrs George Swinton, 1896. Oil on canvas. 90×49 in (228.7×124.5 cm). Wirt D. Walker Fund 269

SCHEEL, SEBASTIAN, Attrib. to, c. $1479^{-1}554$: Madonna and Child with Saints, c. 1525. Oil and tempera on panel. Center $54\frac{1}{2} \times 39\frac{1}{2}$ in $(138.5 \times 100.3 \text{ cm})$; wings $54\frac{1}{2} \times 16\frac{3}{4}$ in $(138.5 \times 42.6 \text{ cm})$. Mr and Mrs Martin A. Ryerson Collection 253

SESSON SHUKEI, 1504–1589: Landscape of the Four Seasons. Six-fold screen, ink and color on paper. 61\(\frac{3}{8}\times 133\) in (155.9\times 337.9 cm) 198–99

SEURAT, GEORGES, 1859–1891: Sunday Afternoon on the island of La Grande Jatte, 1884–86. Oil on canvas. $81 \times 120\frac{3}{8}$ in $(205.7 \times 305.8 \text{ cm})$ 92 Trees on the Bank of the Seine, c. 1884–85. Conté crayon. $24\frac{3}{8} \times 18\frac{1}{2}$ in $(62.0 \times 47.1 \text{ cm})$ 161

SHANG DYNASTY, before 1028 BC: Wine vessel called a *Lei*. Bronze with patination. H. 17³/₄ in (45.2 cm)

Late Shang or Early Chou Dynasties, 12th–10th centuries BC: Food vessel called a Kuei . Bronze with patination. H. $9\frac{1}{4}$ in (23.5 cm) 175

SHOJO SHOKADO, 1584–1639: Plum and Bamboo. Hanging scrolls, ink with touches of color on paper. 46×12 in (116.9×30.5 cm) 200

SISLEY, ALFRED, 1839–1899: Sand Heaps, 1875. Oil on canvas. $21\frac{1}{4} \times 28\frac{7}{8}$ in $(54.1 \times 73.4$ cm) 83

SPANISH, UNKNOWN ARTIST, 14th century: The Ayala Altarpiece, 1396. Tempera on panel. Altarpiece $99\frac{3}{4} \times 251\frac{3}{4}$ in $(253.6 \times 639.4$ cm); Antependium $33\frac{1}{2} \times 102$ in $(85.2 \times 259.2$ cm)

UNKNOWN ARTIST: Dossal and Antependium: Scenes from the Life of Christ, c. 1468. Silver and gold, silk on linen. Dossal $62\frac{3}{4} \times 77\frac{1}{2}$ in (159.5×196.9 cm); Antependium $30\frac{1}{2} \times 79\frac{1}{4}$ (77.5×201.3 cm) 237

STEEN, JAN, 1626–1679: The Family Concert, 1666. Oil on canvas. $34\frac{1}{8} \times 39\frac{3}{4}$ in $(86.6 \times 101.0 \text{ cm})$. Gift of T. B. Blackstone

STROZZI, BERNARDO, 1581-1644: An Episcopal Saint, c. 1630. Oil on canvas. $51\frac{1}{4} \times 39\frac{3}{8}$ in (130.3× 100.0 cm). Alexander A. McKay Fund

STUART, GILBERT, 1755–1828: Major General Henry Dearborn, 1811–12. Oil on canvas. $28\frac{1}{8}\times$ $22\frac{9}{16}$ in $(71.5 \times 57.3$ cm). Friends of American Art Collection

SUGIMURA JIHEI, active 1680-1697: Lovers. Woodblock print. $10 \times 14\frac{1}{4}$ in $(25.5 \times 36.3 \text{ cm})$

SULLY, THOMAS, 1783-1872: Anna Milnor Klapp, 1814. Oil on canvas. $36\frac{1}{4} \times 28\frac{1}{8}$ in (92.1×71.5 cm). Gift of Annie Swan Coburn to the Mr and Mrs Lewis Larned Coburn Memorial Collection 263

SUNG DYNASTY, UNKNOWN PAINTER, AD 960-1279: Palace Musicians. Handscroll, ink and colors on silk. $16\frac{1}{2} \times 72\frac{1}{2}$ in $(42.0 \times 184.2 \text{ cm})$ 183

T'ANG DYNASTY, AD 618-906: Standing Warrior. Painted pottery with traces of gilt. H. 38 in (96.5 cm) 182 Tomb figure of a Horse. Glazed pottery. H. 301/2 in (77.5 cm)

T'ANG YIN, 1470-1523: Drinking at Night. Handscroll, ink on paper. 13×35 in (33.0×88.9)

TEOTIHUACAN CULTURE, AD 400-700: Painted Wall Decoration. Adobe with lime and Indian red pigment. $36\frac{5}{8} \times 25\frac{1}{8}$ in (93.0×63.9 cm)

TERBORCH, GERARD, 1617-1681: The Music Lesson, c. 1660. Oil on canvas. $25 \times 19\frac{5}{8}$ in $(63.6 \times$ 50.0 cm). Demidoff Collection, Gift of Charles T. Yerkes

TIEPOLO, GIOVANNI BATTISTA, 1696-1770: The Baptism of Christ. Oil on canvas. $13\frac{1}{8} \times 17\frac{7}{8}$ in $(33.3 \times 44.4 \text{ cm})$ 261 The Death of Seneca. Pen, brush, and sepia wash. $13\frac{1}{2} \times 9\frac{1}{2}$ in $(34.4 \times 24.2 \text{ cm})$ Madonna and Child with St Dominic and St Hyacinth, 1740-50. Oil on canvas. 108×54 in (274.4×137.2 cm) Ubaldo and Guelpho surprising Rinaldo and Armida in the Garden, c. 1740. Oil on canvas. $73\frac{1}{2} \times 102\frac{1}{8}$ in $(186.9 \times 259.5 \text{ cm})$

TIEPOLO, GIOVANNI DOMENICO, 1727-1804: Christ in the House of Jairus. Pen and ink with grey and brown wash. $18\frac{7}{8} \times 15$ in (48.0×38.2 cm) 151 TORII KIYONAGA, 1752-1815: Party at the Nakasuya, c. 1783. Colored woodblock print. $15\frac{1}{4} \times 20$ in $(38.8 \times 50.9 \text{ cm})$ Women landing from a Pleasure Boat. Colored wood-

block print. $15\frac{1}{2} \times 10\frac{1}{4}$ in $(39.5 \times 26.0 \text{ cm})$

Toscano, Meliore: Virgin and Child Enthroned, c. 1270. Tempera on panel. $32\frac{1}{4} \times 18\frac{3}{4}$ in (82.0× 47.7 cm)

Toshusai Sharaku, active 1794-1795: The Actor Morita Kanya VIII. Colored woodblock print. $12\frac{1}{2} \times 9\frac{3}{4}$ in $(31.8 \times 24.8 \text{ cm})$

Toulouse Lautrec, Henri de, 1864-1901: At the Moulin Rouge, 1892. Oil on canvas. $48\frac{3}{8} \times 55\frac{1}{4}$ in (122.9×140.4 cm) Elsa, The Viennese, 1897. Colored lithograph. $22\frac{7}{8} \times 15\frac{3}{4}$ in (58.2×40.1 cm) Moulin de la Galette, 1889. Oil on canvas. $35 \times 39\frac{7}{8}$ in (88.9×101.3 cm). Mr and Mrs Lewis Larned Coburn Memorial Collection

Turchi, Alessandro, 1578-1649: Venus and Cupid, c. 1630. Oil on canvas. $45\frac{3}{4} \times 62\frac{5}{8}$ in (116.2× 159.1 cm). Charles H. and Mary F.S. Worcester Collection 259

TURNER, J.M.W., 1775-1851: Valley of Aosta -Snowstorm, Avalanche, and Thunderstorm, 1836-37. Oil on canvas. $36 \times 48\frac{1}{4}$ in $(91.5 \times 122.6$ cm)

VANDERBURGH, Cornelius: Caudle Cup. c. 1683. Silver. H. $5\frac{1}{2}$ in (14.0 cm)

VAN GOGH, VINCENT, 1853-1890: Bedroom at Arles, 1888. Oil on canvas. $28\frac{3}{4} \times 36$ in $(73.0 \times$ 91.5 cm) Grove of Cypresses, 1889. Ink and reed pen over pencil. $25\frac{5}{8} \times 18\frac{1}{4}$ in $(65.2 \times 46.5$ cm) Self-Portrait, 1886–88. Oil on cardboard. $16\frac{1}{2} \times 13\frac{1}{4}$ in $(42.0 \times 33.7 \text{ cm})$ 94

VAN HEMESSEN, JAN SANDERS, c. 1500-after 1575: Judith, c. 1560. Oil on panel. $39\frac{1}{4} \times 30\frac{7}{16}$ in (99.8×77.2 cm). Wirt D. Walker Fund 255

VAN OSTADE, ADRIAEN, 1610-1685: The Family, 1647. Etching. $6\frac{7}{8} \times 6\frac{1}{16}$ (17.5×15.4 cm)

VAN SOEST, GERAERD, c. 1600–1681: Portrait of Dr John Bulwer. Oil on canvas. $39\frac{1}{2} \times 33\frac{1}{4}$ in (100.3) × 129.9 cm). Alexander A. McKay Fund

VASARI, GIORGIO, 1511-1574: Mystical Vision of S. Jerome, c. 1550. Oil on panel. $65\frac{3}{8} \times 47\frac{1}{2}$ in (166.1 × 120.6 cm). Charles H. and Mary F.S. Worcester Collection 254

Velázquez, Diego Rodriguez de Silva Y, 1599–1660: Isabella of Spain, c. 1632. Oil on canvas. $49\frac{3}{8} \times 40$ in (126.4×101.7 cm) 49 The Servant, 1618–22. Oil on canvas. $21\frac{7}{8} \times 41\frac{1}{8}$ in (55.7×104.5 cm). Robert A. Waller Fund 258 St John in the Wilderness, 1619–20. Oil on canvas. 69×60 in (175.3×152.5 cm). Gift of Mrs Richard E. Danielson 257

VENETO-BYZANTINE, UNKNOWN ARTIST: Enthroned Virgin and Crucifixion, 13th century. Tempera on wood. Each panel $11\frac{1}{2} \times 8\frac{3}{4}$ in $(29.2 \times 22.2 \text{ cm})$

VENETO-RIMINESE, Attrib. to the Master of the Haniel Tabernacle: Virgin and Child with Scenes from the Life of Christ, c. 1325–30. Tempera on panel. 25¼×37 in (64.2×94.0 cm). Denison B. Hull Restricted Fund

VERONESE, PAOLO, 1528–1588: Creation of Eve, c. 1570. Oil on canvas. $31\frac{7}{8} \times 40\frac{1}{4}$ in (81.0×102.2 cm). Charles H. and Mary F. S. Worcester Collection

VILLON, JACQUES (GASTON DUCHAMP-VILLON), 1875–1963: The Set Table. Drypoint etching. 11 $\frac{1}{4}$ ×15 in (28.6×38.2 cm) 137

VITTORIA, ALESSANDRO, 1525–1613: St Luke, c. 1570. Terracotta. H. 23\frac{1}{8} in (58.7 cm) 225

VLAMINCK, MAURICE DE, 1876-1958: Houses at

Chatou, 1903. Oil on canvas. $32 \times 39\frac{5}{8}$ in $(81.3 \times 101.3$ cm). Gift of Mr and Mrs Maurice E. Culberg

WATTEAU, ANTOINE, 1684–1721: The Dreamer. Oil on cradelled panel. $9\frac{1}{8}\times 6\frac{1}{2}$ in $(23.2\times 16.5$ cm). Mr and Mrs Lewis Larned Coburn Fund 261 The Old Savoyard. Red and black chalk. $14\frac{1}{4}\times 8\frac{7}{8}$ in $(36.3\times 22.5$ cm) 147 Studies of Figures from the Italian Comedy. Red, black, and white chalk. $10\frac{1}{4}\times 15\frac{5}{8}$ in $(26.0\times 39.8$ cm) 146

WHISTLER, JAMES ABBOTT MCNEILL, 1834–1903: Arthur Jerome Eddy, 1894. Oil on canvas. $82\frac{3}{4}\times36\frac{3}{4}$ in (209.1 \times 93.4 cm). Arthur Jerome Eddy Memorial Collection

WOOD, GRANT, 1892–1942: American Gothic, 1930. Oil on beaverboard. $29\frac{7}{8} \times 24\frac{7}{8}$ in $(76.0 \times 63.3 \text{ cm})$

Wyeth, Andrew, b. 1917: The Cloister, 1949. Tempera on board. 32×41 in $(81.3\times104.2$ cm). Gift of Mrs Joseph Regenstein

YOSHITOSHI, 1838–1892: Japanese Girl in Western Dress, 1888. Colored woodblock print. $14\frac{1}{4} \times 9\frac{5}{8}$ in $(36.3 \times 24.5 \text{ cm})$ 212

ZURBARÁN, FRANCISCO DE, 1598–1664: St Roman, 1638. Oil on canvas. 97×63 in $(246.5 \times 160.1 \text{ cm})$ 51 ZURBARÁN, FOLLOWER OF: Still Life: Flowers and Fruit, c.1633-34. Oil on canvas. $32\frac{1}{2} \times 42\frac{3}{4}$ in $(82.6 \times 108.6 \text{ cm})$. Wirt D. Walker Fund 258